BILL BRANDT

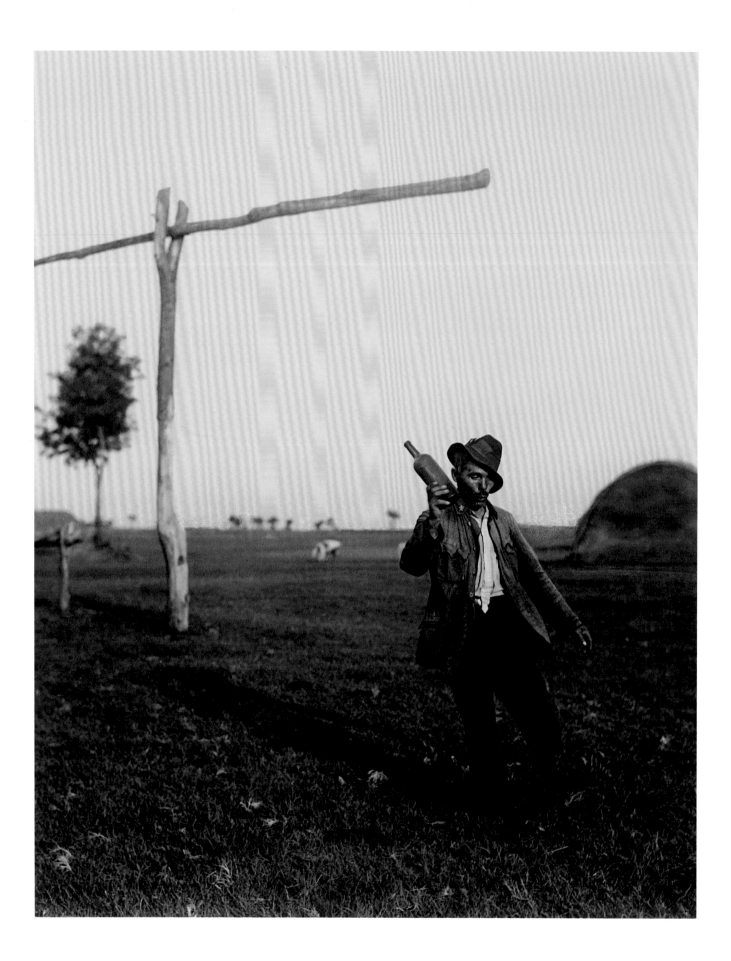

BILL BRANDT
SHADOW AND LIGHT

Sarah Hermanson Meister

With 255 illustrations, 162 in tritone

Published in conjunction with the exhibition *Bill Brandt: Shadow and Light*, at The Museum of Modern Art, New York (March 6–August 12, 2013), organized by Sarah Hermanson Meister, Curator, Department of Photography.

Major support for the exhibition is provided by GRoW Annenberg/ Annenberg Foundation, The Robert Mapplethorpe Foundation, Heidi and Richard Rieger, Ronit and William Berkman, and by Peter Schub, in honor of Anne and Joel Ehrenkranz. Research and travel support provided by The International Council of The Museum of Modern Art.

Additional generous funding for this publication was provided by the John Szarkowski Publications Fund.

Produced by the Department of Publications, The Museum of Modern Art, New York

Edited by Jason Best
Designed by Beverly Joel, pulp, ink.

Production by Matthew Pimm

Printing and binding by NINO Druck GmBH, Neustadt an der Weinstrasse, Germany

Tritone separations by Martin Senn

This book is typeset in Erato and Johnston ITC. The paper is 150gsm Magno Satin.

First published in the United Kingdom in 2013 by Thames & Hudson Ltd, 181A High Holborn, London WC1V 7QX

British Library Cataloguing-in-Publication Data
A catalogue record for this book is available from the British Library

ISBN: 978-0-500-54424-2
Printed and bound in Germany

To find out about all our publications, please visit **www.thamesandhudson.com**. There you can subscribe to our e-newsletter, browse or download our current catalogue, and buy any titles that are in print.

Endpapers: Detail of *Cuckmere River, Sussex*, 1963
(see page 143)

Frontispiece: Bill Brandt. *Hungary*, c. 1930. Gelatin silver print, 10 $\frac{5}{16}$ x 8 $\frac{3}{8}$" (26.2 x 21.2 cm). The Museum of Modern Art, New York. Acquired through the generosity of Ronald A. Kurtz

Table of Contents

The Museum of Modern Art is proud to present this major reconsideration of the work of Bill Brandt, the artist who defined the potential of photographic modernism in England for much of the twentieth century and whose remarkably broad oeuvre endures as a landmark in the history of the medium. Brandt achieved early acclaim for his characterizations of the British social structure and life in London in the 1930s; three decades later, he would publish the fruits of an extended investigation that yielded some of the most striking and inventive studies of the female nude ever produced. In the intervening years, Brandt trained his lens on a variety of subjects, ranging from the Depression-stricken industrial towns of Northern England to portraits of some of the leading literary figures in Britain of the time, working both by his own inclination and on assignment for several of the most widely read illustrated magazines of his day. A number of his images of the Blackout in London and the impact of the Blitz on the city's residents during World War II remain iconic.

Even as many of Brandt's photographs became instantly recognizable and the photographer himself (a natural-born German) acquired enormous popularity in his adopted country and abroad, critical appraisals of Brandt have often been confounded by one of the very aspects that made his career so unique: its impressive breadth. Brandt ranged widely; he had neither a signature subject nor printing style. As such, his body of work has typically been considered not as a whole but as separate and distinct parts marking disparate accomplishments. This exhibition is the first attempt since the retrospective organized by John Szarkowski at the Museum in 1969 to present the various aspects of Brandt's career as the sum of a single oeuvre, the singular product of one artist's dynamic fifty-year engagement with the photographic medium. The fresh scholarship produced by Sarah Meister, Curator in the Department of Photography, has resulted in a more nuanced and coherent path by which one can follow the trajectory of Brandt's development as an artist, particularly during the transformative period coinciding with the Second World War, and her attentive consideration of the dramatic evolution of Brandt's printing style stands as an indispensable resource for future assessments of Brandt's art.

It is fitting that this important examination would take place at MoMA, as the Museum's relationship with Brandt dates back to when the Department of Photography was less than a year old and the artist was not yet forty, when MoMA first exhibited Brandt's photographs in the exhibition *Britain at War* in 1941 (the work itself was unattributed, a practice that was not uncommon at the time). Several years later, Edward Steichen, the newly appointed Director of the Department of Photography, presented a cross-section of Brandt's work to date within *Four Photographers* (1948). Steichen would go on to include four photographs by Brandt in his landmark exhibition *The Family of Man*, which opened at MoMA in 1955 and subsequently circulated to thirty-seven countries on six continents, and at the conclusion of his tenure in 1961, Steichen exhibited forty-two photographs from Brandt's groundbreaking series of postwar nudes—the series's first institutional embrace, concurrent with the publication of Brandt's collection, *Perspective of Nudes*.

By the next year when John Szarkowski succeeded Steichen in the Department of Photography, the Museum owned fourteen Brandt photographs: four landscapes acquired in 1959 and ten nudes following the 1961 exhibition. A few more trickled in, and MoMA purchased forty of the 125 prints made by Brandt for his 1969 retrospective (for $25 each). Until recently, these prints—the vast majority of which were printed decades after the original negatives—formed the core of MoMA's Brandt collection. Recognizing the fundamental significance of Brandt's achievement to the history of twentieth-century photography, the Museum identified Brandt's work as a strategic priority for acquisition in 2006, and since then MoMA has acquired seventy vintage prints, which have allowed for a more comprehensive understanding of the radical transformations of the artist and his technique. Peter Galassi, then Chief Curator in the Department of Photography, was the first to articulate this need, and his enthusiasm was matched, and occasionally surpassed, by the efforts of Sarah Meister and David Dechman, a longtime Brandt enthusiast and a Member of the Board of Trustees and the Museum's Committee on Photography, who was instrumental in this initiative. This exhibition and catalogue reflect the culmination of that effort, which has not only more than doubled the number of Brandt prints in MoMA's collection but now, for the first time, allows each chapter of Brandt's sweeping career to be represented in the way the artist had originally intended for it to be seen.

Director's Foreword

Glenn D. Lowry

Alfred H. Barr, Jr., the Museum's founding director, had a vision for the institution that would "expand beyond the narrow limits of painting and sculpture," encompassing modern art in all media, and not long after opening its doors in November 1929, the Museum was collecting and exhibiting film, photography, architecture, and industrial design, highlighting the connections among them in a way that would find echoes in Brandt's work. Like many contemporary artists, Brandt drew inspiration from (and, in turn, inspired) an artistic milieu broader than the medium with which he chose to create. His close attention to the cinematography of Gregg Toland in *Citizen Kane* had a profound effect on the way in which he approached his early nudes, for example, and the anatomical distortions in the sculptural forms of Henry Moore resonate strongly with the extreme and unfamiliar perspectives of the photographer's late nudes. Brandt's achievement had a significant impact on artists as disparate as Ansel Adams, Robert Frank, R. B. Kitaj, and David Hockney, a fact to which they attest in their writings. A quick perusal of his bibliography suggests how the luminaries of twentieth-century British literature felt compelled to comment on Brandt's work, which itself drew inspiration from theirs.

With the appointment of Quentin Bajac, who will become Chief Curator of the Department of Photography in January 2013, the Museum will begin a new chapter in the acquisition, publication, and display of photographs, and in exploring the role those photographs play within the broader context of modern and contemporary art. While MoMA remains keenly attuned to the future and to the critical role of photography within the visual culture of the twenty-first century, the Museum is equally and actively committed to a deeper understanding of key figures in photography's history, exemplified by this reconsideration of the work of Bill Brandt.

On behalf of the staff and trustees of the Museum, I would especially like to thank Gregory Annenberg Weingarten, Peter Schub, The Robert Mapplethorpe Foundation, Heidi and Richard Rieger, and Ronit and William Berkman for their generous support of the exhibition, as well as The International Council of The Museum of Modern Art for its research and travel support. The John Szarkowski Publications Fund has made this book possible, and I would also like to thank the Committee of Photography and the many other enthusiastic and dedicated friends of the Department of Photography whose contributions fittingly established this fund in honor of John Szarkowski.

Any exhibition at the Museum and its accompanying catalogue require the essential involvement of dozens of dedicated individuals, and this project is no exception. My first thanks are to Glenn D. Lowry, Director; Peter Reed, Senior Deputy Director for Curatorial Affairs; and Ramona Bronkar Bannayan, Senior Deputy Director, Exhibitions and Collections, for their critical and steadfast support. I am grateful to Diana Pulling, Chief of Staff, for her encouragement and diplomatic guidance, and to Leah Dickerman, Curator in the Department of Painting and Sculpture, for her constructive early feedback. My profound appreciation goes to Lee Ann Daffner, Andrew W. Mellon Conservator of Photographs, whose deep commitment to furthering our material understanding of photographs manifests itself in the illustrated glossary she had contributed to this book. Both she and Hanako Murata, Assistant Conservator of Photographs, are responsible for the skillful treatment of several photographs reproduced on these pages, work that is at once invisible to most viewers yet is vital to best appreciate Brandt's prints, and her work with Ana Martens, Associate Conservation Scientist, also contributed tremendously to our efforts to illuminate Brandt's career through contemporary conservation analysis. I am grateful as well to the Museum's outstanding team of professionals who ensure the high quality of our exhibitions, and in particular I would like to thank Jerry Neuner, Director, and David Hollely, Manager, Exhibition Design and Production; Ellen Conti, Assistant Registrar, Collections; and Jessica Cash, Assistant Coordinator of Exhibitions.

The origins of this project reach back to 2006, when Bill Brandt was first identified as a strategic priority for acquisition. Peter Galassi, Chief Curator in the Department of Photography from 1991 through 2011, articulated this need with characteristic passion and intelligence, and his influence on my understanding of Brandt and the directions in which this initiative has unfolded cannot be underestimated. I have also enjoyed the support of my extremely dedicated and talented colleagues in the Department of Photography, beginning with Roxana Marcoci, Curator, and Eva Respini, Associate Curator, who have each provided welcome insights throughout. Marion Tandé, Department Manager, has expertly managed the complexities of this ongoing acquisition effort and so much more, and Megan Feingold, Department Coordinator, has ensured that the internal and external presentations related to this project are both elegant and without error. I have repeatedly relied on Karen Van Wart, Preparator, to care for the physical well-being and presentation of the prints considered for acquisition and exhibition. Tasha Lutek, Cataloguer, has handled countless research tasks regarding the history of Brandt and his work at the Museum with creativity and persistence. I am also grateful to Mitra Abbaspour, Associate Curator for the Thomas Walther Collection Research Project, for her enthusiasm and, in particular, for her helpful commentary on my catalogue essay.

This project has enjoyed the focused attention of three people within the Photography Department without whose involvement I cannot imagine drafting these words: Dan Leers, Beaumont and Nancy Newhall Curatorial Fellow (2008–11); Drew Sawyer, who holds that position today; and Marley Blue Lewis, Research Assistant. In distinct and significant ways, these three have made this book and exhibition possible, and I owe each of them an enormous debt of gratitude. Not surprisingly, given the project's long gestation period, the list of interns who have provided important assistance with a variety of tasks is long: Grayson Cowing, Amy Creighton, Kristen Gaylord, Laura Guerrin, Andrea Hackman, Sarah Jamison, Emily Kloppenburg, Seyoung Lee, Sarah Montross (who deserves special mention for her instrumental research, both during her time at the Museum and after), Sarah O'Keefe, Allison Pappas, Noah Pritzker, Kristen Ross, and Juanita Solano.

In the Department of Publications, my thanks begin with Christopher Hudson, Publisher, whose stalwart support began early and has continued undiminished. The wise counsel of David Frankel, Editorial Director, has been as welcome and needed here as ever, and for it I am deeply grateful. Kara Kirk and Chul (Charles) Kim, past and present Associate Directors of Publications, expertly managed the project both internally and externally. Marc Sapir, Production Director, and Matthew Pimm, Production Manager, are responsible for the unfailingly high quality of the book's printing, balancing the individuality of the prints and the potentially distracting appearance of Brandt's active retouching with true sensitivity. And I thank Hannah Kim, Marketing Coordinator, for helping to ensure all this hard work receives the notice it is due. For their instrumental help with the imaging for this book, my

Acknowledgments

Sarah Hermanson Meister

appreciation extends to Erik Landsberg, Director, and Robert Kastler, Production Manager, both from the Department of Imaging and Visual Resources, and David Allison, who photographed the majority of the objects that appear in this catalogue. My thanks as well to Martin Senn for his skill in making the color separations.

That Beverly Joel of pulp, ink. developed a design for this book that is a fitting foil to Brandt's art will no doubt become apparent to anyone reading these pages: I deeply appreciate her creativity, good humor, hard work, and the distinctive elegance of this finished product. Jason Best's extraordinary talent as an editor might be less evident but has been no less critical to ensuring the quality of the finished product. To both these talented individuals I extend my heartfelt thanks, and the three of us together commend Elizabeth Smith for her attentive proofreading.

Half of the reproductions in this catalogue are made from prints that are not in the Museum Collection, and I am indebted to those who provided access to their exceptional collections of Brandt's work and their attendant assistance: John-Paul Kernot at the Bill Brandt Archive; David Dechman; Edwynn Houk, Julie Castellano, and Alexis Dean at Edwynn Houk Gallery; Malcolm Daniel, Jeff Rosenheim, Meredith Friedman, and Anna Wall at The Metropolitan Museum of Art; Sandy Phillips, Corey Keller, and Erin O'Toole at the San Francisco Museum of Modern Art; Terence Pepper, Helen Trompeteler, and Georgia Atienza at the National Portrait Gallery, London; Anne Tucker and Del Zogg at the Museum of Fine Arts, Houston; Sarah McDonald at Getty Images/Hulton Picture Archive, London; Michael Wilson and Polly Fleury at the Wilson Centre for Photography; Michael Mattis and Judith Hochberg; Robert Stevens; Vince Aletti; and last but certainly not least, Pryor Dodge, son of Lyena Barjanski, who has shared his extensive research and insights along with his mother's extraordinary albums.

For instrumental help in my research and for sharing his personal perspective on Brandt's work, I would like to express my gratitude to Mark Haworth-Booth, curator at the Victoria and Albert Museum from 1970 through 2004, whose distinguished scholarship has shaped many subsequent appreciations of Brandt's work. Likewise, I would like to thank Martin Barnes and Marta Weiss at the Victoria and Albert Museum; Hilary Roberts at the Imperial War Museum; and Lindsey Stewart at Bernard Quaritch, Ltd. Through our informal conversations about aspects of Brandt's practice and the ways their own work has shaped my understanding of Brandt's legacy, I would also like to thank the artists Chris Killip and Paul Graham.

On a personal note, I feel fortunate to enjoy the advice and friendship of Harper Montgomery and Elise Meslow Ryan, each of whom has helped with this project over the years. I thank my parents, Susie Hermanson and Terry Hermanson, for their support of my passion for photography since the sixth grade, and my sisters (and most candid critics), Leslie Lynch and Merril Hermanson. To my husband, Adam, and our children, Madeline and Lee, thank you for your unending love, patience, and understanding as I took time away from you all to work on this.

I would like to echo Glenn Lowry's expression of gratitude to Gregory Annenberg Weingarten, Peter Schub, The Robert Mapplethorpe Foundation, Heidi and Richard Rieger, and Ronit and William Berkman for their essential support of this exhibition, to The International Council of The Museum of Modern Art for a very important travel grant, and to the John Szarkowski Publications Fund (and all who contributed to it) for making it possible for the Museum to publish such independent scholarship. Finally, I would be remiss not to underscore my deep gratitude to three individuals whom I've already mentioned but who nevertheless have made essential contributions to the development of this project and to the overall collection of Bill Brandt's work at the Museum: David Dechman, an ardent supporter and informed connoisseur of Brandt's work; Edwynn Houk, whose gallery represents the Estate of Bill Brandt; and John-Paul Kernot, Brandt's step-grandson and director of the Bill Brandt Archive. My sincere appreciation as well goes to Noya Brandt, Brandt's wife from 1972 and a champion of his work before and after his death in 1983, for sharing her personal insights with me; it is fitting that one of the most recent acquisitions to the Museum's collection of Brandt's photographs was given in her honor. It has been a pleasure and a privilege to get to know each of these individuals better through this project.

Shadow and Light
The Life and Art of
Bill Brandt

Sarah Hermanson Meister

I.

Bill Brandt is a founding figure of photography's modernist traditions whose visual explorations of the society, landscape, and literature of England are indispensable to any understanding of photographic history and, arguably, to our understanding of life in Britain during the middle of the twentieth century. Although perhaps not as well-known as some of his contemporaries—Henri Cartier-Bresson and Walker Evans, for instance—he ranks among the visionaries who, in the diversity of their approach, established the creative potential of photography based on observation of the world around them. With a variety of cameras (from the handheld Leica to large-format view cameras) and sensibilities (from engaged to dispassionate, poetic to clinical), these photographers distilled life into art through the camera's lens. Brandt's distinctive vision—his ability to present the mundane world as both fresh and strange—reveals traces of the influence of Eugène Atget, Man Ray, and Brassaï (an unusual combination of egos and approaches), drawing almost capriciously, and often simultaneously, from each across a career that is impossible to reduce to a particular genre or style.

Brandt established his reputation before the Second World War with the publication of two books that featured his early photographic studies of British life, *The English at Home* (1936) and *A Night in London* (1938), and he expanded upon this social documentary work during the war and in the decades that followed with assignments for some of the leading illustrated magazines of his day, a path that led variously into extended investigations of portraiture and landscape photography, with a strong emphasis on contemporary cultural figures in Britain and the country's rich literary heritage. His crowning artistic achievement—developed primarily from 1945 to 1961—is a series of nudes that are both personal and universal, sensual and strange, collectively exemplifying the "sense of wonder" paramount to Brandt. Considered against the achievements of his peers, Brandt's work is unpredictable, not only in the range of his subjects but also for his printing style, which varied widely throughout his career. It is, in part, this wide-ranging approach that makes Brandt such a compelling figure, yet the difficulty it presents in arriving at a comprehensive understanding of his life's work has also long complicated critical appraisals of him.

Brandt's unfettered approach to his art extended to his life as well. Born to a prosperous German family, he lived comfortably, if modestly, in England throughout his adulthood, blending easily with his affluent relatives there after spending most of his twenties drifting about continental Europe. Handsome and reserved, he often enjoyed the attention of more than one woman simultaneously, suggesting an unconventional aspect of his personality, if not quite bohemian. He had a delicate constitution (suffering from tuberculosis in childhood and diabetes as an adult), a wry sense of humor, and a purposefully apolitical perspective, particularly when considered against the political backdrop of Europe at the time. Although he would become something of an icon in Britain, as the almost exhaustive circulation of his exhibitions by the Arts Council of Great Britain and the British Council suggests, he was not born British, and though the material comfort of his family enabled a lifestyle one might associate with the upper classes, this was not synonymous with British aristocracy. To Brandt, though, all this was irrelevant: art was what mattered.

Throughout his nearly fifty-year career, Brandt embraced photography's potential to use unadorned fact to create art—a central tenet of photographic modernism. But to a degree unmatched by his peers, he resolved the tension between reality and fantasy by transcending (or ignoring) either label. With characteristic ambivalence, Brandt suggested through his work that photographic "truth" simply didn't matter or, perhaps, given the political landscape in which he formed his artistic identity, that it had been manipulated beyond the point where it had meaning. Much has been written of Bill Brandt's mystery, of his willful evasiveness on the subject of his own life, of the incongruity of his creating such a personal photographic vision while working often on assignment, and of the difficulty of naming a single subject or style that approaches an adequate characterization of his life's work. Since his death in 1983, every major book and exhibition that has attempted to represent his career has done so with a number of carefully chosen thematic divisions—indeed, in Brandt's own first attempt to summarize his oeuvre, a book titled *Shadow of Light* (1966), he did the same, and the chapters he chose have formed the backbone of Brandt retrospectives ever since. In that respect, this book is no exception, for its structure respects Brandt's desire to have his work organized thematically, not simply according to some formal likeness. This book,

1 Bill Brandt, "A Photographer's London," in *Camera in London* (London: The Focal Press, 1948), 15.

however, fundamentally differs from those prior in that its primary function is to convey the art of Brandt's photographic achievement in all its unruly splendor.

In the past, discussion of the dramatic evolution of Brandt's printing style has been relegated to the sidelines, and while it is necessary to value the nearly impenetrable darkness and muted tones of his early prints from the 1930s, it is not so simple to dismiss the forcefulness of his later interpretations as an aging man's bastard prints. Indeed, a significant part of Brandt's art is that the exposure of the negative was, for him, only the beginning. In many respects each Brandt print is unique because the pervasiveness of his hand in retouching his work—to correct and to enhance, with a variety of tools— means that it is rare to find two prints presented in an identical manner.[2]

Whereas the sections of plates here correspond roughly to Brandt's dominant subjects and to the structure he favored for his own retrospective publications, a significant difference is the expanded consideration of the work Brandt made during World War II, a survey that goes much beyond the pictures he made of the underground shelters in London during the Blitz and the moonlit scenes of the city during the Blackout that have long stood as a synecdoche for his work during that period. The organization of this essay itself seeks to provide a fresh analysis of Brandt's art, with critical issues of his artistic development addressed for perhaps the first time in a chronological, rather than thematic or project-based, context.

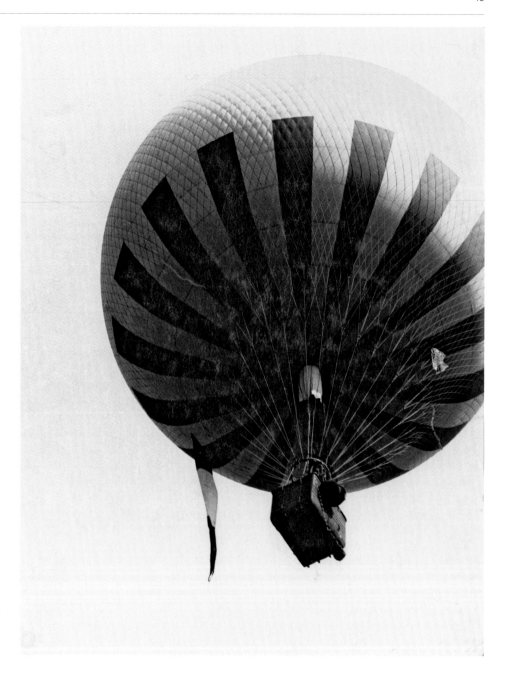

2 In the mid-1970s, Brandt began making prints specifically for sale, in association with Marlborough galleries in New York and London. The "Marlborough prints" were made from copy negatives (and then mounted and signed). They are arguably Brandt's least inspiring prints, with a production-line uniformity to them, and yet a number of these include evidence of Brandt's retouching on the final print, when it would have been much easier for him to have made those adjustments at an interim stage.

Bill Brandt. *Balloon Flying over the Northern Suburbs of Paris*, 1929. Gelatin silver print, 9 x 6 ⅞" (22.9 x 17.5 cm). Courtesy Edwynn Houk Gallery, New York

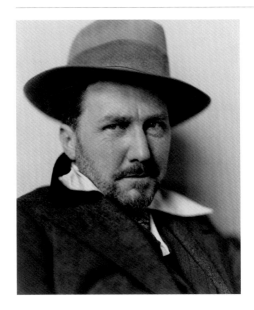

II.

For many generations, Brandt's family had operated a successful shipping and banking business based in Hamburg, Germany. That Brandt's paternal grandfather was born in Russia and that his father was born in London suggest the expansive reach of the business and explains how Brandt's father (the youngest of seven siblings) was, technically, a British citizen.[3] Bill Brandt actively promoted the impression that he was British, but the fact is he was born Hermann Wilhelm Brandt in Hamburg in 1904, the second of four brothers, and raised in a German-speaking household. There has been much speculation concerning the reasons for Brandt's apparent disavowal of his roots, but politics alone should suffice. In response to one request, he wrote:

My wife tells me that you would like some information about my life between 1953/69. I am afraid nothing happened during those years. Actually, nothing has ever happened to me. I have never hitch-hiked through Russia, nor has anybody ever telephoned me from Peking in the middle of the night. Even with such highlights, I find biographical chronologies pathetic and boring. I think it would be less conventional and much more interesting to concentrate on photography and leave my life alone. I hope you think so too.[4]

Brandt was intensely private, so although his soft-spoken nature has been interpreted as an attempt to mask the German accent that persisted even after decades of living in London, one might also consider it a reflection of an artist's reticence to speak for his art. Brandt's declining health as a teenager in the years following World War I led his parents to pull him from his German boarding school, and he spent more than four years in Swiss sanatoria (first in Agra, then Davos) in an attempt to cure his tuberculosis. Essentially all physical activity was forbidden in these sequestered alpine environments, which left Brandt plenty of time to read, watch movies, and experiment with a camera. His profound interest in the visual and literary arts— the foundation of which can be traced to his bourgeois family life—was nurtured during this period of forced passivity.

Brandt likely dabbled with photography during his treatment in Davos, but his first formal engagement with the medium began in a Viennese photography studio. In the spring of 1927, he had been drawn to Vienna, where his younger brother Rolf was then living, by the prospect of having his tuberculosis cured through psychotherapy.[5] Although it is unclear whether psychoanalysis deserves credit, Brandt succeeded in stabilizing his health, and he needed to decide what to do with his life. It was Dr. Eugenie Schwarzwald, a prominent Viennese intellectual and philanthropist with a particular interest in education, who is credited with suggesting photography. Brandt found a position as an apprentice in the studio of Grete Kolliner, and he worked there for much of 1927–28. His forceful portrait of Ezra Pound (left) was made during this time, employing the traditional studio techniques of directed lighting, shallow depth of field, and a plain backdrop. The portrait is more than a convincing likeness: the tight cropping signaled Brandt's avant-garde intent, and he used the reductive means of Pound's own poetry to convey the sitter's intensity.

Bill Brandt. *Ezra Pound*, 1928. Gelatin silver print, 7½ x 6⅜" (19.1 x 16.2 cm). The Museum of Fine Arts, Houston

3 Paul Delany, *Bill Brandt: A Life* (Stanford, Calif.: Stanford University Press, 2004). All biographical details about Brandt's life are drawn from this book as well as Mark Haworth-Booth's texts in *Bill Brandt: Behind the Camera, Photographs 1928–1983* (Oxford, U.K.: Phaidon; New York: Aperture, 1985).

4 Bill Brandt to Katherine Kinear at the Arts Council of Great Britain, March 11, 1970, Victoria and Albert Museum archives, London. I am indebted to Mark Haworth-Booth for directing me to the original letter.

5 For about six months, Brandt was a patient of the Viennese physician and psychoanalyst Wilhelm Stekel, who championed the potential of this approach to treat tuberculosis.

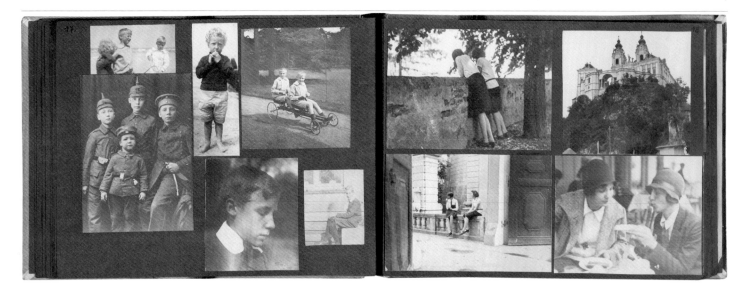

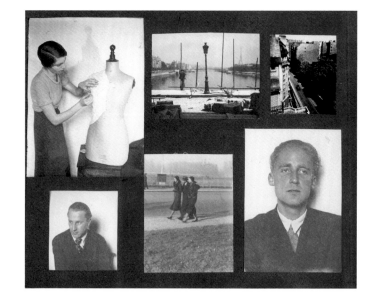

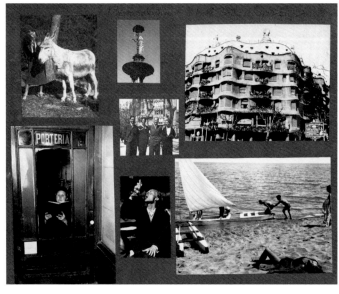

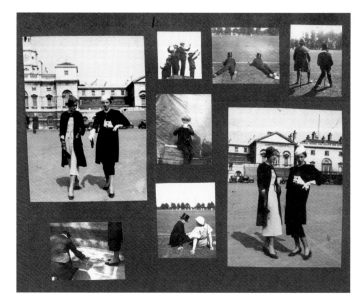

Its success notwithstanding, this portrait bears little in common with the hundreds that would define Brandt's contribution to the genre during and after World War II, where he would capture his sitters in their homes or other familiar surroundings, and where their expressions would often suggest a dreamlike aura (see, for example, pp. 104–5).[6]

It was in Austria that Brandt made the acquaintance of two women with whom he would remain close for decades. Just after leaving the sanatorium, he met Lyena Barjansky, a sixteen-year-old of Russian descent who attended Schwarzwald's school for girls, and, in the fall of 1928, Eva Boros, whom Kolliner had taken on as another apprentice in her studio. Eva was Hungarian and four years older than Lyena, but these two young women became Brandt's constant companions, traveling and living together throughout continental Europe. The scrapbook albums kept by Eva and Lyena, filled with photographs of and by Brandt, are extraordinary records of this generative period in Brandt's life and are revealing in terms of his interests and travel, as well as the very casual and personal nature of his early explorations with a camera—a distinct counterpoint to his studio experience (facing).[7] The nature of Brandt's romantic, or physical, relationship with each woman is unclear, so this arrangement may not have been as radical as it seems, but it speaks to his magnetism and to his willingness to defy social conventions, by appearance if nothing else. In April 1932, during a trip to Spain, Eva became Brandt's wife, but it was several years before they lived under the same roof, which suggests a third possible factor in this unusual arrangement: a fear of being

reinfected with tuberculosis, from which Eva continued to suffer periodically throughout her life.

The trio moved to Paris in 1930, although they continued to travel throughout the continent. Brandt started working as an informal apprentice in the studio of Man Ray, the American expatriate painter and photographer fourteen years his senior who had become a key figure in both the Dada and Surrealist movements. It was at this time that Brandt developed his Surrealist sensibility—his obvious delight in the uncanny aspects of the everyday that permeates much of his work. Even if Man Ray was not actively instructing Brandt, from his work Brandt could not have failed to notice his printing experimentation, particularly with the female nude, which would later find echoes in Brandt's own practice.[8] The French photographer Eugène Atget, whose "documents" of Paris had captured the imagination of the Surrealists shortly before his death in 1927 and whose first monograph (required reading for any aspiring photographer) appeared in 1930, was another defining influence.[9] Inspired by Atget's simultaneously methodical and poetic exploration of Paris, particularly its mannequins and shop windows, Brandt wandered through the city with his camera. One of the best of his resulting images was featured in *Minotaure* (the Surrealist-oriented magazine that had succeeded *La Révolution surréaliste*), at the center of an article by René Crevel in 1934 (right).[10]

Paris in 1930 was teeming with photographers of extraordinary talent, but it was the Hungarian-born Brassaï who managed to make his name synonymous with the city, most emphatically with the publication of *Paris de Nuit* ("Paris by

6 Underscoring the need for more attention to the chronology of Brandt's career, his portrait of Pound is often published alongside the postwar portraits, as if the intervening decades were immaterial.

7 Two of Eva Boros's scrapbooks are in the collection of the Victoria and Albert Museum, London. Lyena Barjansky's scrapbooks are in the collection of her son, Pryor Dodge, in New York. Brandt would ultimately include at least a dozen pictures that appear in the scrapbooks in *The English at Home*.

8 Many years later Brandt told Man Ray: "You went out so often that I did not learn much from you directly. But what I did was go through all the drawers and files that I would not have dared touch when you were in the studio. So I learnt a great deal when you were not there." Ian Fraser, "Bill Brandt in Camera," *The World of Interiors*, February 1983: 80; quoted in Delaney, 62–63. Man Ray used the term "Rayograph" to refer to his cameraless photographs, but more relevant to Brandt's darkroom work, he would use solarization (which reversed some tones from positive to negative during the printing process) and various screens to achieve his desired effect from a given negative.

9 Eugène Atget, *Atget: Photographe de Paris* (New York: E. Weyhe, 1930), with an introduction by Pierre Mac Orlan.

10 René Crevel, "La grande mannequin cherche et trouve sa peau," *Minotaure* 5 (May 1934): 18–19.

(facing, top row) Pages 17 and 18 from Lyena Barjansky's first album chronicling her time with Bill Brandt, including Brandt family photographs and images of Eva Boros and Lyena in Vienna, 1928–29. Lyena Barjansky Collection, courtesy of Pryor Dodge

(facing) Individual pages from Lyena Barjansky's second album. Lyena Barjansky Collection, courtesy of Pryor Dodge. (middle row, left) Page 11, Paris, 1930; (middle row, right) Page 23, Paris, 1931; (bottom row, left) Page 26, Barcelona, April 1932; (bottom row, right) Page 34, London, 1931–32

(above) *Minotaure*, May 1934, p. 18. Brandt's photograph (*Marché aux Puces, Paris*, c. 1930) illustrates an article by René Crevel

Night") in 1933. Brassaï was Brandt's only contemporary with a similarly fluid approach to photographic realism, and Brandt paid close attention to his example. Brandt's photograph of a prostitute in Hamburg's red-light district is a direct homage, although Brassaï's subjects were real women he encountered at work on the street, while Brandt used Eva as a model (facing, left).[11] It was only with the publication of *A Night in London* in 1938 that Brandt demonstrated the full extent of Brassaï's influence—and how he made it his own. The similar titles were likely dictated by their shared publisher, Arts et Métiers Graphiques, and both books feature glimpses into a range of noctural urban circumstances, although access to the affluent came more easily to Brandt, who had a number of family members and their servants who could pose for him.[12] Brandt embraced the inky black expanses that appeared frequently in Brassaï's work and the hyper-glossy surfaces that amplified this effect, which were favored for their superior reproducibility, but his pictures manifested a distinctly less sensational flair—Brandt was more interested in looking at the mundane world with "a sense of wonder."[13] Of course, in the early and mid-1930s in Paris, opportunities for Brandt to publish his work were few and far between: André Kertész, Germaine Krull, Henri Cartier-Bresson, Ilse Bing, and many others—in addition to Brassaï—were actively seeking jobs for the illustrated press. Brandt's decision to settle permanently in London allowed him to sidestep this competition, and it was in the British capital that he transformed the avant-garde esprit into his own art.

III.

Brandt and Eva moved to London in April 1934.[14] Supported in part by his parents, who would join the rest of the family in England shortly before the outbreak of the war, Brandt set about applying the lessons he had learned on the continent to his photographic explorations of the city that he would call home for the rest of his life. By the late 1940s, after Brandt had established himself as a regular contributor to the illustrated press, he wrote, "As a matter of fact I am able to forget photography almost completely when I am not working and never carry a camera except on an assignment."[15] Yet this was not the case in 1934. It would be more than two years before Brandt received a commission to do a photo-story and two years after that before he could rely upon these assignments as a regular source of income. Fortunately, his pursuit of the English through the lens of his camera needed no external motivation.

The absence of regular assignments allowed Brandt the luxury of photographing whatever caught his eye, and this frequently included friends and family members going about their everyday lives or posing for his camera. His photographs were factual, and they rang true whether or not he had arranged the scene. He was fascinated by the British social hierarchies, and he worked diligently to create a visual inventory of distinctly English types: palace guards, "bobbies," tailors, miners, homemakers, schoolchildren, nurses, professors, huntsmen, racegoers, and more. Brandt's attentiveness to the distinctions of social class, "that most British of preoccupations,"[16] helped cement his identity as a British photographer, even while he was,

rightly, also considered a foreigner. He had the advantage of seeing this world as "fresh and strange" but with access typically not afforded to outsiders. His favorite subject was undoubtedly his uncle's parlormaid, known to the family as Pratt, and he photographed her repeatedly, once even arranging his camera so that he could appear with her (facing, right).[17] The art of these photographs lies in their ability to present each subject with an air of transparency, asking viewers to "stand and stare" but without judgment: the miners returning to daylight and the racegoers at Ascot are seen with an impassiveness that is often overlooked by those seeking to establish a political position for Brandt.

Less than two years after moving to London, Brandt published his first book, *The English at Home*, in February 1936. It wasn't easy to find a publisher, but Brian Batsford, who had published the English edition of Brassaï's *Paris de Nuit* in 1933, thought its subject in a novel-sized format had the potential for commercial success, perhaps based on his 1935 publication of Paul Cohen-Portheim's *The Spirit of London*.[18] *The English at Home* would become Brandt's calling card. His familial connections to affluent, if not aristocratic, social spheres in England provided an intimate look at their costumes and habits in a way that had eluded Brassaï, who photographed the Parisian elite almost surreptitiously, from a distance or through a window. But Brandt was careful to balance this work with images from across the social spectrum, and there is an equanimity to his approach that imbues his *Workmen's Restaurant* (c. 1934; p. 62) with the dignity of the *Clubmen's*

11 A clear model for this photograph appears in *Paris de Nuit* (Paris: Arts et Métiers Graphiques, 1933), pl. 30. Even before the book was published, it is highly likely that Brandt would have seen Brassaï's photographs based on the photographers' mutual acquaintances in Paris.

12 See Anne Wilkes Tucker, "Brassaï: Man of the World" in *Brassaï: The Eye of Paris* (Houston: The Museum of Fine Arts, 1998), 61–63, for a detailed comparison of Brandt and Brassaï.

13 Many of Brassaï's prints from this era are 11-by-14 inches, with a glossy, ferrotyped surface. The vast majority of Brandt's prints—before and after the war—are on 8-by-10-inch semi-gloss paper, but there are a significant number of early prints that echo the surface and size of Brassaï's work.

14 Brandt lived at 43 Belsize Avenue, and Eva had her own apartment, less than a ten-minute walk away. Lyena remained in Paris.

15 Brandt, *Camera in London*, 13.

16 Richard Howells, "Self Portrait: The Sense of Self in British Documentary Photography," in *National Identities* 4, no. 2 (2002): 104.

17 Another view of Pratt in the dining room of Brandt's uncle appears as the sixth plate in *The English at Home*, and Pratt is the protagonist in Brandt's 1939 *Picture Post* article "The Perfect Parlourmaid," in which this self-portrait appears.

18 Mark Haworth-Booth, "The English at Home," in *Bill Brandt: Behind the Camera, Photographs 1928-1983*, 12.

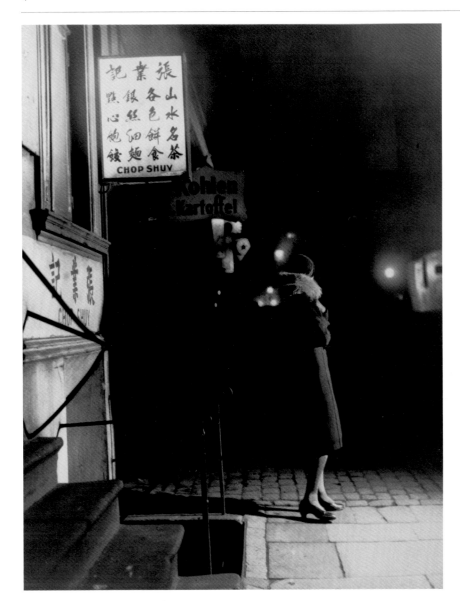

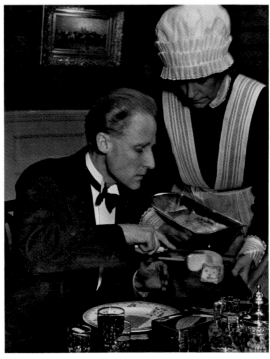

Bill Brandt. *Hamburg, St. Pauli District*, c. 1933. Gelatin silver print, 8 x 6¼" (20.3 x 15.9 cm). Courtesy of Edwynn Houk Gallery, New York

Bill Brandt with Pratt, c. 1939. Gelatin silver print, 5⅛ x 4⅛" (13 x 10.5 cm). Lyena Barjansky Collection, courtesy of Pryor Dodge

Sanctuary that appeared opposite it. One contemporary reviewer noted: "It is because each scene or figure has interested him purely for itself that his pictures are so good and carry such implications. He does not only set out to illustrate the contrast between rich and poor; he takes his pictures and the contrast is there. The best of them are—what can one call them?—pictorial epigrams, surprisingly, vividly, exactly, seen."[19]

In all subsequent books and, indeed, in the vast majority of his prints, Brandt's work is reproduced almost exclusively in a slightly vertical, rectangular format. But at this early stage, Brandt was still considering a variety of presentation methods—the examples of the jumble of pictures on the pages of Eva's and Lyena's albums, as well as on the pages of several popular German, French, and British weekly illustrated magazines being fresh in his mind. Almost a quarter of the plates present strong horizontal rectangles and are printed sideways to maximize the image size on the page, requiring the viewer to flip the book in order to look at the picture in its proper orientation.[20]

The pictures are paired, most often to elaborate a narrative sequence, although there are a handful that might be characterized as describing the class contrasts that provide the backdrop for the book (right, top). Despite Brandt's success in describing his titular subject, there is an air of strangeness that persists throughout, such as in his rendering of the Billingsgate porter with an enormous fish balanced nonchalantly atop his head (p. 65), or the children's party in Kensington, where the balloons suspended in midair act as surrogates for the privileged innocents

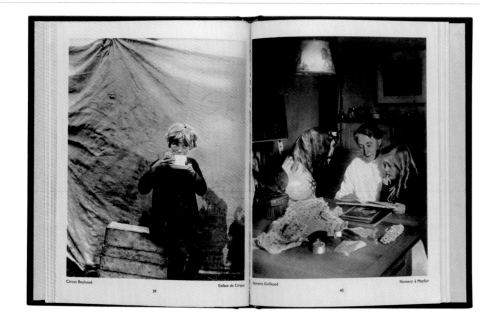

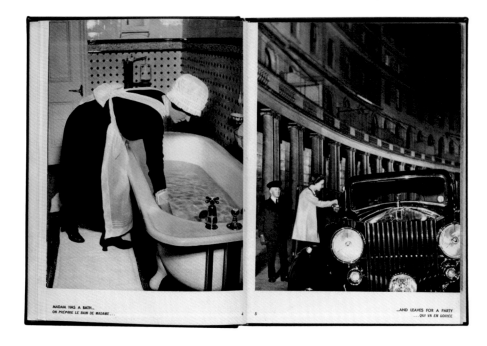

19 G. W. Stonier, "Ourselves in Photograph," *New Statesman*, February 29, 1936: 318; quoted in Delany, 110.

20 This had been the same solution used to include Atget's horizontal images in *Atget: Photographe de Paris*, although in that instance the trim size was significantly more generous.

(top) Plates 39 and 40 from *The English at Home*, 1936

(bottom) Plates 4 and 5 from *A Night in London*, 1938

below (p. 45). The apparently hypnotic power of Brandt's flash in prosaic settings across class boundaries suggests the ways in which he was adapting the surrealist lessons he had learned in Paris to his own purposes.

Despite the book's positive critical reception, *The English at Home* was far from a commercial success.[21] Brandt continued to receive a modest allowance from his parents, but magazine work held the key to increased financial stability. It was Tom Hopkinson, the editor of *Picture Post* and *Lilliput* magazines throughout the 1940s, who wrote the first profile of Brandt in 1942, which begins with his description of meeting the artist for the first time:

Some time in the spring of 1936 a young man came into the office where I was working. He was tall and slim, sunburned, with golden hair brushed back. He had a rather narrow mouth with thin lips, long forehead and chin, and very clear blue eyes. He wore a grey flannel suit, had a voice as loud as a moth, and the gentlest manner to be found outside a nunnery.

Altogether, he did not seem a very likely person to be given a job on a weekly picture paper. However, he carried under his arm a book, and in the book were photographs taken by himself. They were remarkable photographs, and they showed more sharply than I had ever seen before how a human eye and a piece of mechanism can combine, not so much to record the world as to impose a particular vision of the world upon it.[22]

The office in which Hopkinson was working in 1936 was of *Weekly Illustrated*, the magazine founded two years prior by the innovative Hungarian-born publisher Stefan Lorant.[23] Brandt's first picture in *Weekly Illustrated* was published on May 23, 1936; his first story, "Opera in a Country House" (at the celebrated Glyndebourne), appeared the following week. However auspicious this may have seemed to Brandt, regular assignments (or, more commonly in the 1930s, the use of his existing pictures) were elusive. Hopkinson may have immediately recognized the uniqueness of Brandt's achievement, but while Lorant was in charge, he had his own favorites.[24] Despite, or perhaps thanks to, the dearth of assignments, Brandt was able to continue his pursuit of the English and to concentrate his attention on his next book.

In 1937, Brandt ventured to the industrial towns of Northern England, an area that had been severely impacted by the Depression. He left no record of what motivated him to travel there, nor does he appear to have been on assignment. At first glance, the images that resulted from his trip can be taken as an investigation of the deep poverty and dire conditions that had attracted the attention of a number of social reformers, and indeed, Brandt made a few great pictures that bear unequivocal witness to the devastating unemployment that plagued the region at the time (see pp. 74–75). But there is a subtle ambiguity to many of his images as well: the social implications inherent in the blackened structures of the industrial landscape or even the photographs of the domestic lives of the miners (both of which find parallels with the pictures he was making in London during the same period) are balanced against or even eclipsed by an obvious aesthetic intent. It would be unfair to suggest that Brandt was indifferent to the circumstances before his camera, and yet in the face of such a major social issue, the recurring visual leitmotifs (soot-covered surfaces of both buildings and people) and the private existence of these pictures (unpublished for more than a decade) suggest that he found it difficult to resist the artistic potential he sensed in these subjects.

The publication of Brandt's second book, *A Night in London*, in June 1938 cemented his artistic alliance with the city. The distinctively neutral sensibility remained consistent with his earlier work, although here the sequence of pictures unfolds chronologically, beginning with twilight and ending just after dawn. It is a signal of Brandt's growing confidence as an artist (and the parallel confidence of his publishers) that he could capture the nocturnal life of London as Brassaï had done in Paris. There were several unique aspects of Brandt's book, most notably his ability to weave together images from across the social spectrum. Brassaï's particular talent for capturing illicit, marginalized, or unconventional activity stands in stark contrast to the normalcy of Brandt's imagery—the routines of the upper and working classes unfold across the pages (facing, bottom). And yet despite the absorbing impression these pictures give of Brandt roaming through the London night and capturing his subjects unaware, a significant number of the images feature his family members playing particular roles: the apparent affair taking place in *Soho Bedroom* (1934; p. 53) or the ambiguous exchange in *Street Scene, London* (1936; p. 56) are all staged for Brandt's camera.[25] This artifice was irrelevant for Brandt so long as the pictures rang true, which they did without exception.

There are no horizontal photographs in *A Night in London*, only gently vertical rectangles, which hints that Brandt

21 Brandt reminisced with Brian Batsford in 1978 that even at a price of five shillings, it was soon remaindered. His letter is quoted in Mark-Haworth Booth, *Bill Brandt: Behind the Camera, Photographs 1928–1983*, 13.

22 Tom Hopkinson, "Bill Brandt—Photographer," *Lilliput* 11, no. 2 (August 1942), 130.

23 *Weekly Illustrated* was the first of three magazines founded in London by Lorant, the other two being *Lilliput* (June 1937) and *Picture Post* (October 1, 1938). By June 1940, Lorant had moved to the United States, and Hopkinson succeeded him as editor at *Picture Post* and *Lilliput*.

24 Felix Man (born Hans Baumann) and Kurt Hutton (born Kurt Hübschmann) had both worked for Lorant in Munich and arrived in London not long after him, at which time they anglicized their names to help obtain assignments—like Brandt, understandably wanting to minimize their affiliation with Germany.

25 Mark Haworth-Booth identifies many of these individuals in *Bill Brandt: Behind the Camera*, p. 26. See also Delaney, pp. 112–3, 120, 128–9.

may have hoped these images might appear in other contexts, namely, *Lilliput*. Almost precisely a year before the publication of Brandt's book, this new monthly magazine appeared in London, targeting a savvy, cultured audience while featuring an occasionally cheeky sense of humor. *Coronet* magazine, founded in November 1936 by Chicago-based publisher David Smart, was likely a model for *Lilliput*, with a similar audience and pocket-size scale. With *Lilliput* evolved a new model for illustrated photo-stories—one that more closely echoed the format of Brandt's early publications both in terms of its diminutive size and the practice of reproducing a single picture per page. *Lilliput* was the second magazine Lorant created in London, and as its title suggests, it was only 7½-by-5¼-inches wide. With this format, the importance of sequencing, with special attention to the images paired across a spread, becomes more important than in articles where multiple pictures appear on a page.

Outwardly, as Hopkinson observed, Brandt seemed an odd fit for magazine work, and this was a reflection not only of his disposition but of his working methods as well. The decade between the publication of *A Night in London* and his next book, *Camera in London*, coincided with World War II, and it marked the peak of Brandt's work for the illustrated press. Yet by any standard, the pace of his contributions was still measured, and it was not uncommon for weeks or months to pass between published stories. This was due in part to Brandt's relative financial stability and, in part, to a natural reserve. He wrote: "By temperament I am not unduly excitable and certainly not trigger-happy. I think

twice before I shoot and very often do not shoot at all. By professional standards I do not waste a lot of film; but by the standards of many of my colleagues I probably miss quite a few of my opportunities. Still, the things I am after are not in a hurry as a rule."[26] While this describes Brandt's approach to a particular assignment, the intermittent nature of his production suggests it may serve as an apt description for his overall career as well.

Still, following the publication of *A Night in London* and coinciding with the introduction of Lorant's third British magazine, *Picture Post*, Brandt could rely on regular assignments from the illustrated press. Although this would have been only a dream in the beginning of his career, by 1948 Brandt could truthfully confess: "I hardly ever take photographs except on an assignment. It is not that I do not get pleasure from the actual taking of photographs, but rather that the necessity of fulfilling a contract—the sheer *having* to do a job—supplies an incentive, without which the taking of photographs just for fun seems to leave the fun rather flat."[27] If his first two books, compiled of work made on his own initiative, became the proof that convinced magazine editors he could fulfill their needs, their assignments profoundly influenced the trajectory of his career.

IV.

One of the challenges of understanding Brandt's career is the apparent incongruity of his prewar social documentary pictures and his postwar portraits, landscapes, and nudes. In retrospective considerations of his work, most notably *Shadow of Light*,

Brandt distilled his photographic activity during the Second World War to his pictures of London during the Blackout and the Blitz. A detailed consideration of his activity during these years illuminates the connections that Brandt himself frequently overlooked: his published photo-stories during the war tell a more complicated story—indeed, one that often involves him making his first forays into those very same categories that he would pursue for much of the rest of his career.[28]

The fascination with English daily life and its social structure that so dominated Brandt's work of the 1930s did not simply disappear with the outbreak of the war. Photographs made in the underground air-raid shelters, commissioned by the Ministry of Information (pp. 90–94), or for photo-stories such as "Fire Guard on the House of Commons" in *Picture Post* (p. 199) bear much in common with Brandt's prewar work and could have appeared in *A Night in London* were it not for the unmistakable backdrop of war. But Brandt's wartime commissions and assignments gave him a chance to explore other genres, and in 1941 alone he was given opportunities to photograph J. B. Priestley and Robert Graves for *Picture Post* (p. 104) and eight young British poets for *Lilliput* (p. 107). He soon found a way to evoke a solemn, vaguely distracted expression from his subjects that would become the hallmark of his work in this genre. Brandt made two journeys north (particularly difficult in wartime, yet equally fruitful for his postwar landscapes) to photograph Hadrian's Wall (for *Picture Post*) and the Brontë country (for *Lilliput*), where issues of British history and the relationship between photography and literature became paramount. It was

26 Bill Brandt, *Camera in London*, 18.

27 Ibid., 17.

28 See "Bill Brandt's Published Photo-Stories, 1939–1945" (pp. 194–203, in this volume) for a detailed list of Brandt's published work during World War II, with many articles illustrated in their entirety for the first time since then.

not only that his subject matter was expanding, but Brandt, as an artist, was changing. In 1970 he reflected:

Towards the end of the war, my style changed completely. I have often been asked why this happened. I think I gradually lost my enthusiasm for reportage. Documentary photography had become fashionable. Everybody was doing it. Besides, my main theme of the past few years had disappeared; England was no longer a country of marked social contrast. Whatever the reason, the poetic trend of photography, which had already excited me in my early Paris days, began to fascinate me again. It seemed to me that there were wide fields still unexplored. I began to photograph nudes, portraits, and landscapes.[29]

It is fair to say that the social structure that had been at the core of *The English at Home* and *A Night in London* and the mass unemployment Brandt had witnessed in the northern industrial towns were things of the past. And just as England had changed, so had Brandt, whose health, which had been stable since his arrival in Vienna in 1927, took a turn for the worse: the trauma of the bombings and deprivations required by rationing may have been contributing factors in the onset of diabetes that would affect him throughout his adult life. The war also saw the deterioration of Brandt's relationship with his first wife, Eva, from whom he separated in 1948. Eva had struggled with tuberculosis on and off for decades, and it was she who introduced Brandt to Marjorie Beckett in 1938, perhaps so that Brandt would have company during the absences necessitated by her treatment. Marjorie would become Brandt's lover,

muse, and model (p. 148), and his companion until her death in 1971.[30]

Certainly one might quibble with Brandt's observation that documentary photography had become fashionable, and with whether "reportage" was ever an apt characterization of his work. Even as he placed the "documentary moment-of-truth school" as the polar opposite of photography's "poetic school," the former seems a poor description of his achievement during the preceding decade. Brandt had never been interested in factual accuracy, regarding his life or his photographs, and during the war the need to obscure certain facts was a necessary component of patriotism—the censors saw to that. Brandt's editors, too, would take whatever liberties they needed to make a good story. An early photograph by Brandt made in Hungary or Barcelona might be the counterpoint to a contemporary picture of a politician as one of the witty or satirical "doubles" in the pages of *Lilliput*, and the editors at *Picture Post* often recontextualized Brandt's work to conform to their political or pictorial agenda. It was common practice at the time for these magazines to reproduce pictures that had first appeared elsewhere, and Brandt would frequently adapt the title, date, or category of a particular image in response to a specific need.[31] Yet it is clear that there was a significant shift in Brandt's approach by the mid-1940s, and indeed, he began to explore the "poetic" potential of photography in earnest. Earlier in this same statement, he identified Man Ray and Edward Weston—two photographers rarely associated with one another—as the leaders of the "poetic school." Their only similarity might be the fact that they both

made extraordinary nudes before the war, which helps explain why Brandt wanted to align himself with their approach.[32]

At the conclusion of the war, stories featuring Brandt's work continued to appear in *Lilliput*, and pictures made for these articles would appear regularly in subsequent books.[33] Brandt's temperament was well-suited to the pace of a monthly magazine, and given the control he exerted over the cropping and printing of his pictures, he surely appreciated knowing that they would appear one to a page. The fact that each would "bleed" off the page at the top and sides was one he could accommodate. His photographs for *Picture Post* during this period appeared with about the same frequency, although fewer reappeared in his own books. Plum assignments to photograph notable figures or places of historic significance seemed to make up for those with less poetic potential, such as the story on army "suitability tests" or holiday camps for war workers. It was at *Picture Post*, however, that Brandt was given the fashion assignments that proved to be a fertile ground for experimenting with the (clothed) female form, providing him access to professional models for the first time.[34] Brandt's first fashion pictures were not editorial stories, however, but advertisements for the fashion line Rima that appeared in many issues of the U.K. edition of *Harper's Bazaar* from May 1944 through December 1948.[35] Brandt likely secured this job with the help of Marjorie, who began working as a fashion editor for the magazine during the war: it was an entrée that led to many significant portrait assignments in the postwar years for both the U.K. and U.S. editions.

29 Bill Brandt, artist's statement, *Album* no. 2 (March 1970): 46–47; reprinted in Nigel Warburton, ed., *Bill Brandt: Selected Texts and Bibliography* (Oxford, U.K.: Clio Press, 1993), 30.

30 Brandt moved to 58 Hillfield Court in 1935, and he lived there with both Marjorie and Eva, occasionally at the same time.

31 Thus *Losing at the Horse Races, Auteuil, Paris* (1932; p. 34) became *Race-goers at Sandown Park* in order to be included in the "London Before the War" section of *Shadow of Light*. One of Brandt's best-known images from *A Night in London*, of a couple embracing beneath a sprig of mistletoe, originally appeared with the caption "Top Floor" (the French title given was "Enfin seuls!" or, "Alone at last!"), but for *Shadow of Light*, Brandt cropped out the mistletoe and used the title *Soho Bedroom* to transform this romantic interpretation into an illicit one. One of Brandt's photographs of Pratt, his uncle's parlormaid, first appeared in *Picture Post* in 1939 above the caption "Taking Her Afternoon Off: Every Wednesday Pratt has her 'half day.' She leaves at noon and makes straight

for London, whence she visits friends at Putney. She does a little shopping, sees a film, and is back again by 10.30." In *Shadow of Light*, the title of the same photograph is given as "Putney landlady." Rather than attempt to resolve these bits of contradictory information, the checklist in this book presents more than one title when applicable.

32 It was John Szarkowski who, in 1969, first drew a comparison between the nudes of Weston and Brandt. It seems likely that this may have inspired Brandt to mention Weston, along with Man Ray, as one of the leaders of the "poetic school."

33 Some examples include: "Hampstead under Snow" (February 1946), "Thomas Hardy's Wessex" (May 1946), "English Composers of Our Time" (September 1946), "The Beauty and Sadness of Connemara" (March 1947), "Over the Sea to Skye" (November 1947), "The Poet's Crib" (March 1948), and "Six Artists" (June 1948).

34 For example, "Fashion-On-Sea" (July 24, 1948) predated Brandt's outdoor nudes by several years, and the cinematic lighting in "New Jerseys Are Made of Jersey" (December 31, 1949) mirrored very closely the settings of his nude photographs of that era.

35 The most comprehensive listing of Brandt's pictures that appeared in *Harper's Bazaar* (both advertising and editorial work) is Appendix D of Ian Jeffrey, ed., *Bill Brandt: Photographs 1928–1983* (London: Thames and Hudson, in association with Barbican Art Gallery, 1993), 187–9.

V.

When compared with the flurry of published work in the 1930s and 1940s, the 1950s was a quiet decade, but one during which Brandt's greatest artistic achievement—his nudes—was percolating. Conflicts with the publisher led to Tom Hopkinson's departure from *Lilliput* and *Picture Post* in 1950, and without his advocacy Brandt's contributions to both publications dwindled. His final pictures in *Lilliput* appeared in 1950 and his last work for *Picture Post* in 1951. As was Brandt's experience in the 1930s, the lack of regular assignments proved to be beneficial for the development of his art. He succeeded in recontextualizing the landscapes he had made for these magazines into *Literary Britain*, which was published by Cassell and Company in July 1951. This luxuriously produced volume also featured new pictures, reproduced full-page, across from biographical notes on or excerpts by British writers, from Chaucer to George Bernard Shaw (facing).[36] The sequence was dictated by the alphabetical ordering of the writers' surnames, and Brandt's photographs were deliberately timeless, as befitted their association with literature frequently written in previous centuries. Brandt pursued the landscapes that would appear in *Literary Britain* throughout most of 1950, but after the book's publication, he largely disappeared from the public eye, other than the occasional portrait that would appear in *Harper's Bazaar*. The landscapes and portraits made manifest Brandt's connection with England in new ways, but by this point the association of the photographer with his adopted country was as strong in the eyes of his publishers as it was for Brandt himself.

Brandt's extended investigation of the female nude remains his most original, unpredictable, and memorable work. With the publication of *Perspective of Nudes* in 1961, he defied preconceived notions of the genre with his choice of settings (inhospitably barren seashores or prim Victorian interiors that conflated the domestic and the sexual in lieu of sterile, but safe, studios), as well as the extreme exaggeration of his distortions, cropping, and printing styles, rendering what might otherwise have been hopelessly clichéd aspects of the female form unfamiliar and surprising. Man Ray's nudes of the late 1920s and early 1930s set a high standard for the genre in the modern era, although not so much for their setting or cropping as for the way in which they were printed (solarized, tonally reversed, through screens), spawning countless imitations, while Weston's nudes from the same period are exquisitely poised, technically perfect, and intimate in a way that is fundamentally distinct from the anonymity of either Brandt or Man Ray. André Kértész's nude *Distortions*, made in 1933 with a funhouse mirror for the Parisian magazine *Le Sourire*, were also a powerful example for Brandt, if an isolated experiment for Kértész. Contextually and formally, Brandt's nudes are distinct from these precedents, but beyond such differences lies the more elusive question of the sexual character of Brandt's images, and it is here that his unconventionality becomes manifest. For unlike the vast majority of nudes made before or since, Brandt's work hovers between lustful celebration of flesh (pp. 161, 173), delicate formal exploration (pp. 168–69),

psychological study with distinctly Freudian undertones (pp. 146, 160)—and, most commonly, work that does not fit neatly into any of these categories. It is this last characteristic, Brandt's apparent willingness to pursue a body of work for more than fifteen years but to allow its purpose or meaning to remain ambiguous, that accounts for a great deal of the critical fascination with these enigmatic images.[37] As with the political or factual ambiguity of his work from the 1930s, clarifying intent or method simply didn't matter to Brandt: "I let myself be guided by the lens. The camera took the pictures for me; I interfered very little.... It is difficult to explain how I took the last photographs [from the series]. They were perhaps chance pictures; unexpected combinations of shapes and landscapes. I watched them appear on the ground glass and exposed. It was as simple as that."[38] Of course, as with so much of Brandt's life and work (his family history, his pictures from the 1930s, or his relationships with women, for example), it is difficult to believe that it was "as simple as that," but Brandt encouraged this fiction.

Although Brandt published a few nudes in *Lilliput*, it would have been impossible to imagine the potential the subject held for him on the basis of those pictures.[39] Just as the absence of regular assignments in the mid-1930s (albeit unwelcome at the time) allowed him the freedom to pursue the work that would define his achievement in that decade, the intermittent nature of his portrait commissions from *Harper's Bazaar*—and the stability of his relationship with Marjorie—granted him the creative space for this achievement to blossom, even if he

36 Mark Haworth-Booth wrote a very informative afterword to the second edition of *Literary Britain* (London: Victoria and Albert Museum, in association with Hurtwood Press, 1984), n.p.

37 In addition to the considerations of this subject by Ian Jeffrey and David Mellor in their contributions to two of Brandt's major posthumous catalogues, Carol Armstrong's article "The Reflexive and the Possessive View: Thoughts on Kertesz, Brandt, and the Photographic Nude," *Representations* 25 (Winter 1989): 57–70; and Stephen Brooke's "War and the Nude: The Photography of Bill Brandt in the 1940s," *Journal of British Studies* 45, no. 1 (January 2006): 118–38, deserve special mention.

38 Bill Brandt, "Notes on *Perspective of Nudes*," *Camera* (Lucerne, Switzerland) 40, no. 4 (April 1961), reprinted in Nigel Warburton, ed., *Bill Brandt: Selected Texts and Bibliography*, 121–3.

39 Brandt made a small number of nudes in Paris in the early 1930s that strongly suggest Man Ray's influence. It seems likely that the first *Lilliput* nude (published in 1942) was one of those early experimentations.

preferred to say "nothing happened during those years." Brandt was soliciting feedback (and suggestions for a publisher) from Edward Steichen as early as 1955,[40] but the nudes from the late 1950s, particularly those made on the beaches of East Sussex and Baie des Anges, seem indispensible to the series.

The publication of *Perspective of Nudes*, and a concurrent exhibition of a selection at MoMA, marked the culmination of more than a decade of work, distilled into just ninety plates, and it also marked the beginning of an escalation of attention that would continue until Brandt's death in 1983 and, arguably, more so even after.[41] Five years after *Perspective of Nudes* appeared, Brandt published his first full retrospective publication, *Shadow of Light*, with an introduction by the esteemed literary critic Cyril Connolly.[42] In 1969, John Szarkowski, Director of MoMA's Department of Photography, organized a retrospective that would come to define the reception of Brandt's work, not so much for his selection (which was similar to *Shadow of Light*), but for its embrace of the scale and contrast that Brandt preferred at that time.[43] The Arts Council of Great Britain circulated the MoMA exhibition throughout the United Kingdom from 1970 through 1971, and Brandt intensified the hyper-pitched tone and exaggerated grain of those prints in the ones he would make for Marlborough Gallery in the mid-1970s, as well as for the second edition of *Shadow of Light*, which was published in 1977. Yet despite the retrospective books and the exhibitions with tours of nearly unprecedented length (at MoMA, only Steichen's legendary *The Family of Man* from 1955 compares), Brandt

Plate 54 from *Literary Britain*, 1951

40 As Brandt wrote to Steichen: "I hate to bother you as I know you are terribly busy, but I should so much like to know what you think of my nudes…. I value your opinion very much and long to hear what you really think of them. I also feel that your views might influence a publisher; [publishers are] so conventional that they are frightened of anything which is not fashionable…." Bill Brandt to Edward Steichen, May 2, 1955, Department of Photography correspondence files, The Museum of Modern Art, New York.

41 Steichen exhibited forty-two prints from *Perspective of Nudes* in fall 1961 as part of the fifth installment of the *Diogenes with a Camera* exhibition series. The show also included work by Lucien Clergue and Yasuhiro Ishimoto.

42 Brandt and Connolly first met in 1942 when Connolly published four of Brandt's pictures in *Horizon* magazine.

43 There was no catalogue, but Szarkowski's text for the fall 1969 edition of the Museum's member newsletter was reprinted in the first issue of *Album* magazine in February 1970.

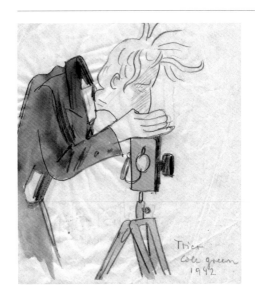

seems not to have gone on to become as renowned as many of his modernist peers, his contributions distilled to a handful of iconic images. Part of this is, no doubt, attributable to the seemingly disparate nature of Brandt's production, but another cause may be found in the extreme transformation of Brandt's printing practice, which has muddled the appreciation of his art.

VI.

That Brandt's techniques and printing style changed radically throughout his career is clear in any survey of his work, but this alone does not suffice to explain how those changes may have compromised his contemporary reputation, for in part it is Brandt's willingness to experiment—with both subject and process—that is a key aspect of his success as an artist. Nonetheless, his brooding, atmospheric prints from the 1930s have little in common with his high-contrast nudes from the 1950s, which increases the challenge of understanding his oeuvre. As John Szarkowski observed in his introductory wall text to the 1969 exhibition at MoMA, "Brandt's approach to the craft of photography has been consistently and casually defiant. It is conceivable that Brandt simply never learned the conventional standards of photographic quality. More probably, he has sensed that a consistently brilliant technique too often assumes for itself in time the status of a creative virtue."[44]

Brandt's measured attitude toward taking pictures ("I think twice before I shoot and very often do not shoot at all …") was undoubtedly reinforced by his choice of camera, a square-format Rolleiflex that he used for the great majority of his pictures.[45] With larger negatives and fewer exposures per roll than a handheld 35mm camera, this format encouraged a more deliberate approach to picture making, as the caricature of Brandt by Walter Trier suggests, which put him at odds with his peers who sought to capture newsworthy images of unfolding events on the fly (left).[46] As evidenced by the plates in this book, the resulting prints rarely share the same proportions as their matrices: the 6-by-6-cm (about 2¼-inch-square) negatives provided Brandt with the flexibility to make a crisp 8-by-10-inch print using less than half of a given negative. He would also flip the negative in his enlarger, making prints that could be oriented one way or another depending on their context. And on occasion, he would do both.[47] In the late 1940s, as Brandt was just embarking on his study of the female form, he bought a secondhand Kodak fixed-focus, wide-angle view camera, which he used to make many interior nudes and with which, as is often noted, the extreme depth of field and unusual camera angles recall the cinematography of Orson Wells. In the mid-1950s he purchased a Hasselblad Supreme Wide Angle, which he used for both portraits and nudes.

If Brandt was somewhat conservative in his adoption of new cameras during his career, in his printing he was far more adventurous. His first published comment on his printing methods, and the first technical notes on his work, appeared in 1948, in his first postwar book, *Camera in London*, which gathered fifty-nine of his

Walter Trier. Caricature of Bill Brandt photographing, 1942. Pencil and ink. Bill Brandt Archive. "Cole Green" refers to the village just north of London where Trier lived.

44 Ibid.

45 See Brandt's "Technical Data" in *Camera in London* for more detailed information regarding his work up to about 1948.

46 Trier illustrated every *Lilliput* cover from its founding in 1937 through 1949.

47 Plate 14 from *The English at Home* is reproduced as a horizontal image with the title *November in the Suburb* (1933; p. 39). Plate 63 from *A Night in London* is made from the same negative, printed in reverse and significantly cropped, with the line of laundry blacked out and under the title *Sky Lightens over the Suburbs*. The title *Rainswept Roofs* comes from its publication in *Shadow of Light*, which approximates the cropping and shares the orientation of *A Night in London* (although the laundry appears as it had in *The English at Home*).

best pictures from the 1930s and 1940s: "I consider it essential that the photographer should do his own printing and enlarging. The final effect of the finished print depends so much on these operations. And only the photographer himself knows the effect he wants. He should know by instinct, grounded in experience, what subjects are enhanced by hard or soft, light or dark treatment."[48] To a degree unmatched by his peers, Brandt experimented with tone and contrast, and he identified his inclination to do this quite early in his career.

And yet for Brandt, the alchemy afforded by the darkroom was rarely sufficient to achieve his vision for a given print. A hallmark of many of Brandt's best prints is an extensive array of interventions, which Lee Ann Daffner characterizes in this volume in her illustrated glossary on Brandt's retouching practices. It was not uncommon for a magazine or newspaper to emphasize (or de-emphasize) certain areas of an image to improve its legibility in reproduction. What appears to be unique to Brandt is the variety of his mark-making techniques and their pervasiveness: he would meticulously accentuate features on the 8-by-10-inch prints that he would typically provide to the magazines, but he would do the same on larger, mounted prints that were clearly intended for exhibition.[49]

Brandt was not a conformist, either in his life or his art. As he explained, "Personally, I am not interested in rules and conventions. Photography is not a sport…. A photographer can even become a prisoner of his own rules. Unless he invents new ones, he will soon copy himself, and his work will become sterile

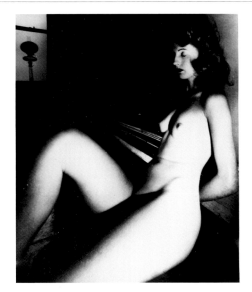

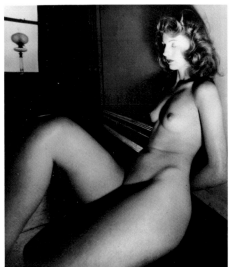

and repetitive. Sometimes the rules are sheer nonsense…. There are certainly no rules governing how a picture should be printed. Some should be dark and muddy, some very white and underprinted."[50] If there were to be no rules as to how pictures should be printed in general, for Brandt this even applied to individual images themselves: as two variant prints of a 1949 nude illustrate, Brandt was able to draw a range of distinct effects from a single negative (left).

Given Brandt's disdain for a rigid approach to printing, one might have anticipated the dramatic transformation that occurred in his printing style. In many ways World War II transformed not only Brandt's subjects but his sensibility: not only was his new work registering more graphic tendencies but even his revisiting of his early work, which he had initially printed with delicate, brooding tones, appeared with the exaggerated contrast and pronounced grain that result from multiple generations of prints. Brandt is not the only photographer whose printing style changed over the course of a career—Ansel Adams considered his negatives akin to a musical score, likening his prints to performances that could and should change over time. But Brandt's evolution was extraordinary. Years before the hyped-up sensibility of the "Swinging Sixties" became commonplace—manifesting itself in the exaggerated grain of Michelangelo Antonioni's *Blow Up* (1966) or the enlarged halftone screens of Roy Lichtenstein's paintings—Brandt was experimenting with contrast and grain. This tendency was amplified as the years progressed, as illustrated by a comparison of a print from 1937 (*East Durham Coal-*

48 Brandt, *Camera in London*, 14.

49 Even more surprising is the frequency with which Brandt's marks appear on second-generation prints beginning in the early 1960s, given that his internegatives were made from prints he had already retouched.

Bill Brandt. *Campden Hill, London*, c. 1949. Gelatin silver prints, each approximately 9 x 7" (22.9 x 17.8 cm). Courtesy Edwynn Houk Gallery, New York.

50 Bill Brandt, "Bill Brandt Today… and Yesterday," *Photography* 14, no. 6 (June 1959): 21–22. This article also featured brief tributes to Brandt, described as "appreciations by his friends," written by Ansel Adams, Henri Cartier-Bresson, Beaumont Newhall, Albert Renger-Patzsch, and others. Many of Brandt's observations were expanded upon in his statement published in *Album* no. 2 (March 1970): 46–47.

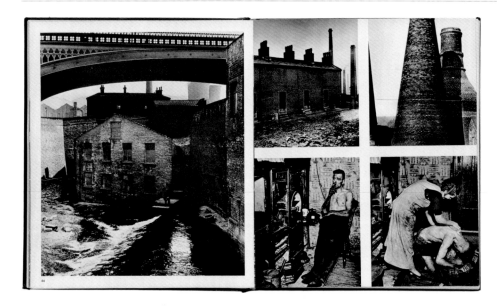

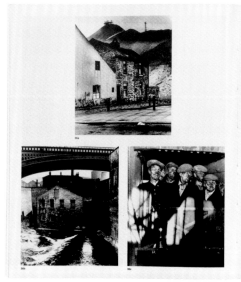

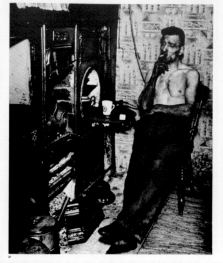

Miner Just Home from the Pit, p. 78) with its reproduction in the two editions of *Shadow of Light* (left). The differing appearances of these two editions can be explained in part by the evolution of printing technologies: by 1977 the photogravure process (by which each of Brandt's previous books had been printed) had been replaced by offset lithography as the dominant method of photo-mechanical reproduction, and Brandt's prints of the 1970s mimicked the higher contrast and more abrupt tonal transitions that characterized this new technology, but he had embraced the offset "look" more than a decade earlier.

Some have argued that Brandt's failing vision was a contributing factor to the radical transformation of his printing style; it may have been, yet Brandt clearly articulated it as an aesthetic decision. Edward Steichen, Director of MoMA's Department of Photography, wrote in early 1959 on the subject of acquiring Brandt's prints for the Museum's collection:

Dear Bill Brandt:

This is a very difficult letter to write to you.

I am sure I do not have to repeat to you how highly I esteem your work as a photographer, and the important place you have in the history of photography.... I have yet to see a picture of yours that does not intrinsically have the Bill Brandt standard. But I am upset about the quality of the prints. These are not in any way up to the standard of the prints you sent us for your one-man show here. They were all prints with carefully balanced photographic quality, whereas the new prints fit more in to the character of black and white effects for newsprint reproduction.[51]

(top) Pages 44–45 from *Shadow of Light*, first edition, 1966

(bottom) Pages 36–37 from *Shadow of Light*, second edition, 1977

51 Edward Steichen to Bill Brandt, January 7, 1959, Department of Photography correspondence files, The Museum of Modern Art, New York. The show to which Steichen refers was *Four Photographers: Lisette Model, Bill Brandt, Ted Croner, Harry Callahan* (1948), which although technically a group exhibition, Steichen conceived of and organized as four concurrent solo shows.

To this letter, Brandt replied:

Dear Edward Steichen,

Thank you very much for your letter. I don't know whether you quite realise what it means to a photographer to be praised by you, so I was terribly disappointed by your criticism of the quality of the prints.

It is true that ten years ago I printed differently. But just as my way of taking pictures has changed, so has my printing also. And when, today, I am asked to produce prints of old pictures I just cannot bear printing them in soft muddy greys any more.

I think the hard black and white effect suits my pictures better. The prints are perhaps less atmospheric but crisper and more different from colour pictures, and I don't mind the superficial resemblance to newsprint reproduction. This may be one of my passing fads, but I don't think so. I feel very strongly about it.[52]

Brandt's response suggests that the emergence of color photography as a viable artistic option was a factor, but this was not really the case for some time. More likely is that in Brandt's experimentation with the female nude he found a subject that he felt was ripe for radically different printing methods, and that his satisfaction with these results led him to want to see his earlier pictures subject to the same trans-formation. Just because they had originally appeared one way would have mattered little to Brandt, who was dispositionally inclined to embrace the new. It was not until 1969, on the occasion of the retrospective exhibition organized by John Szarkowski, who had succeeded Steichen at MoMA, that any additional prints by Bill Brandt were added to the Museum Collection. Perhaps Szarkowski had more time to make peace with Brandt's new style of printing or, perhaps, the world had changed and photography along with it.[53]

These 1969 prints are not without merit and are particularly effective with Brandt's later negatives, but they are gross distortions of his original intent. Notably, towards the end of his life, Brandt's attitude towards his early printing style softened. He donated a set of eight vintage landscapes to the Victoria and Albert Museum in 1980, in preparation for a second edition of *Literary Britain*, and the following year he allowed the National Portrait Gallery to include a section dedicated to his vintage work. In response to this, the art critic for *The Sunday Times* in London wrote, "The vintage prints of the 1940s are much smaller, exquisitely sharply detailed, toned in silvery, iridescent muted brown. It's heresy to say so, but [they] are much more aesthetically satisfying."[54]

Before long, it was not "heresy" to admire Brandt's work in its original form, although even the most valuable, serious considerations of Brandt's artistic legacy have included great numbers of reproductions made from the photographer's later prints. This, in combination with a disregard for inconvenient chronological facts, has compromised an understanding of his art. The plates in this book present a coherent development of Brandt's career, represented by the finest known vintage prints. On occasion, it was necessary to include a later print, but only if it captured the scale and spirit of an early one. In this context it seemed preferable to omit a particular image rather than represent it by a print that did not adequately reflect Brandt's printing method of the time.

There are also three groups of works whose absence from this selection deserves comment, examples of experimentation that were, on the whole, less successful. First, Brandt's color landscapes, eight of which he made between 1963 and 1965 that were included in the first edition of *Shadow of Light* but not the second. Shot on the beaches of Normandy and East Sussex, these are loosely related to Brandt's black-and-white nudes, but with a cool, sterile beauty. Brandt's own willingness to excise these from his oeuvre from one edition of his retrospective book to the next suggests he recognized they were more a novelty than integral to his artistic accomplishment. Also omitted here are the three-dimensional assemblages that Brandt began making in the late 1960s of Victorian trinkets combined with natural and man-made detritus he found washed up on the beach. These were first exhibited in London in 1974, and he continued to construct them in his remaining years. Their appeal as compilations of objects that Brandt fancied is enhanced by the delicacy of their composition, but they represent a private curiosity, quite apart from his work as a photographer. The third group absent from this project is Brandt's late nudes, which delight those seeking insight into Brandt's psychology but have inspired little critical favor.[55] Made between 1977 and 1980, they are often disturbing images of a female form subjected to violent inter-ventions on the print and in the image.[56] Whether these are expressions of Brandt's innermost fears or desires, like most great artists, Brandt, on occasion, needed an editor.

52 Bill Brandt to Edward Steichen, January 17, 1959, Department of Photography correspondence files, The Museum of Modern Art, New York.

53 It was common practice at the time to make new, often dramatically enlarged prints for exhibition, and for the Museum to acquire a selection of these (Dorothea Lange's 1966 retrospective and an exhibition of Henri Cartier-Bresson's postwar work in 1968 being two notable examples). Brandt's 1969 prints were thus part of a larger trend, albeit the most extreme in their use of contrast and grain, which was consonant with Brandt's postwar work.

54 Marina Vaizey, quoted in Roy Strong's foreword to the second edition of *Literary Britain* (1984), n.p. Vaizey's perspective is reiterated, albeit in more moderate tones, in her review of the 1982 book and exhibition of Brandt's portraits, in which she calls the vintage prints "exceptionally instructive" with "an all over sharpness of focus, and a delicacy of hue and tone." She went on, "Things are now much more rough hewn. Black and white are used strikingly." Vaizey, "The Power of Seeing," in *Art Book Review* I, no. I (1982), 70.

55 Paul Delaney describes these nudes and his understanding of their significance in *Bill Brandt: A Life*, 271–6.

56 Brandt's second wife, Marjorie, died in 1971, and Brandt's frail health required that he have a full-time caregiver. When Noya Kernot entered Brandt's life in summer 1972, she assumed this role and became the object of Brandt's affection. They were married the following December. Whether or not one assumes these late nudes reflect aspects of their relationship, Noya cared for Brandt until his death in December 1983.

VII.

Thus it was I found atmosphere to be the spell that charged the commonplace with beauty. And still I am not sure what atmosphere is. I should be hard put to define it. I only know it is a combination of elements, perhaps most simply and yet most inadequately described in technical terms of lighting and viewpoint, which reveals the subject as familiar and yet strange.[57]

This is Bill Brandt, describing his approach to photography in his first and most comprehensive statement on the subject in 1948, in his introduction to *Camera in London*. It was the nebulous realm of "atmosphere" that Brandt placed at the center of his art, and while he undoubtedly appreciated the literal connection this word afforded him to the storied London fog, he was more interested in its metaphoric connotations, as is evident in the words and phrases he sprinkles throughout the text: "magic," "fantasy," "indefinable," "unfamiliar," "unknown," "unearthly," "bewilderment," "familiar and yet strange," "imagined or dreamed of," "dream-like atmosphere" (twice), "weird beauty," "sense of wonder" (twice), and "vague." To underscore the ambiguity he cherished, Brandt concluded, "Yet when all is said and done, I do not really know how I take my pictures."[58] Hopkinson, too, had noted these characteristics, in the profile he wrote of Brandt in 1942: "It was under these Paris influences, perhaps, that Brandt developed what is, for me, the outstanding quality of his work—its sense of mystery."[59] And as a new generation of photographers emerged, they would remark upon it as well. When he saw Brandt's 1969 show at MoMA, Robert Frank wrote that the images "went right through my eyes into my heart and to my stomach. I heard a sound, and a feeling inside me woke up. Reality became a mystery."[60]

Again and again, in every important posthumous consideration of Brandt, we find these sentiments echoed. In 1985: "The strange and the uncanny are key operational devices in Brandt's projection and construction of Britain," and, "We should recognize in Brandt's aesthetic a certain principle: a privileging … of an object, a phantasm … an estranged object that is accorded magical or spellbinding powers."[61] In 1993: "Brandt's career, from beginning to end, was the most elaborate and mysterious in the whole history of twentieth-century photography … he preferred non-disclosure and mystery as a matter of policy."[62] Six years later we hear these same notes sounded again: "The most important aspect of Brandt's work [is] its ineffable mystery."[63] Even his biography opens with the sentence: "Bill Brandt was a man who loved secrets, and needed them."[64]

To be sure, there are many secrets inherent to Brandt's photographs. One cannot know the thoughts of the parlormaids waiting to serve dinner (p. 47), the nature of a nocturnal exchange on the streets of London (p. 56), or even why we accept that photographs of ears, fingers, and feet should be considered nudes, but it is this mystery of Brandt's pictures that is responsible for so much of the enduring fascination with them. Brandt settled on the word *atmosphere* as a means of describing his attempts to render the world before his camera lens as simultaneously familiar and strange, knowing that his pictures captured this better than his words ever could. One can describe an extinguished lamppost during the Blackout on the streets of London, or Stonehenge on a moonlit, snowy night, but it is far more difficult to convey the effect of Brandt's pictures in words.

And yet, there is a difference between appreciating the mystery of Brandt's images and extending that sense of mystery to the photographer himself—a conflation, it must be admitted, for which Brandt himself was primarily responsible. He was loath to reveal biographical details or to consider his career according to the kind of strict chronology that otherwise might reveal important developments in an artist's career. In 1963 he wrote, "May I mention just one point about which I feel very strongly? … Portraits, I like to hang next to portraits, nudes next to nudes, and landscapes next to landscapes, and even here, pictures of similar atmosphere next to each other."[65] Quite rightly, this preference has been respected in every subsequent consideration of Brandt's work (including this one), but it has often led to some awkward compromises, changing titles so that a picture fits within a given category, or ignoring chronological gaps.[66] The reasons for doing this are not mysterious, but they make it more difficult to grasp the trajectory of Brandt's career.

Knowing Brandt, however, does not detract from the strange power of his work, but in fact, it can help us appreciate its mystery, its sense of atmosphere, more fully, both through an appreciation of its singularity and of Brandt's ability to bring his unique vision to bear on a remarkable variety of subjects. When Brandt first settled in London, the photographic

57 Bill Brandt, *Camera in London*, 11.

58 Ibid., 16. Individual words and phrases referenced in this paragraph are drawn from the same essay.

59 Tom Hopkinson, "Bill Brandt—Photographer," 141.

60 Robert Frank, "Robert Frank: Letter from New York," *Creative Camera*, no. 66 (December 1969): 414; quoted in Sarah Greenough, *Looking In: Robert Frank's The Americans* (Washington, D.C.: National Gallery of Art, Washington, in association with Steidl, 2009), 24.

61 David Mellor, "Brandt's Phantasms," in *Bill Brandt: Behind the Camera, Photographs 1928–1983*, 80, 96.

62 Ian Jeffrey, introduction to *Bill Brandt: Photographs 1928–1983*, 12.

63 Bill Jay, "A Cabinet of Wonders," in *Brandt: The Photography of Bill Brandt* (New York: Harry N. Abrams, Inc., 1999), 10.

64 Paul Delaney, *Bill Brandt: A Life*, 7.

65 Bill Brandt to Robert Doty, curator of the 1963 Brandt exhibition at George Eastman House, March 23, 1963, from a copy in the Bill Brandt artist file at The Museum of Modern Art, New York.

66 In the first edition of *Shadow of Light* (1966), the fifth and final section, "Landscapes and Nudes," includes only outdoor nudes or those with landscape-like forms; the other four nudes reproduced appear in the "Portraits" section, which was justified by including only nudes with visible faces. Brandt addressed this circumstance by adding a separate "Nudes" section to the second edition of *Shadow of Light* (1977). In that edition he also added an "Interlude," which included Surrealist-inflected work made between 1930 and 1963. Subsequent publications have either added a section for Brandt's early work (with chapters such as "European Background," "Travels in Europe," or "A European Apprentice") or included a more nebulous chapter, akin to Brandt's "Interlude" ("Shadowlands" or "A Return to Poetry").

tradition there had been all but abandoned, and he took advantage of this vacuum to establish himself as a distinctly British photographer. His only contemporary who could make a comparable claim was Cecil Beaton, who nourished his photographic talents within a tightly defined range of fashion and celebrity portraiture. The range of Brandt's work was sufficiently broad that from it new generations of British photographers could draw their own lessons and find varied paths forward. Roger Mayne's pictures on the streets of West London in the late 1950s connect most directly with Brandt's prewar pictures of the urban working class, but it was not until the late 1970s when there emerged a group of photographers of extraordinary talent, including Paul Graham, Chris Killip, and Martin Parr, whose work was as independent in spirit as Brandt's own.

Beginning with Raymond Mortimer's introduction to *The English at Home*, distinguished figures from the world of British letters, from John Hayward to Lawrence Durrell to Cyril Connolly, felt compelled to comment on Brandt's work. Their introductions, as much as Brandt's portraits of their peers and his photographs of the landscapes that had been significant to their antecedents, confirmed Brandt's place in the broader British artistic tradition, which Brandt had first established through his work of the 1930s. In the end, though, Brandt's legacy is not defined by his national identity, chosen or actual, but instead by his unique contributions to the history of photographic modernism—his ability to present the world around him as "familiar and yet strange" through his camera's lens.

188

THE ENCHANTED THIRD EYE

OF PHOTOGRAPHER BILL BRANDT

Every artist sees with unique insight, and a great photographer uses a third eye—his camera lens—to transform the ordinary into the extraordinary, the drab into the poetic; or conversely to intensify the essence of reality. This four-page portfolio is the work of England's Bill Brandt—many of whose photographs, including the haunting self-portrait above, were taken expressly for HARPER'S BAZAAR.

Harper's Bazaar, November 1966, page 188. Brandt's self-portrait appears on the first page of "The Enchanted Third Eye of Photographer Bill Brandt," followed by full-page reproductions of *Edith and Osbert Sitwell, Portrait of a Young Girl, Eaton Place*, and *East Sussex Coast* (see pp. 103, 117, and 173, respectively, in this volume)

Plates

After spending much of his twenties in Vienna and Paris, Bill Brandt finally settled in London in April 1934, on the eve of his thirtieth birthday. During previous visits, he had begun his photographic pursuit of British culture, but it was only once he was living there that the city became the centerpiece of his creative endeavors.

Brandt's first book, *The English at Home*, was published by B. T. Batsford in February 1936 with an introduction by Raymond Mortimer, the literary editor for the left-leaning British political and cultural magazine *New Statesman*. The book is the size of a standard novel, only seventy-two pages long, with sixty-three full-page illustrations and captions in both English and French. Brandt succeeded in cementing his identity as a photographer of the British but not yet as a British photographer. In his introduction, Mortimer refers to Brandt's "foreign eyes," noting that Brandt "seems to have wandered about England with the detached curiosity of a man investigating the customs of some remote and unfamiliar tribe. And his illustrated report brings home very amusingly the variety and importance in England of clothes."[1] As the title suggests, the photographs represent a sweep of British life, not exhaustive but nonetheless broad enough to convey an understanding of that society before the war.

This book became Brandt's calling card, and although it was far from a commercial success, it was instrumental in securing the opportunity to make his next book of photographs. *A Night in London* appeared in June 1938, published by Country Life in London and Charles Scribner's in New York, with an introduction by James Bone, and it was virtually identical in format to *The English at Home*. Arts et Métiers Graphiques published the book simultaneously in Paris as *Londres de Nuit* with an introduction by André Lejard, editor of *Arts et Métiers*, the luxurious magazine that had recently started publishing books. The house had also published Brassaï's *Paris de Nuit* in 1933, so the theme was tried and true, but to promote Brandt's English version the publisher arranged an exhibition of his photographs (Brandt's first) in Paris to coincide with the book's publication.

A decade later, supplemented by his wartime work, Brandt's name was synonymous with his distinctively personal vision of London, and Focal Press distilled this accomplishment into fifty-nine plates in *Camera in London*. Brandt's introduction begins with a question: "I wonder if anyone could ever succeed in photographing London?,"[2] and the plates are arranged to illustrate his answer to that question, with chapters titled "The River," "The Homes," "The People," "The Kids," "The Air," "The Lights," and "The War." Towards the end of his essay Brandt concludes: "I am a photographer of London."[3]

1 Raymond Mortimer, introduction to *The English at Home* by Bill Brandt (London: B. T. Batsford, 1936), 4.

2 Bill Brandt, "A Photographer's London," introduction to *Camera in London* (London: The Focal Press, 1948), 9.

3 Ibid., 18.

1

London in the Thirties

Tic-Tac Men at Ascot Races. 1935

Losing at the Horse Races, Auteuil, Paris. c. 1932

Park Lane. 1932

Coach Party, Royal Hunt Cup Day, Ascot. 1933

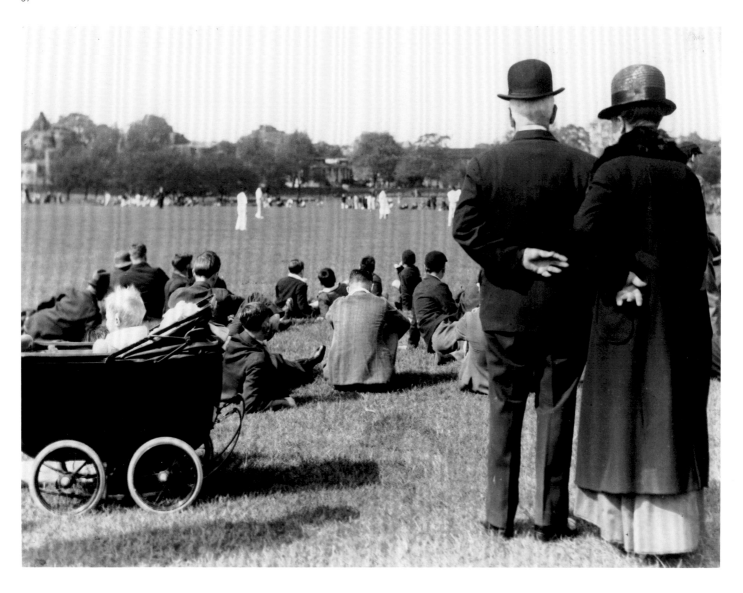

Cricket in the Park. c. 1934

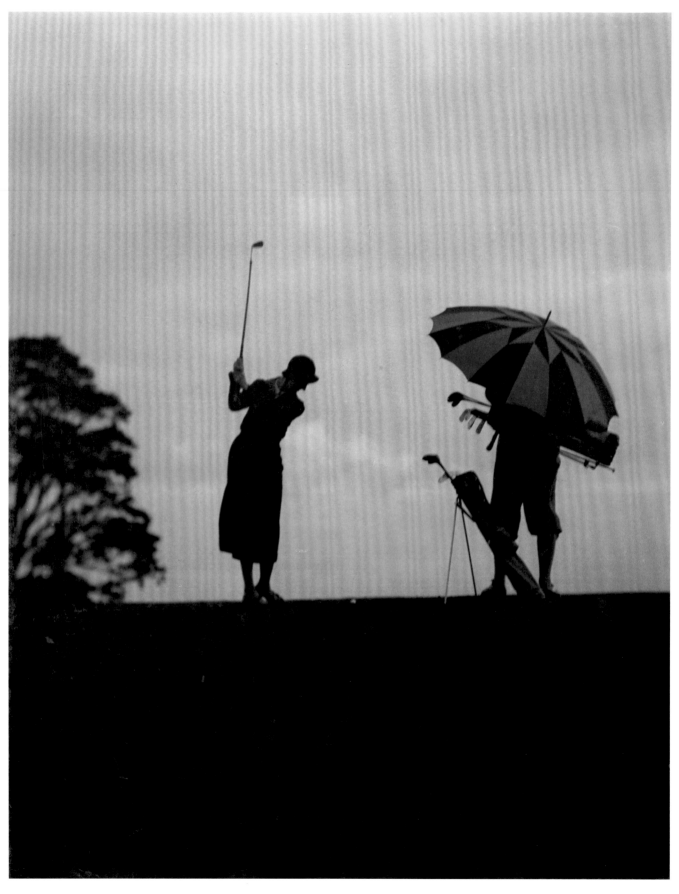

Golf in the Rain. c. 1934

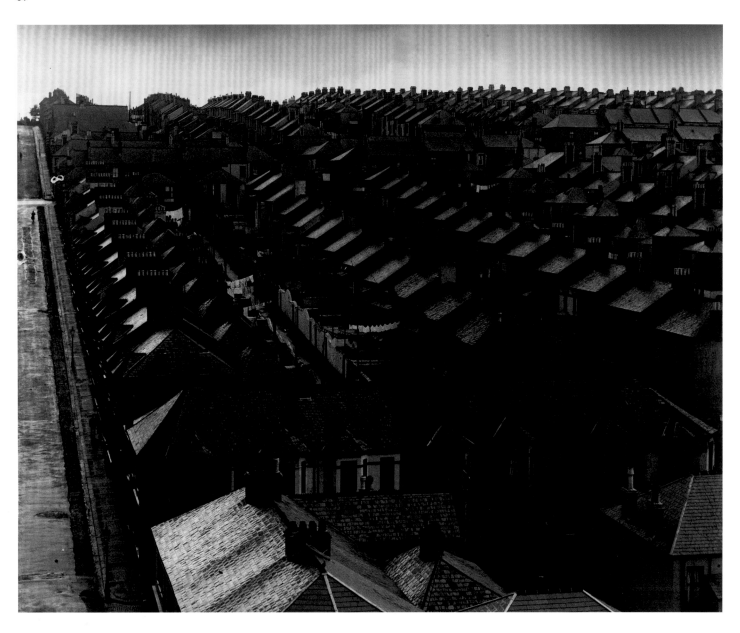

Rainswept Roofs. 1933

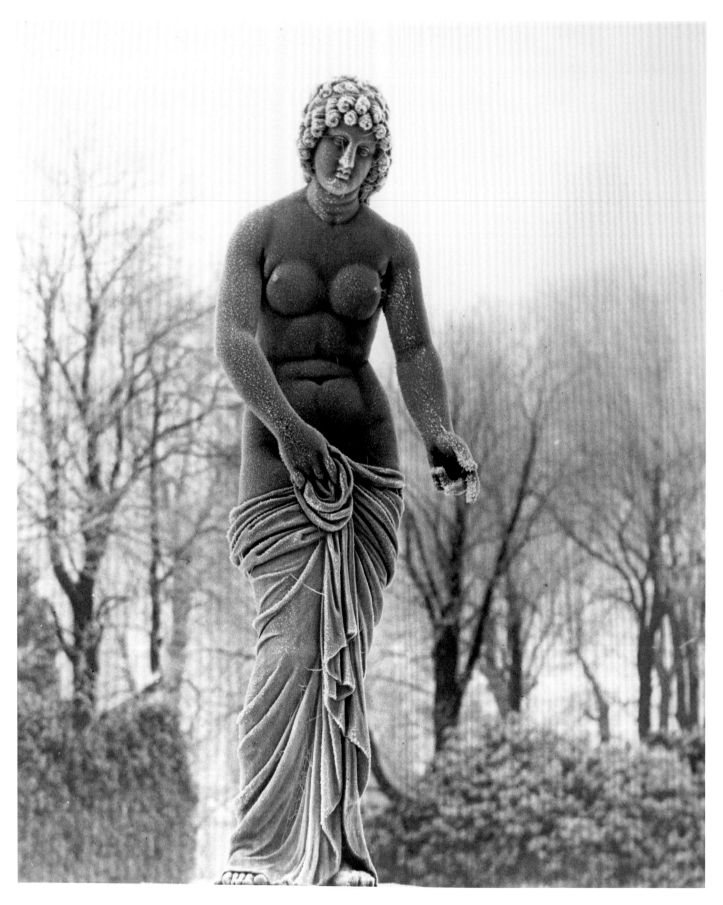

Crystal Palace. 1938

Evening in Kew Gardens. c. 1935

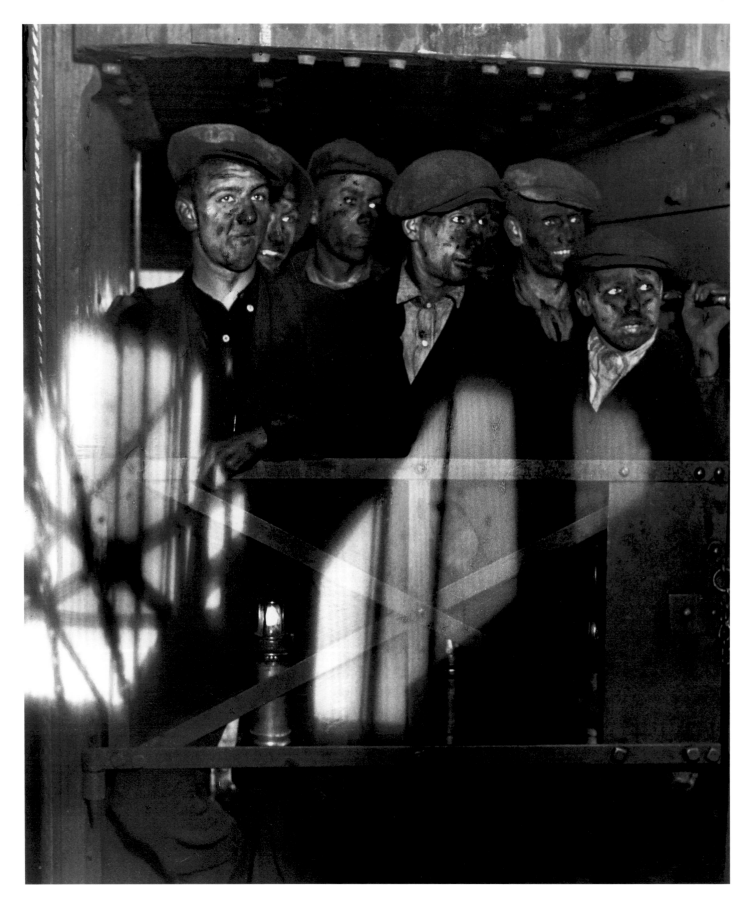

Miners Returning to Daylight. c. 1934

Battersea Bridge. 1939

Bond Street Hatter's Show-Case. c. 1934

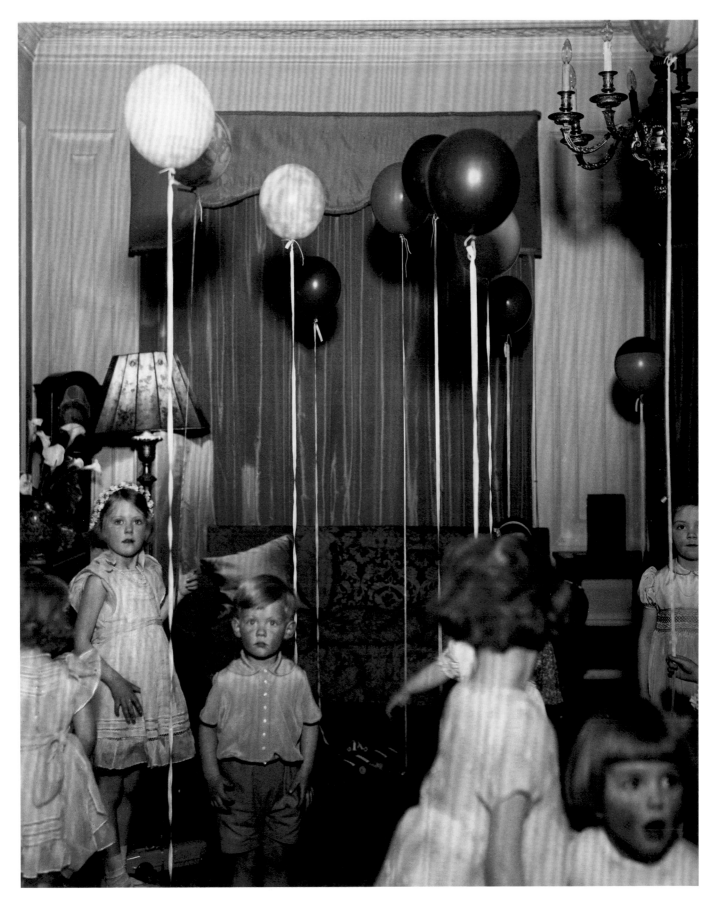

Kensington Children's Party. c. 1934

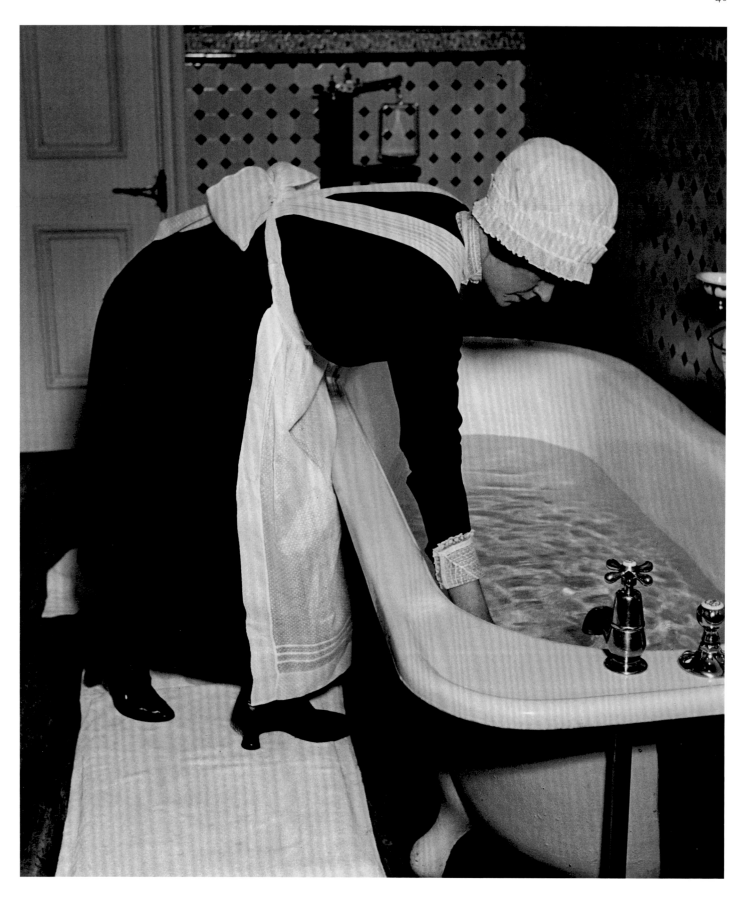

Parlourmaid Preparing a Bath before Dinner. c. 1937

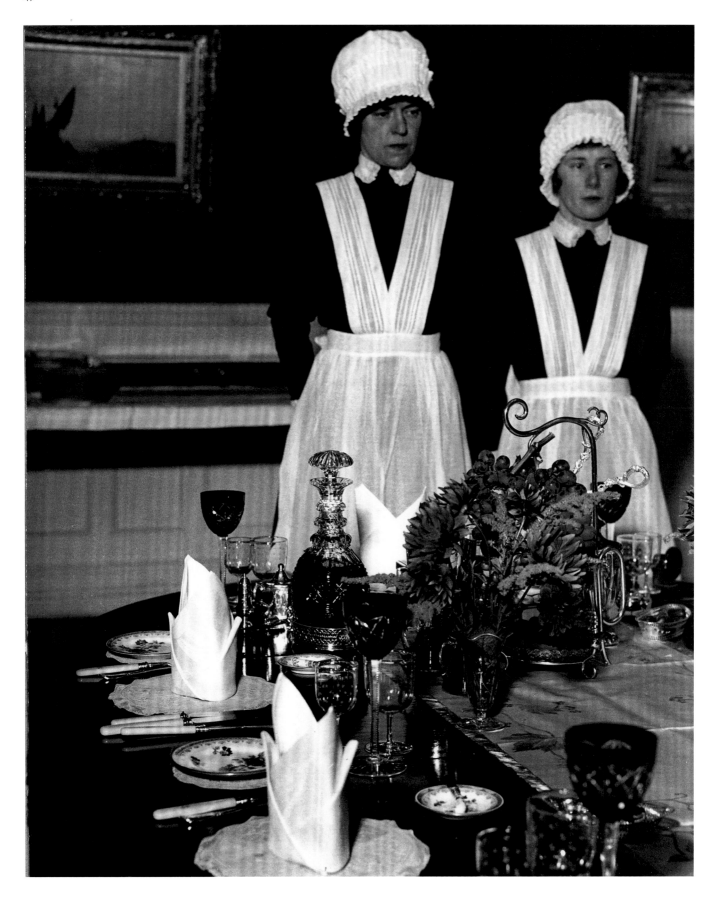

Parlourmaid and Under-Parlourmaid Ready to Serve Dinner. c. 1934

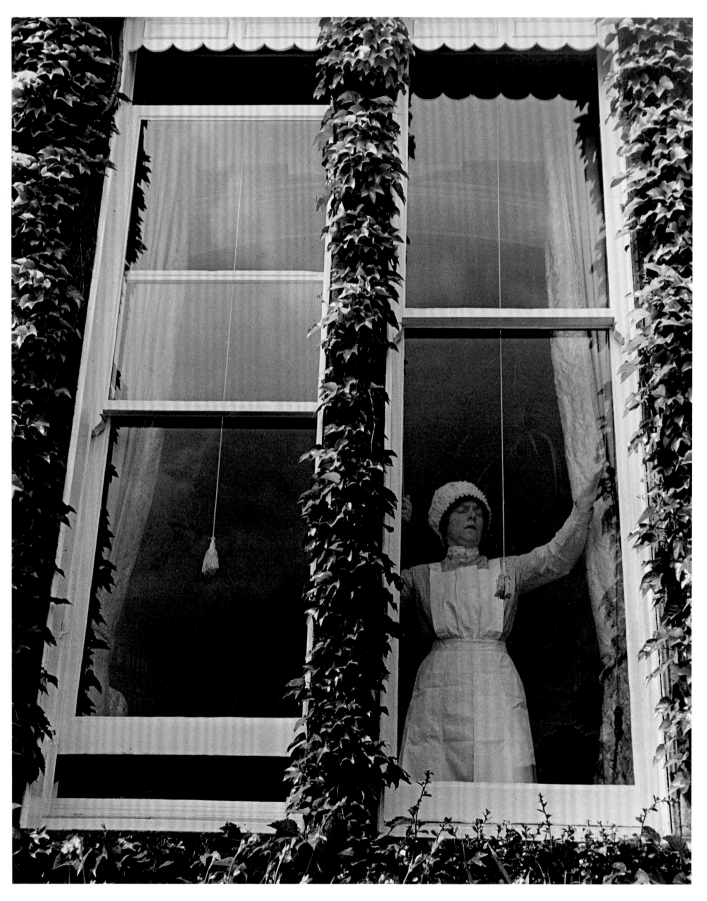

Parlourmaid at a Window in Kensington. c. 1939

Late Evening in the Kitchen. c. 1937

Audience at His Majesty's Theatre. c. 1937 At Blackfriars Ring. c. 1937

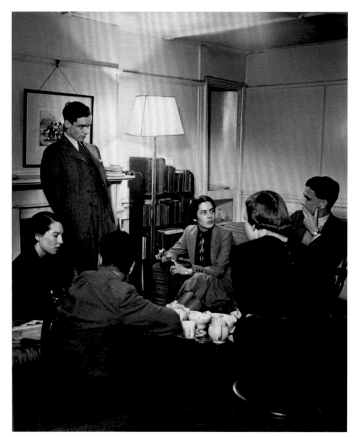

Backgammon, Mayfair. c. 1937 Bloomsbury Party. c. 1937

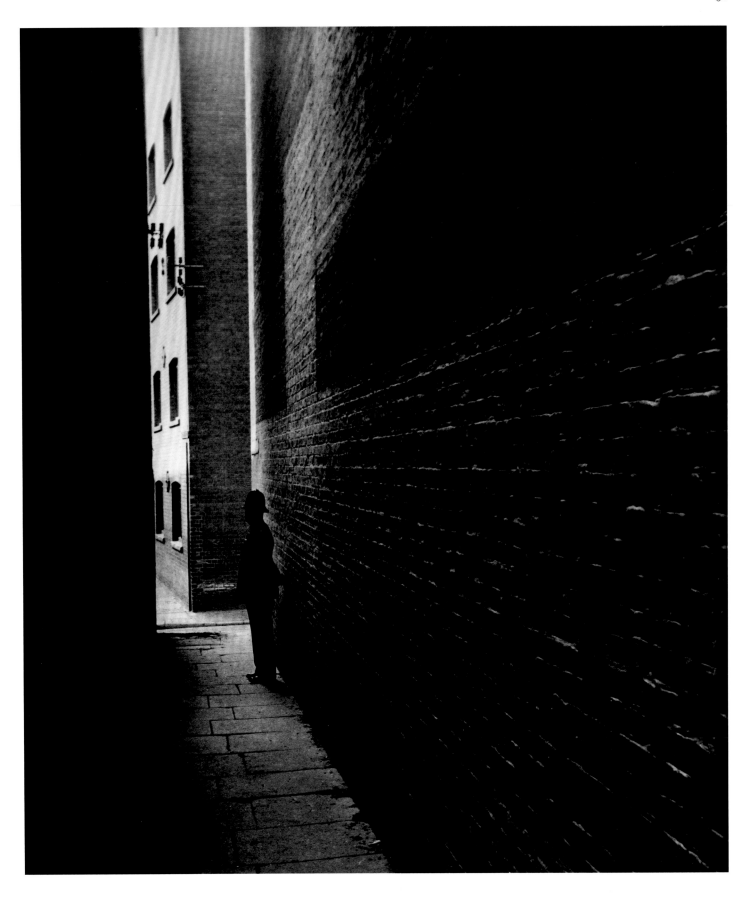

Policeman in Bermondsey. 1938

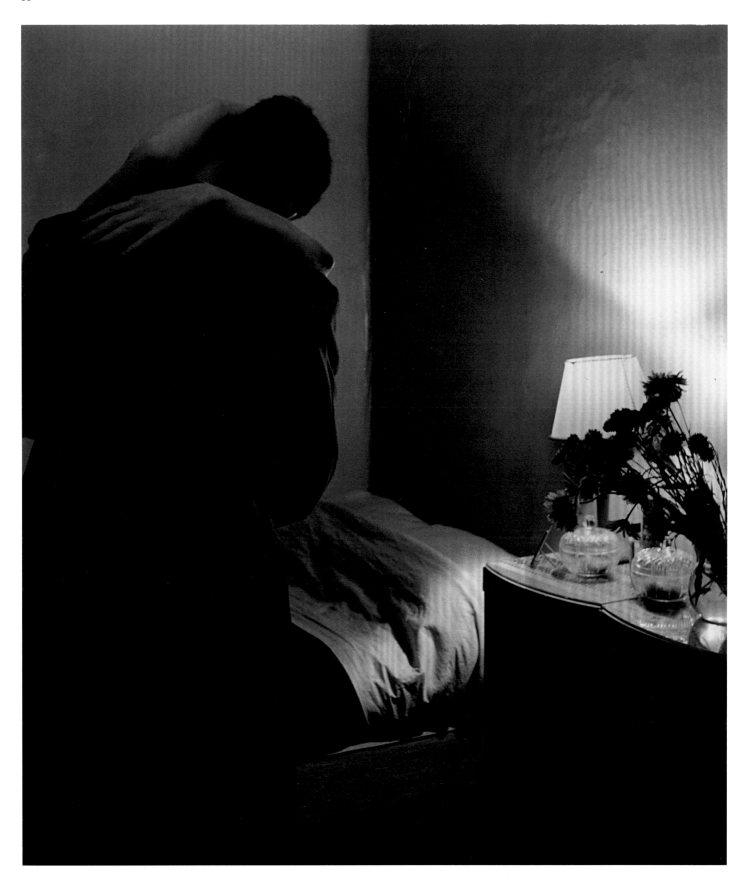

Soho Bedroom. 1934

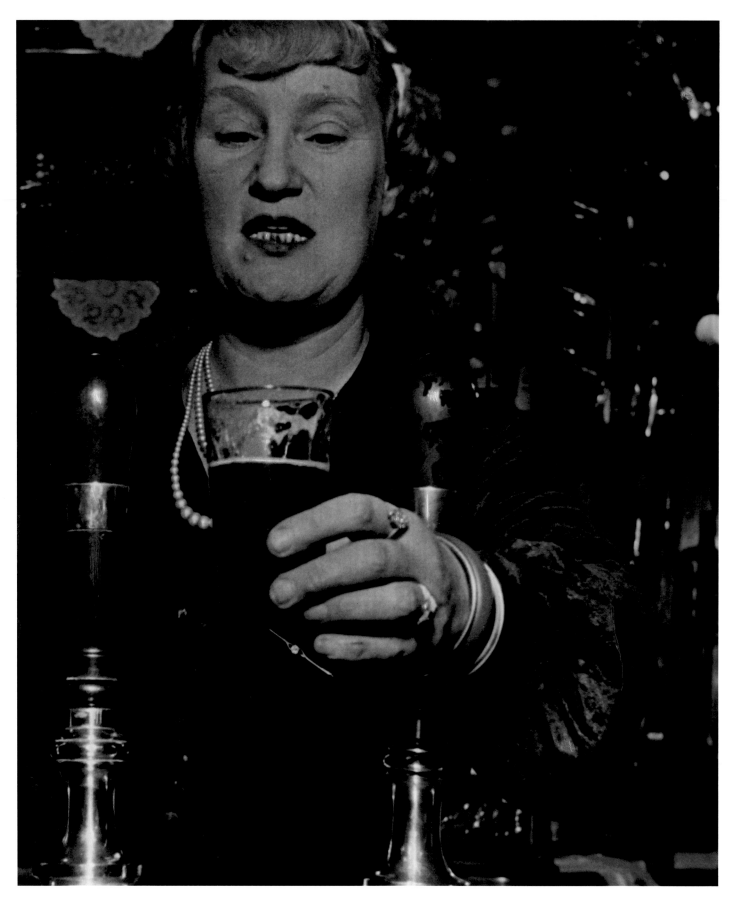

Barmaid at the Crooked Billet, Tower Hill. 1939

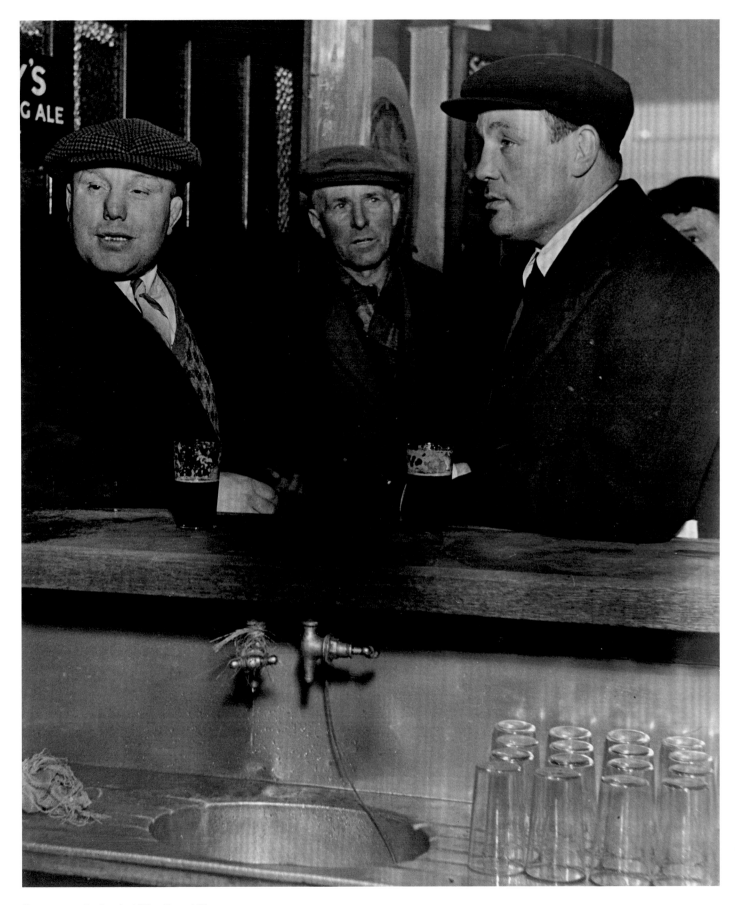

Customers at the Crooked Billet, Tower Hill. 1939

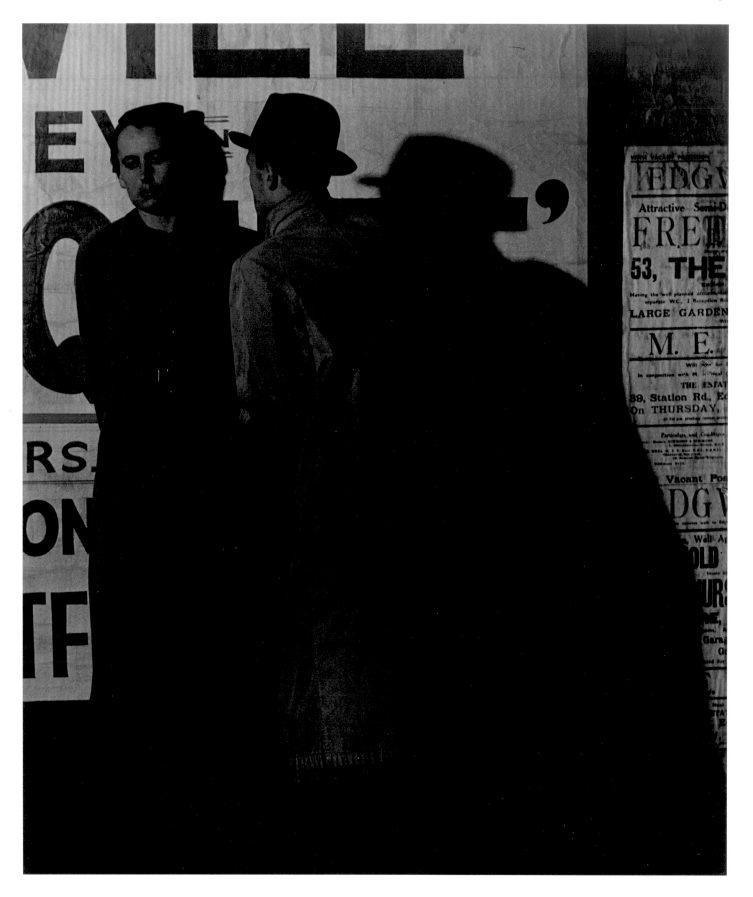

Street Scene, London. 1936

Night Patrol in the Underground. c. 1937

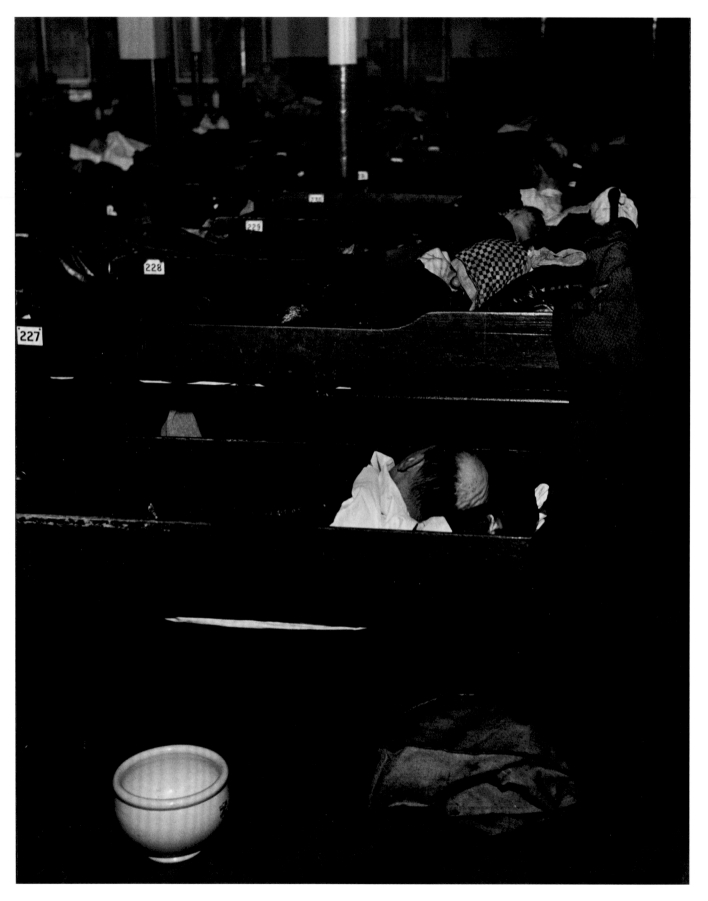

Common Lodging House, near the Elephant and Castle c. 1937

Bedroom in West Ham. c. 1937

Bedtime. c. 1937

East End Girl Dancing the Lambeth Walk. 1939

Girls in Shared Attic, Shoreditch. 1939

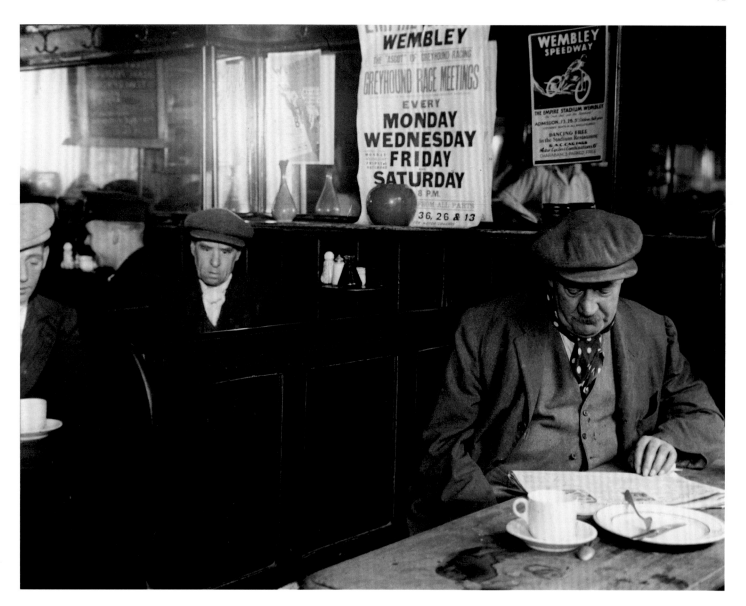

Workmen's Restaurant. c. 1934

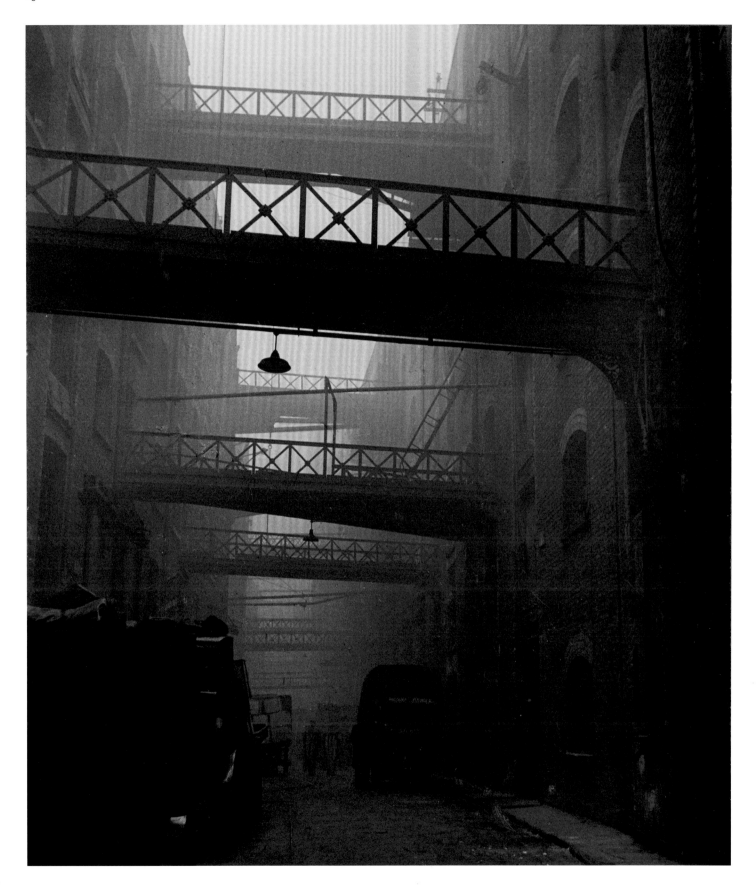

The River East of Tower Bridge, Shad Thames: A Street Between Warehouses in Bermondsey. c. 1936

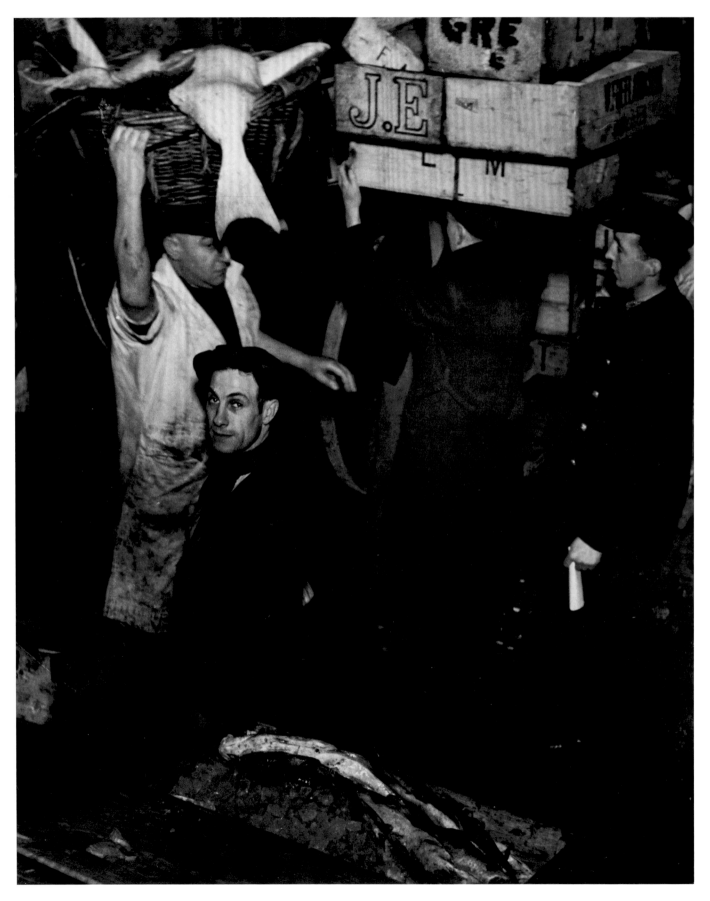

Billingsgate Fish Market. c. 1934

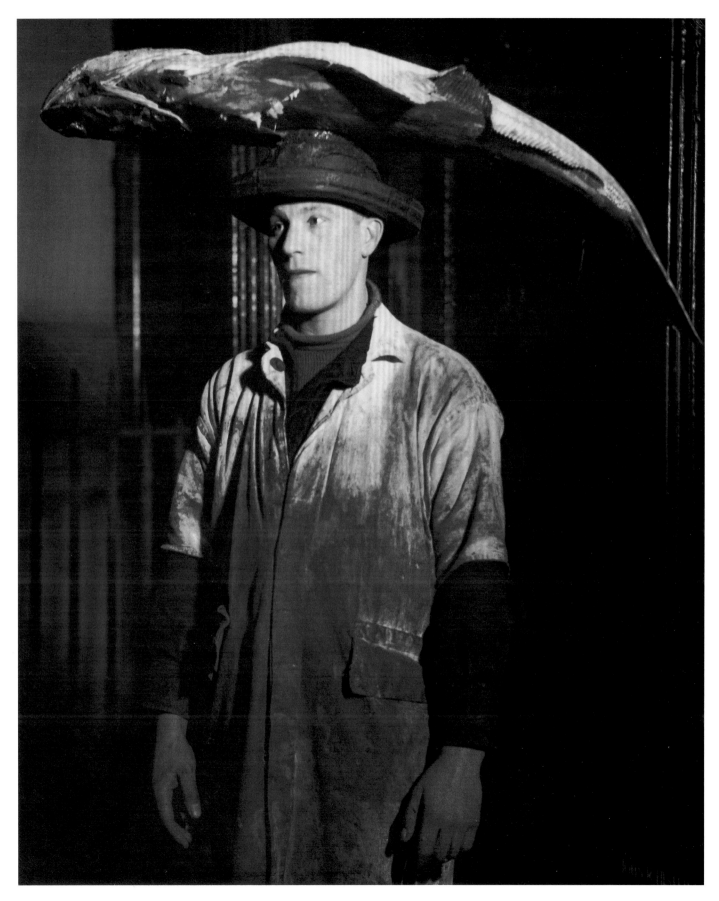

Billingsgate Porter. C. 1934

Prisoner in a Cell at Wormwood Scrubs. 1939

Evening in Kenwood. c. 1934

Circus Boyhood. 1933

East End Morning. 1937

In 1937, Brandt traveled to the industrial towns of Northern England, photographing in Halifax, Jarrow, Newcastle, and Sheffield. At the time, he had completed a few assignments for *Weekly Illustrated*, and two of his early photographs from Spain had appeared in *Lilliput*, but it seems unlikely that Brandt's trip to one of Britain's most economically depressed areas came at the request of an illustrated magazine because it would be nine years before any of these pictures would be published.[1] Nonetheless, this was an important body of work for Brandt, and both editions of *Shadow of Light* (1966/1977), Brandt's own retrospective look at his career, include a chapter dedicated to photographs made in the coal-mining regions that had suffered most acutely through the depression of the 1930s.

Brandt later alluded to the example of J. B. Priestley's *English Journey* as a motivating influence in his work, and his fervor to understand the English matched Priestley's own, with a few key differences. First, Priestley was born in England, and as he wrote in 1934, "I am here, in a time of stress, to look at the face of England, however blank or bleak that face may chance to appear, and to report truthfully."[2] Brandt was deeply interested in making a good picture and more than willing to sacrifice "truth" to get it, if truth was something that could not be arranged before a camera's lens. Priestley was committed to reinventing the British economic system, whereas Brandt reflected in 1959: "I was probably inspired to take these pictures because the social contrast of the thirties was visually very exciting for me. I never intended them, as has sometimes been suggested, for political propaganda."[3]

Brandt was likewise aware of George Orwell's *The Road to Wigan Pier*, published in January 1937. Orwell had been commissioned by the Left Book Club, a socialist group, to investigate the poverty and mass unemployment in the north of England, but the sense of advocacy and urgency that permeates his literary exploration is almost entirely absent from Brandt's work. Brandt was hardly indifferent to the suffering he witnessed, yet the deep blacks of the industrial architecture and soot-stained surfaces competed for his attention.

2

Northern England

1 Six of Brandt's pictures from this series were featured in the February 1948 issue of *Lilliput*, in the article "Hail, Hell and Halifax" (pp. 151–6), including the images reproduced here on pages 71, 77 (despite the fact it was taken in Sheffield), 81, and 83.

2 J. B. Priestley, *English Journey* (London: Penguin Books edition, 1977 [1934]), 63.

3 Bill Brandt, "Bill Brandt Today … And Yesterday," *Photography* 14, no. 6 (June 1959): 20.

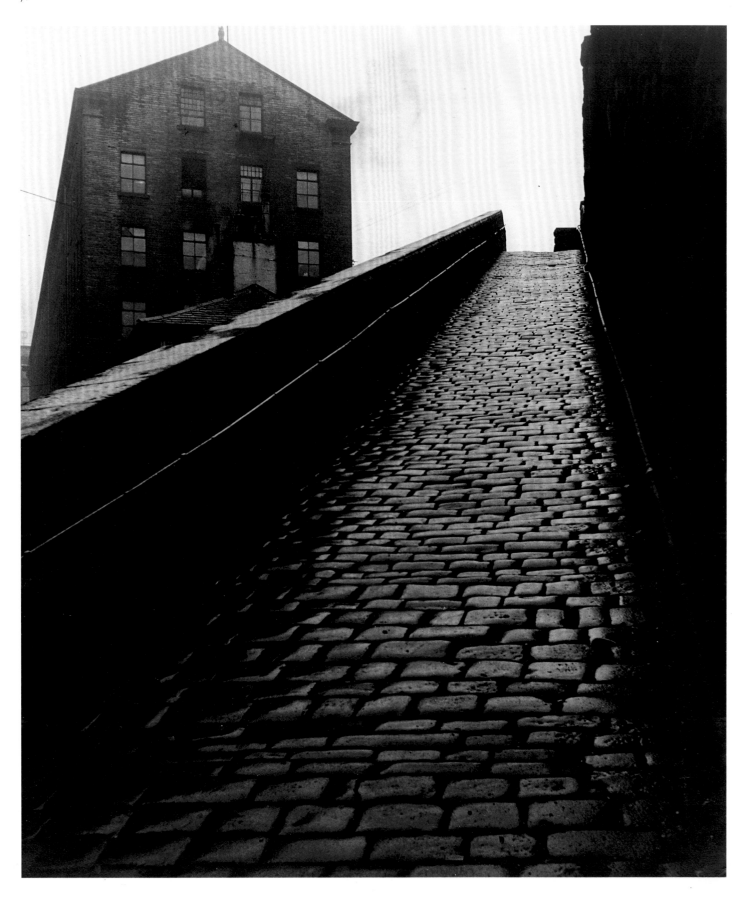

A Snicket in Halifax. 1937

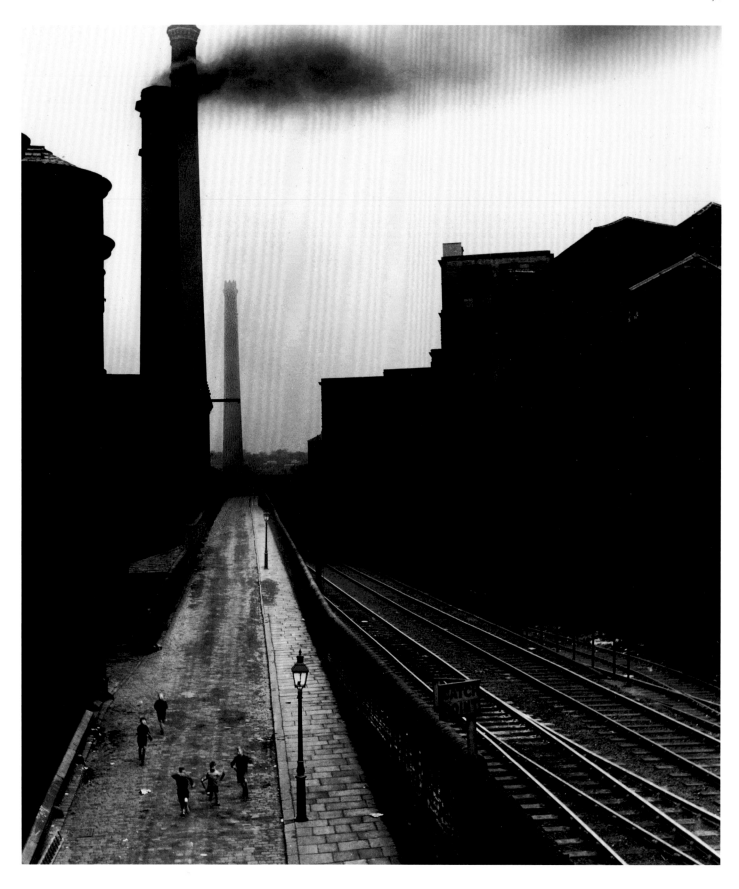

Halifax. 1937

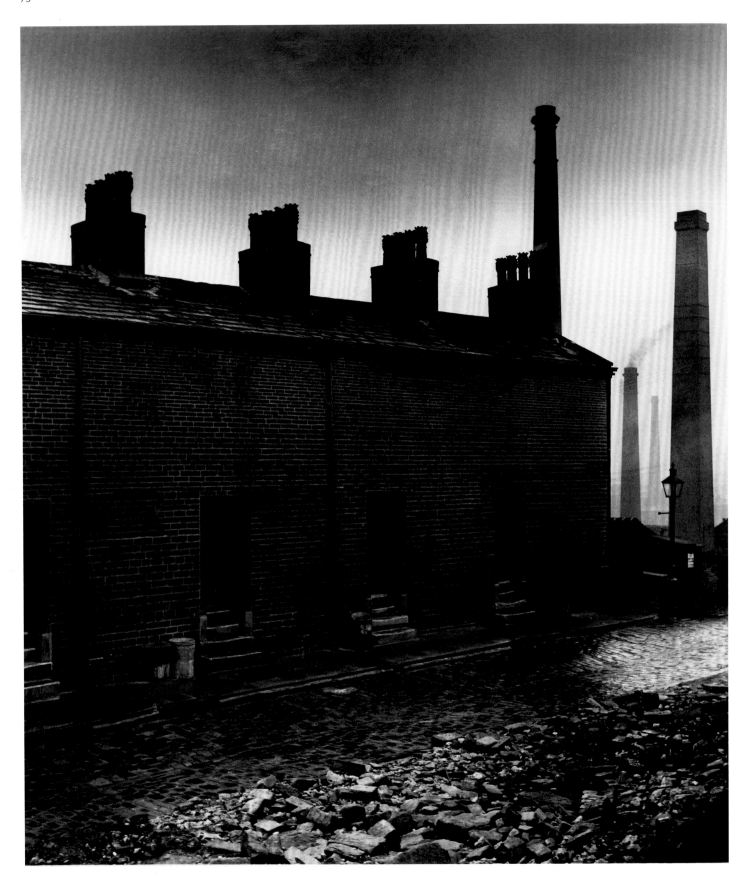

Coal-Miners' Houses Without Windows to the Street. 1937

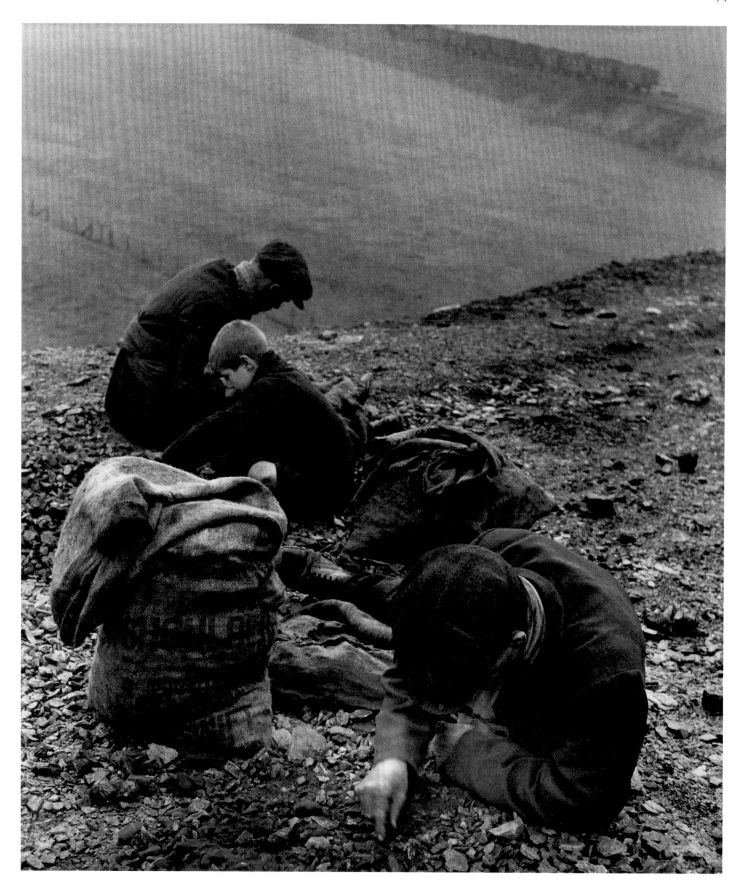

A Group of Coal-Searchers near Heworth, Tyneside; Pithead Train in the Distance. 1937

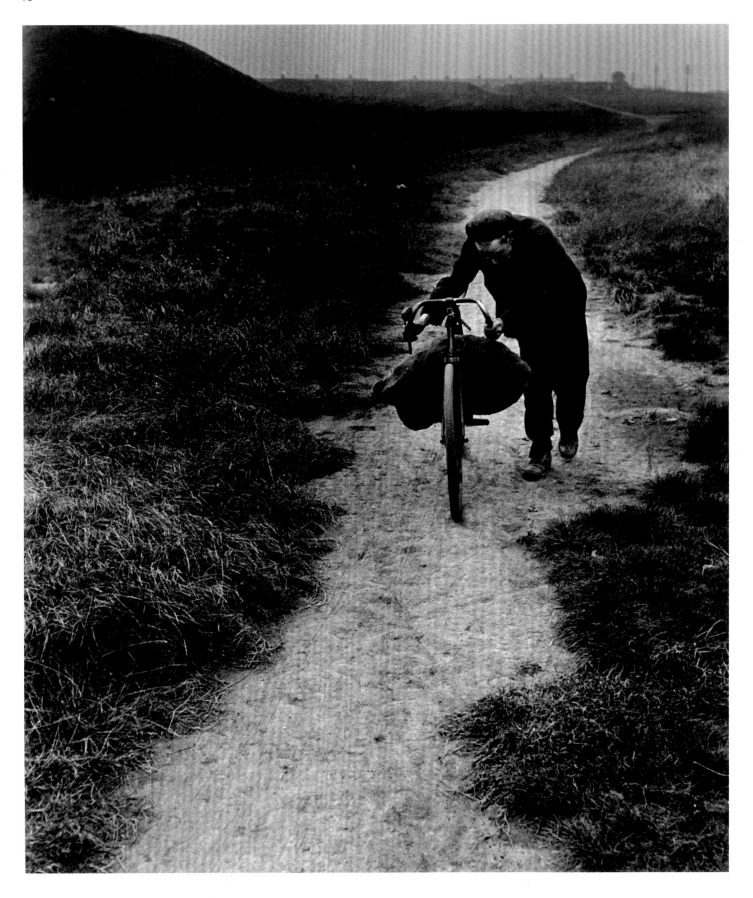

Coal-Searcher Going Home to Jarrow. 1937

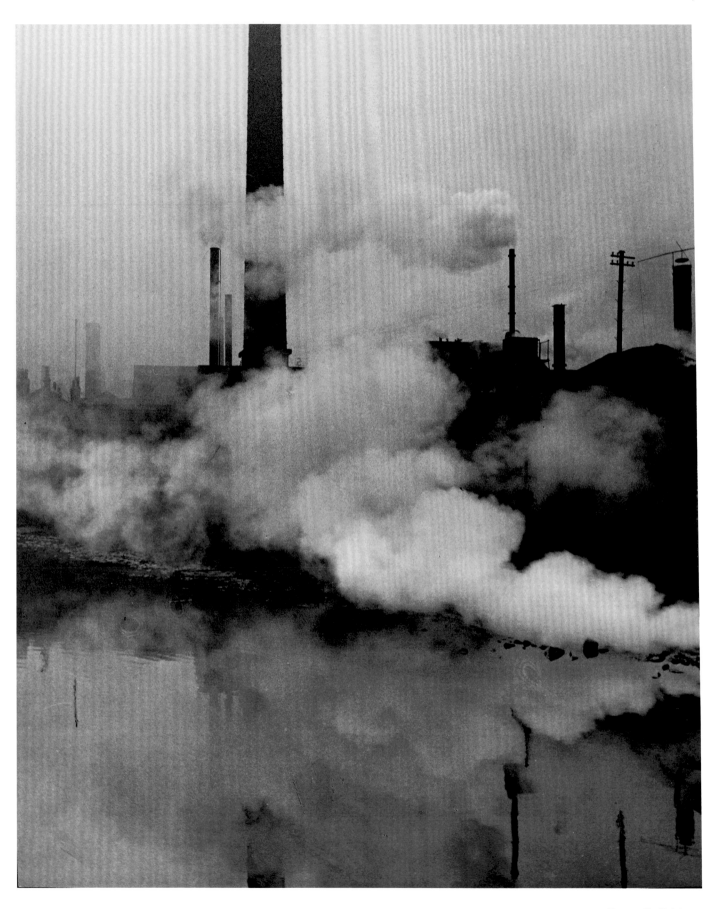

Factory, Sheffield. 1937

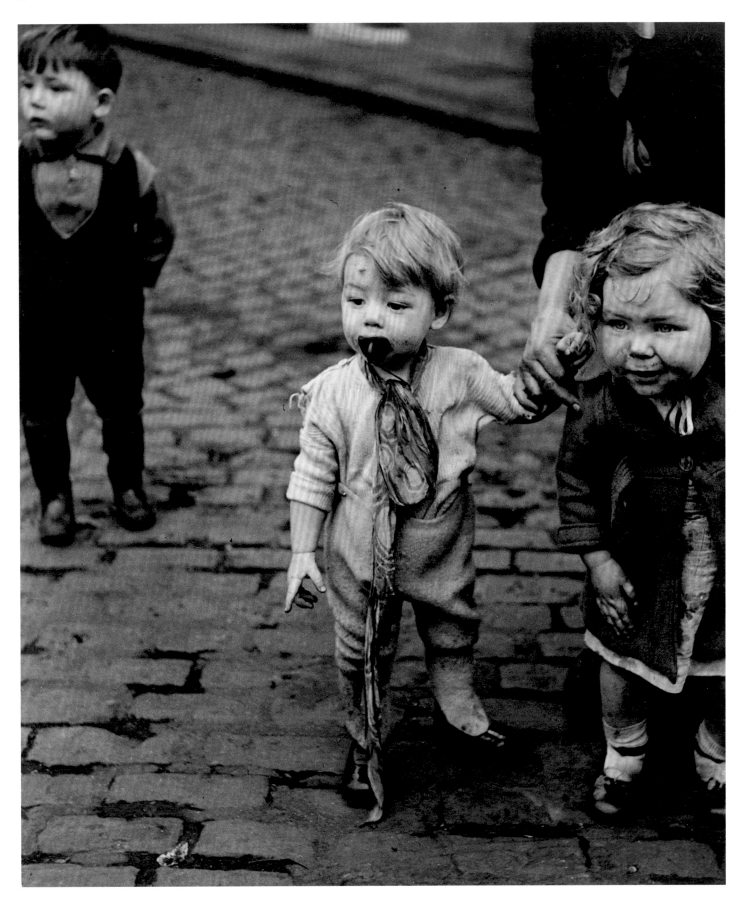

Children in Sheffield. 1937

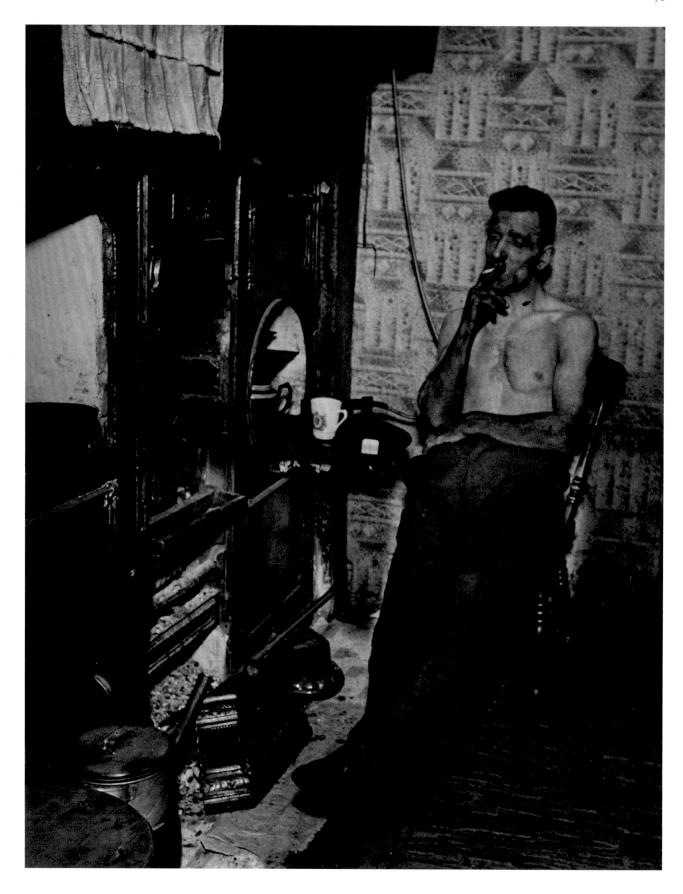

East Durham Coal-Miner Just Home from the Pit. 1937

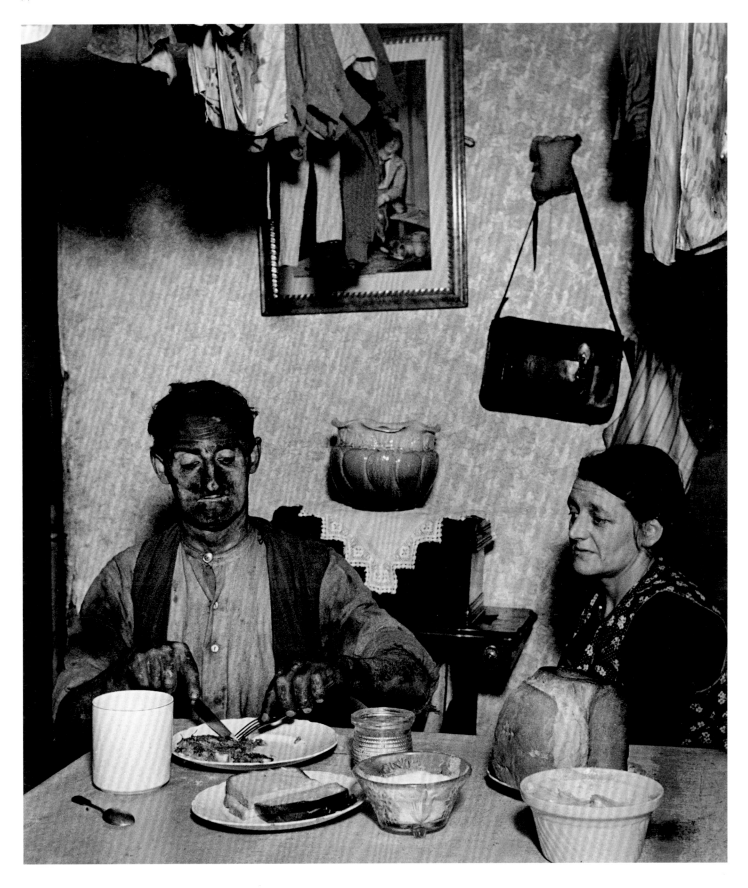

Northumbrian Miner at His Evening Meal. 1937

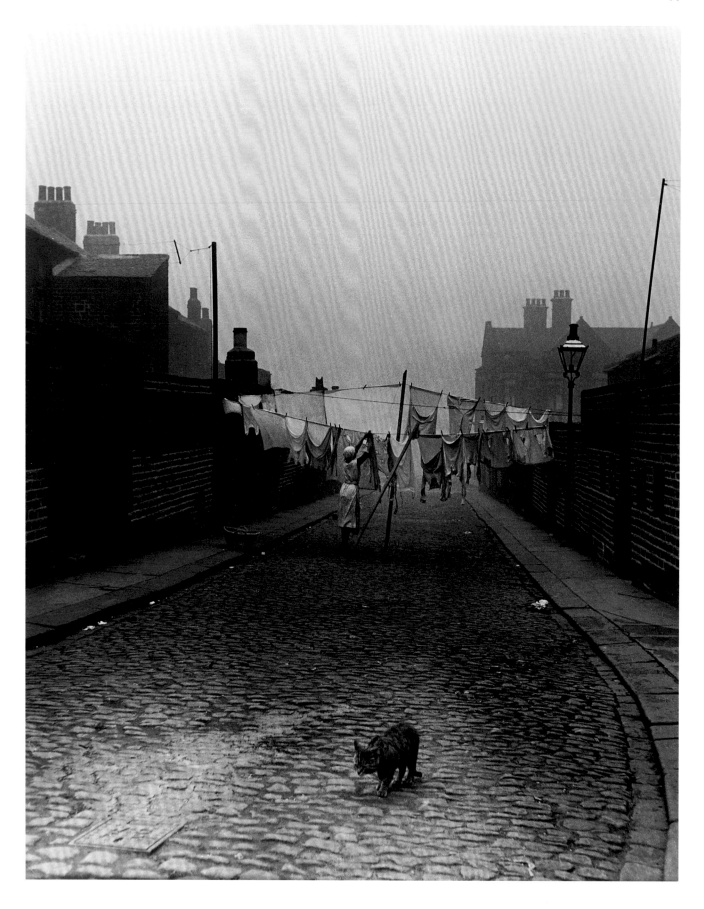

Back Street in Jarrow, Tyneside 1937

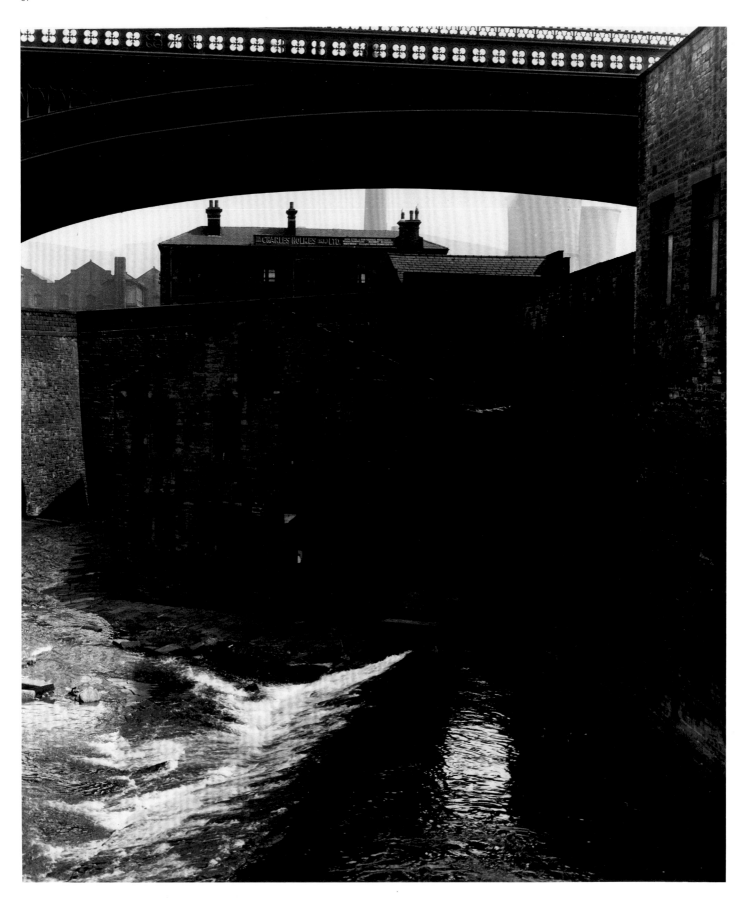

North Bridge over the River Hebble, Halifax. 1937

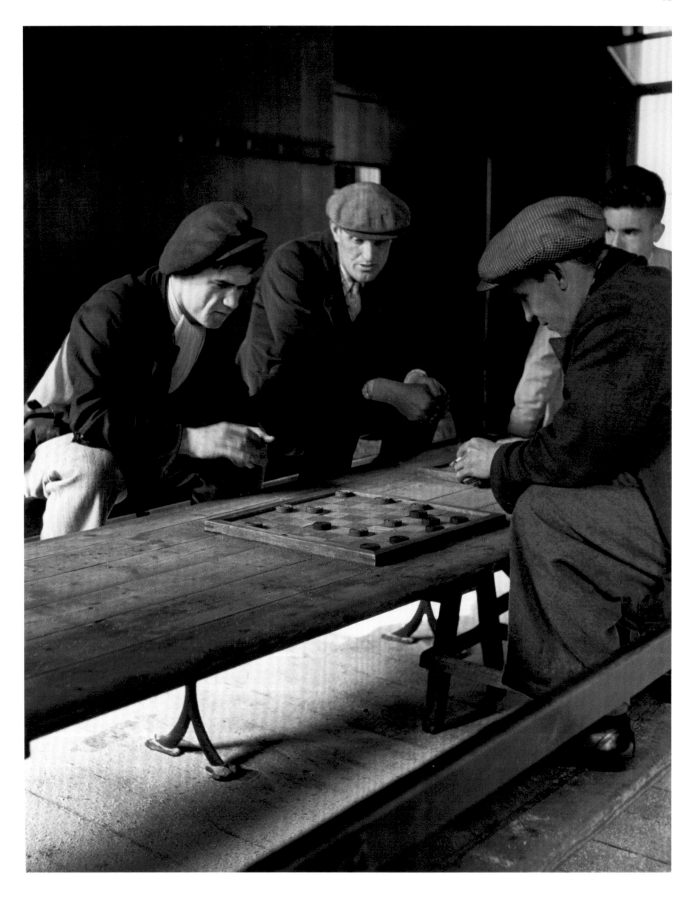

Jarrow. 1937

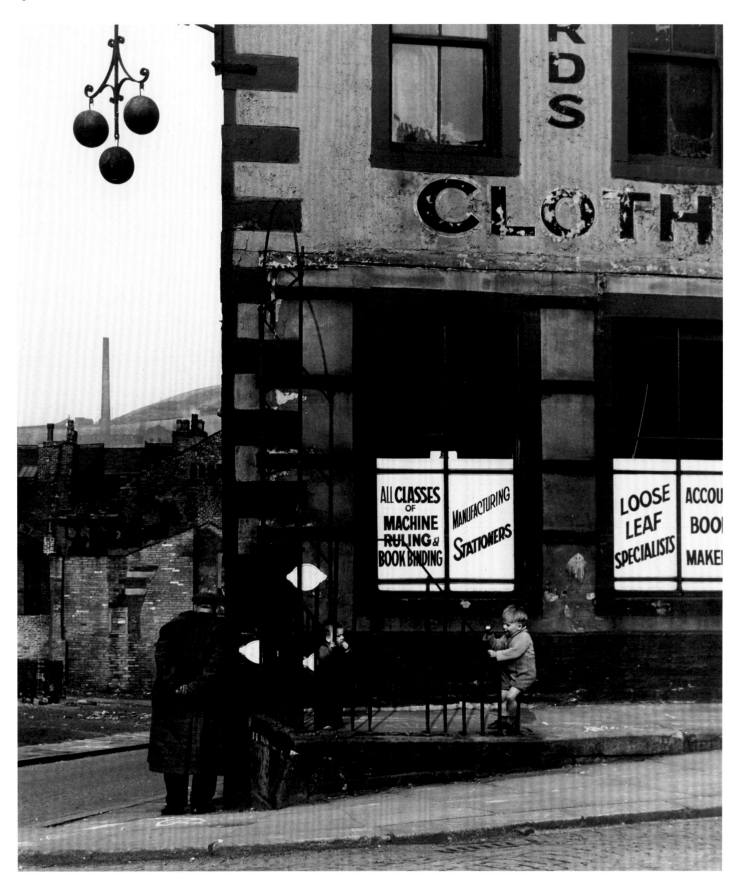

Pawnbroker's Premises in Halifax. 1937

For decades now, two iconic series of work have stood as synonymous with Bill Brandt's activity during World War II: his photographs of London by moonlight during the Blackout and of makeshift underground shelters during the Blitz. The reality is that his wartime production was much more varied, which is key to understanding the overall evolution of Brandt's work. By 1939, Brandt could expect regular assignments from the illustrated press, although his editors also drew liberally from work he had pursued independently. *Lilliput* published a sequence of Brandt's pictures of London during the Blackout in December 1939, and again in August 1942.[1] Brandt described the appeal of this nocturnal work: "Night photography is often a very leisurely way of taking pictures. The main thing you need is patience. But you also have plenty of time. After midnight, in particular, there is hardly anybody about, you can do almost anything without being disturbed. There are rarely any watchers, and you are seldom troubled even by passing cars. Night photography can indeed be a quiet and pleasurable sort of game."[2]

Brandt was commissioned by the British Ministry of Information to take pictures of the improvised shelters that had appeared in the wake of the first German air raids on London in September 1940. In early November, Brandt photographed in Tube stations, wine cellars, shop basements, and crypts—anywhere Londoners sought protection. This project was the antithesis of his moonlit nocturnes, using artificial lighting to document crowded, cramped spaces. The artist Henry Moore had received a similar commission, and his drawings appeared opposite several of Brandt's photographs in *Lilliput*.[3] Moore's and Brandt's shelter pictures were also included in the exhibition *Britain at War*, which was presented at MoMA from May to September 1941.[4]

Virtually every retrospective consideration of Brandt's work distills his wartime activity to these two bodies of work, a decision initially made by Brandt himself in his first retrospective book, *Shadow of Light* (1966). The remainder of the plates in this section, considered with the stories listed and reproduced on pages 195–203, tell a decidedly more complicated story: almost without exception these photographs were made for *Lilliput*, *Picture Post*, or *Harper's Bazaar*. Brandt, like every inhabitant of London, was profoundly changed by the war, and the same was true of the city itself. He used these assignments to expand his oeuvre: through his portrait commissions and his photographs of the British landscape, in particular, he found new ways to position himself as a British photographer.

3

World War II

1 The first appeared in "Blackout in London," *Lilliput* 5, no. 6 (December 1939): 551–8; followed by "London by Moonlight," *Lilliput* 11, no. 2 (August 1942): 131–40.

2 Bill Brandt, "Pictures by Night," in L. A. Mannheim, ed., *The Rollei Way: The Rolleiflex and Rolleicord Photographer's Companion* (London and New York: The Focal Press, 1952), 185; reprinted in Nigel Warburton, *Bill Brandt: Selected Texts and Bibliography* (Oxford, U.K.: Clio Press, 1993), 41.

3 "Shelter Pictures," *Lilliput* 11, no. 6 (December 1942): 473–82.

4 Brandt's work was unattributed, as were all other photographs in the exhibition.

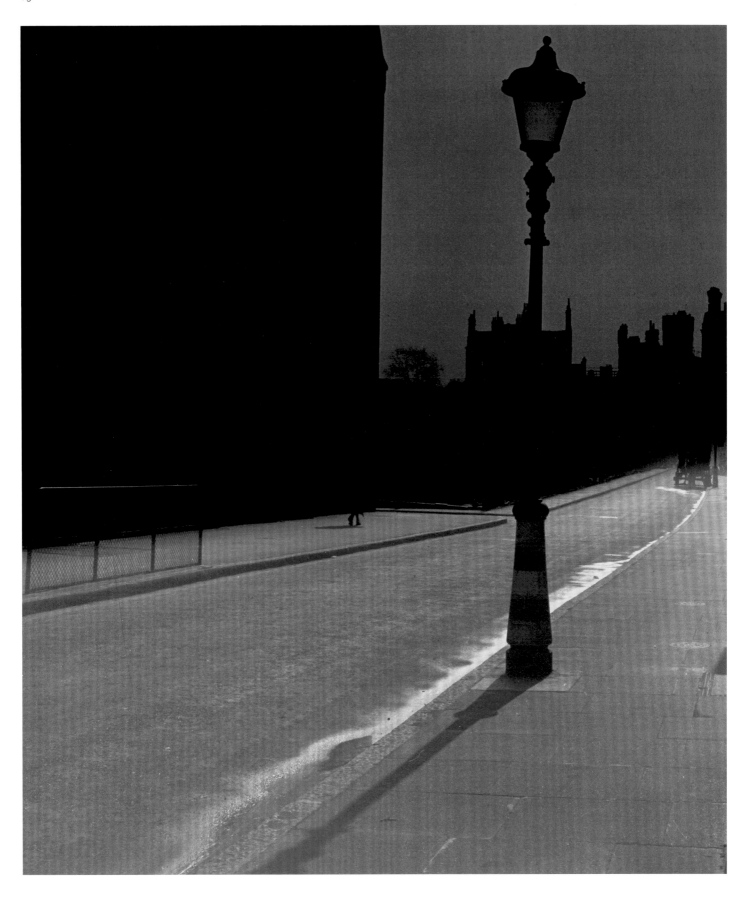

Deserted Street in Bloomsbury. 1942

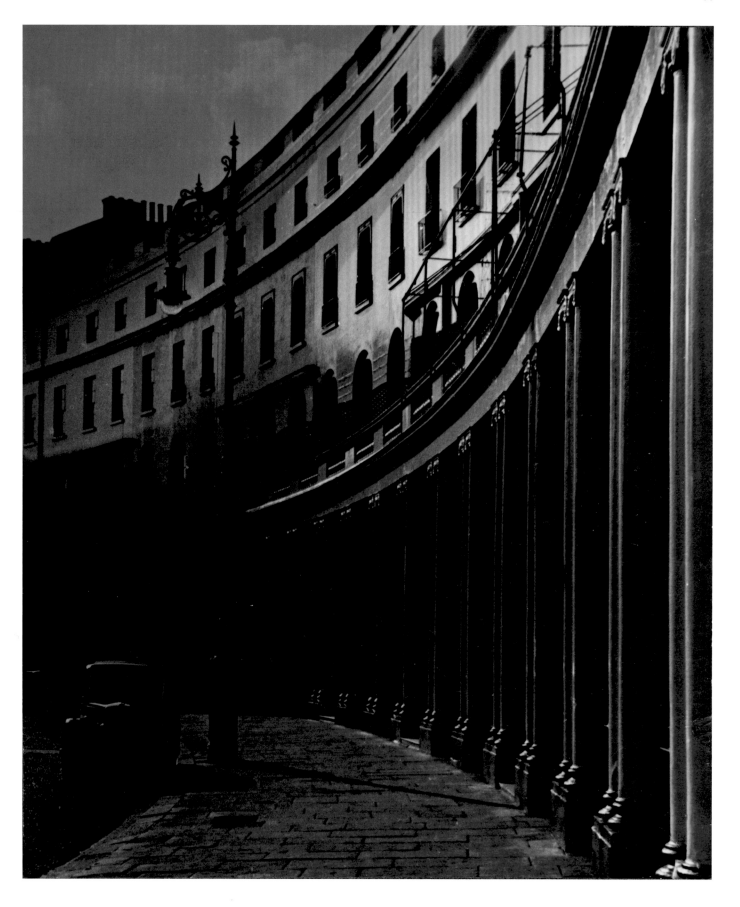

The Moon on Park Crescent. 1939

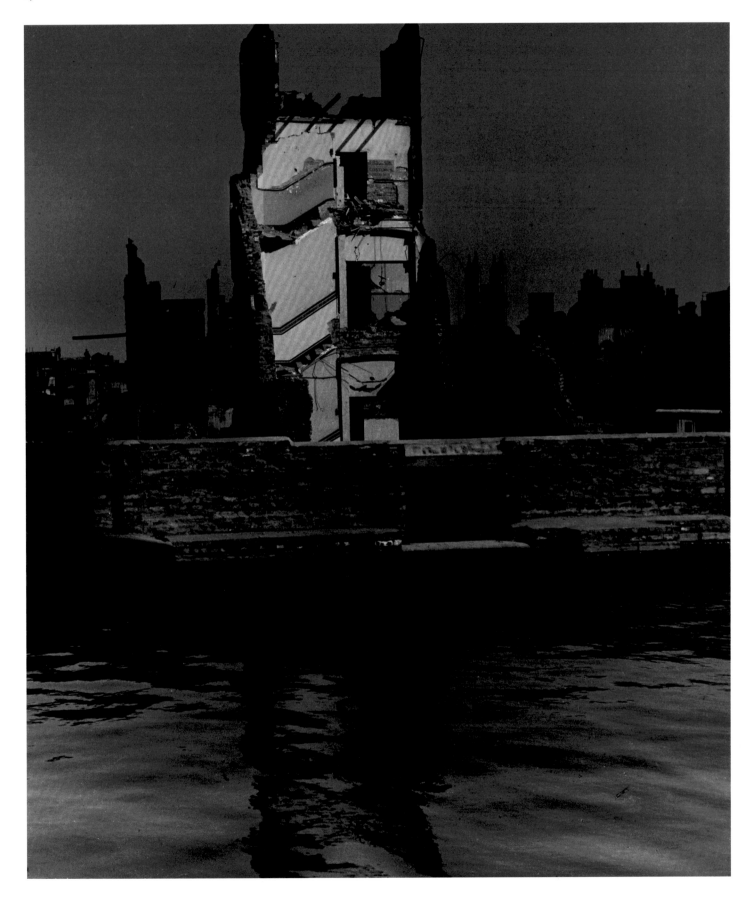

The Bombed City. 1942

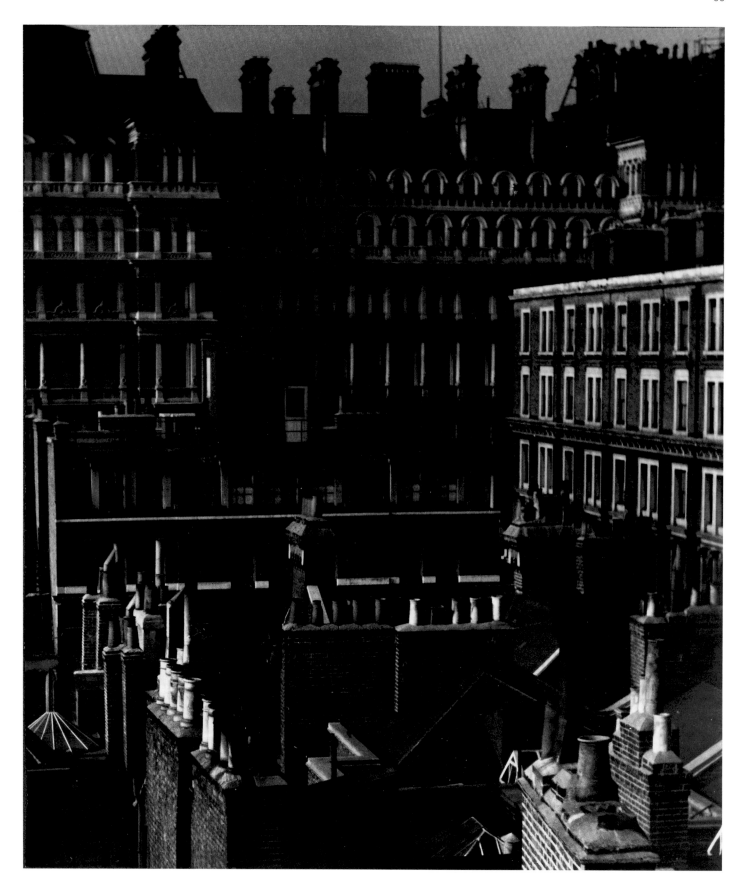

Moon on the Adelphi. 1939

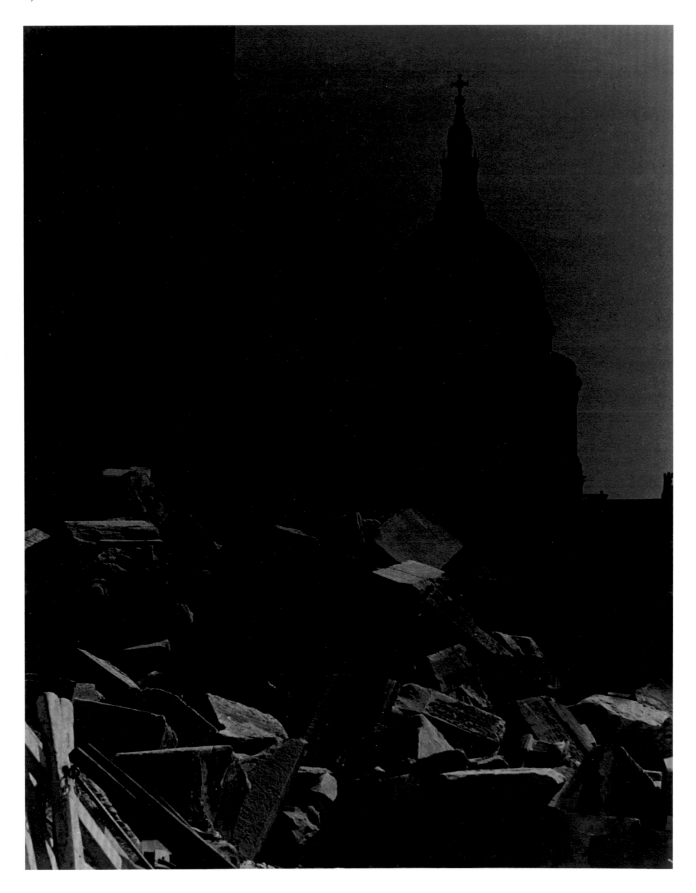

St. Paul's Cathedral in the Moonlight. 1939

A Sikh Family Sheltering in an Alcove Where Coffins Once Stood,
in the Crypt of Christ Church, Spitalfields. 1940

East End Wine Merchant's Cellar: A Group of Orthodox
Jews Reading Their Bibles. 1940

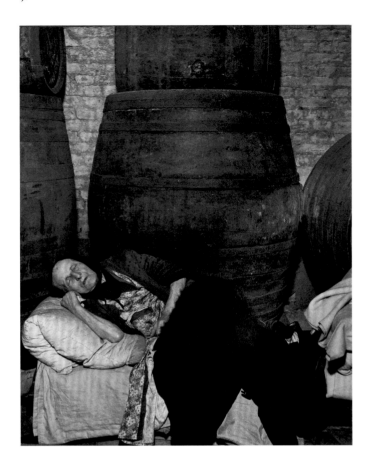

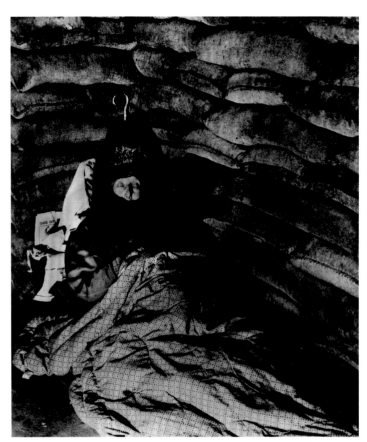

East End Wine Merchant's Cellar: Old Woman Sleeps on a
Bed Constructed on top of a Row of Barrels. 1940

Old Lady in a Pimlico Air-Raid Shelter, Her Silver-Handled Umbrella
Safely Tucked Away behind Her. 1940

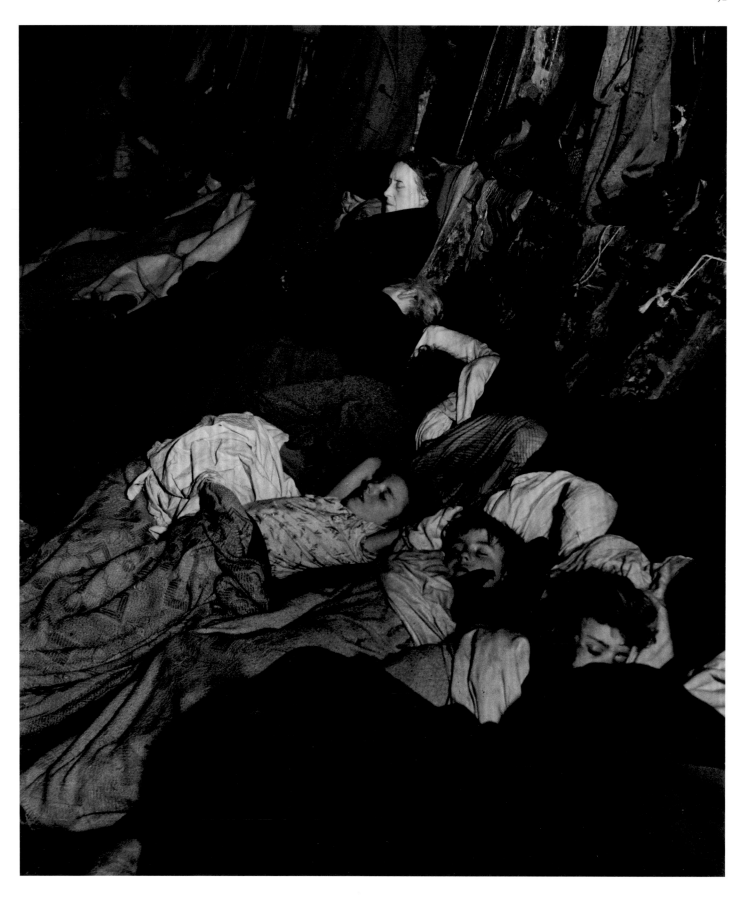

Crowded, Improvised Air-Raid Shelter in a Liverpool Street Tube Tunnel. 1940

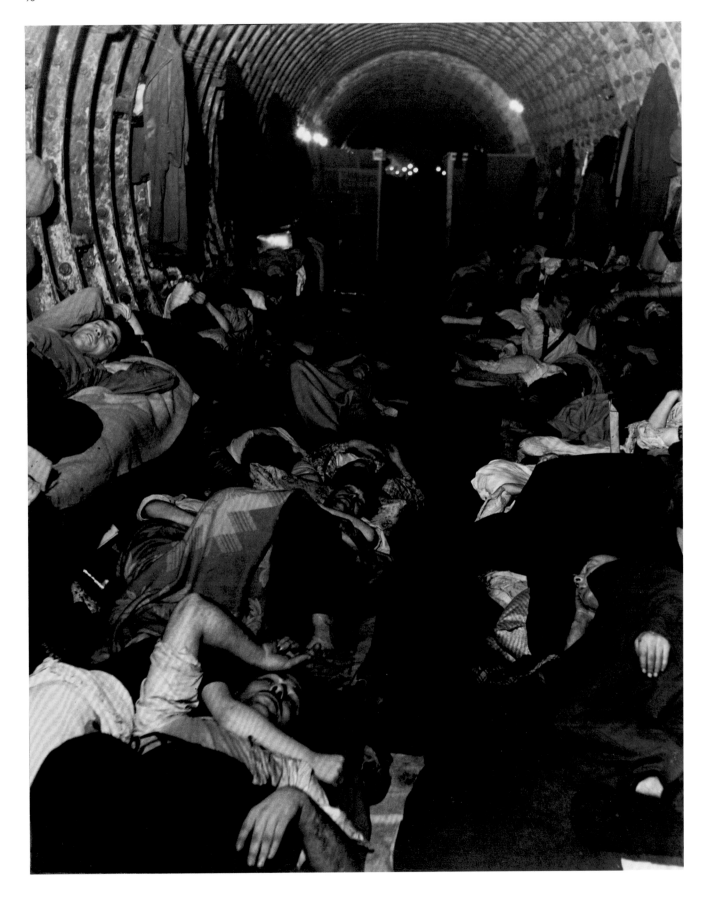

Liverpool Street Underground Station Shelter. 1940

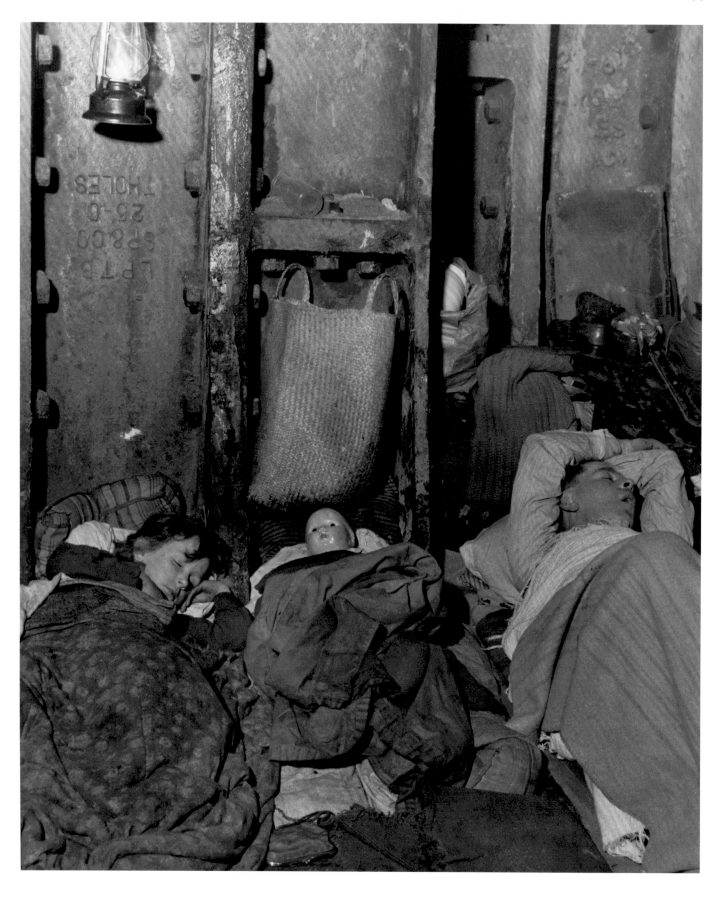

Liverpool Street Underground Station Shelter. 1940

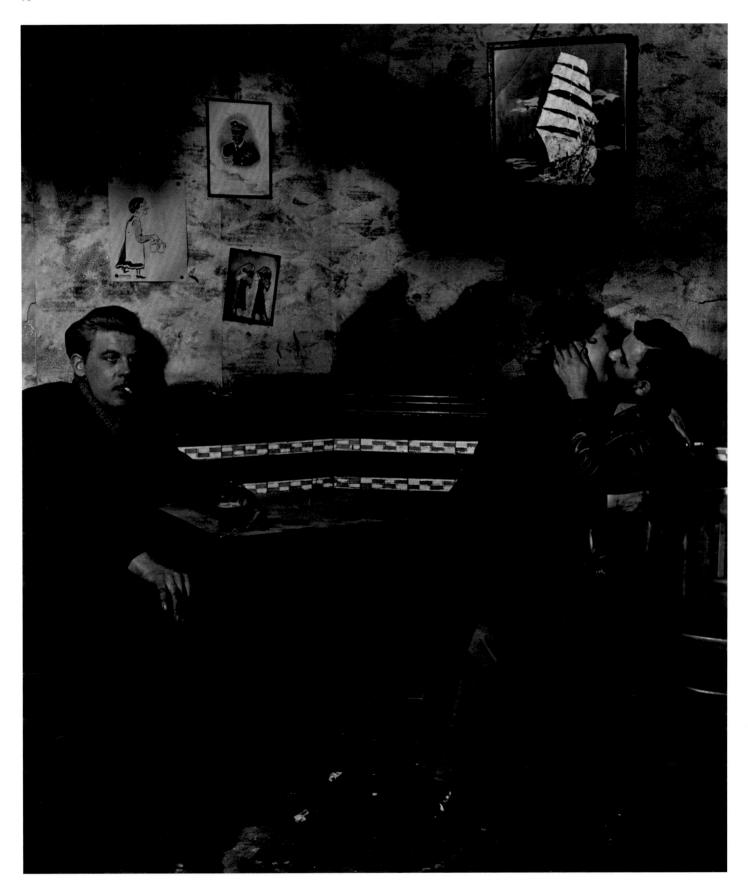

In the Public Bar at Charlie Brown's, Limehouse. c. 1942

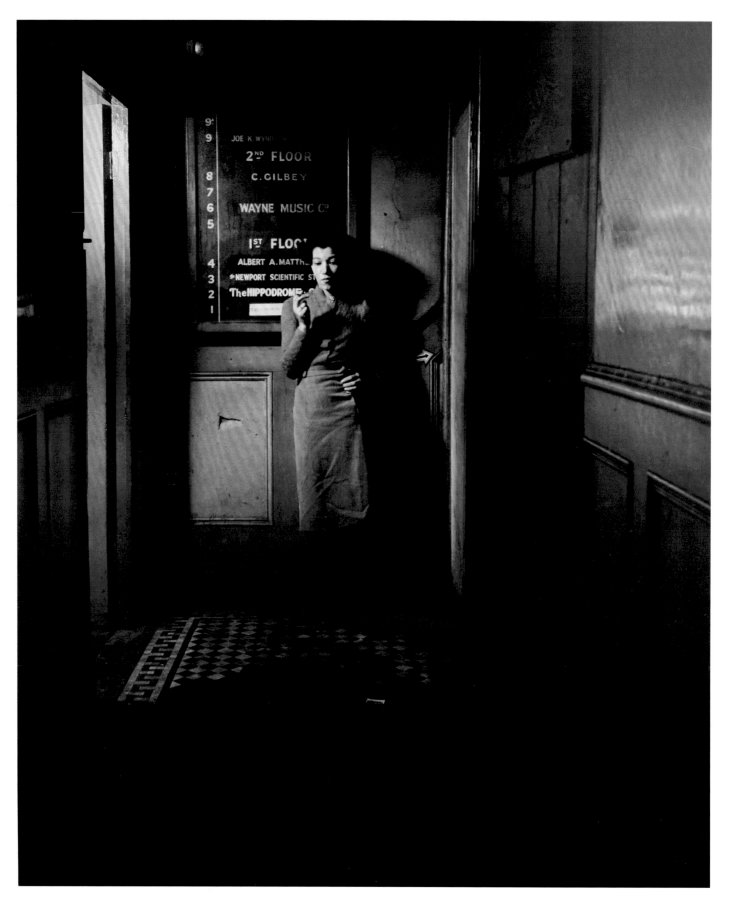

Outside a Soho Nightclub. 1942

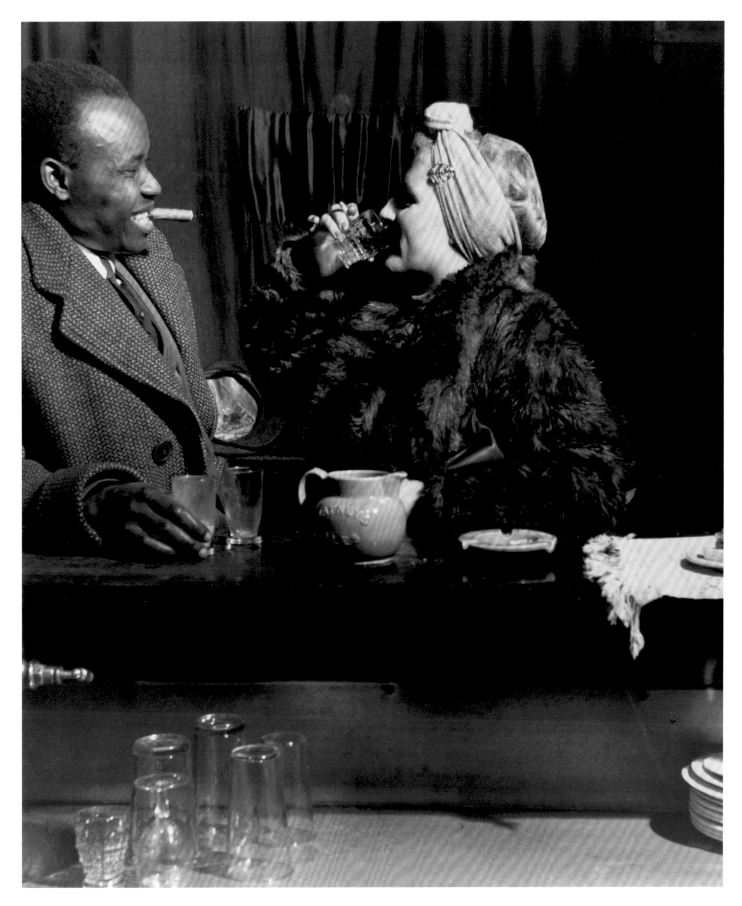

Soho. 1942

Bath—The Circus. 1942

Packaging Post for the War. c. 1942

Bombed Regency Staircase, Upper Brook Street, Mayfair. c. 1942

Sphinx, Chiswick House Gardens. 1944

Prior Park, near Bath. 1942

Hadrian's Wall. 1943

Edith and Osbert Sitwell beneath the Family Group by Sargent, Renishaw Hall, Yorkshire. 1945

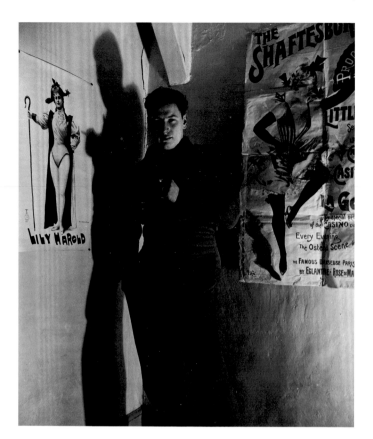

Robert Graves in His Cottage at Churston, Devon. 1941

Peter Ustinov. 1945

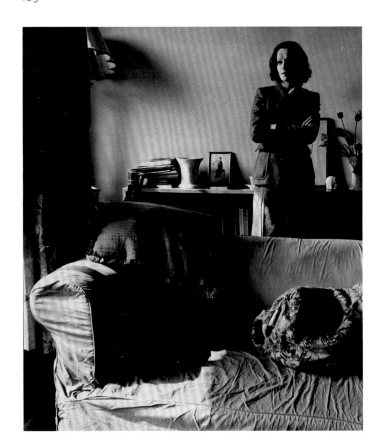

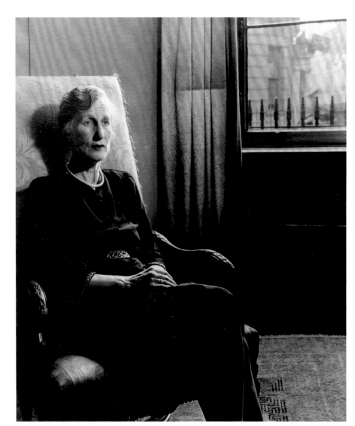

Beatrix Lehmann. 1945

Lady Violet Bonham Carter. 1945

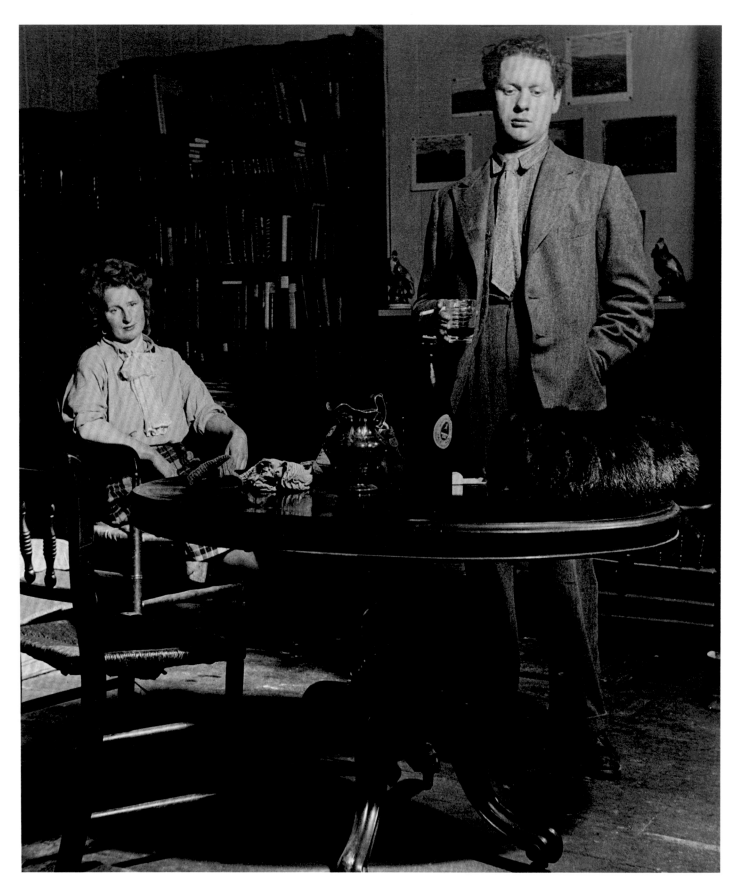

Dylan Thomas and His Wife, Caitlin, in Their Room, Manresa Road, Chelsea. 1944

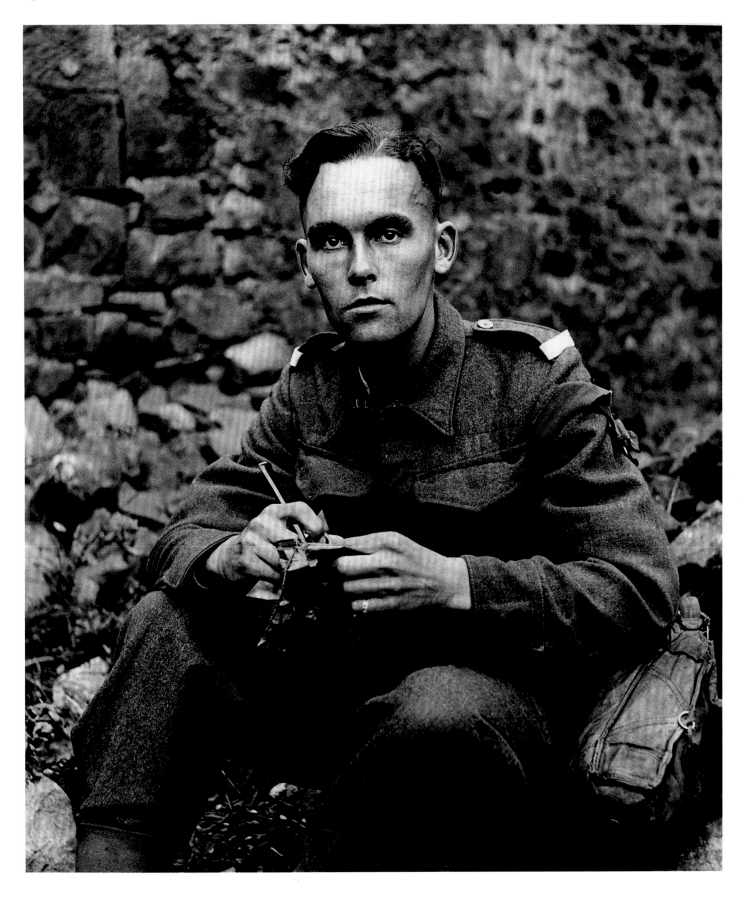

Alun Lewis. 1941

Although Brandt received a few portrait assignments from *Picture Post*, it was in *Lilliput* (and, later, *Harper's Bazaar*) that the vast majority of his portraits would first appear. Brandt's success with "Young Poets of Democracy" in December 1941 led to numerous other articles for *Lilliput* over the next decade.[1] Not coincidentally, these assignments revolved around cultural, artistic, and literary figures—people whose creativity could be read across their faces. Indeed, except as "types" in the 1930s, Brandt almost never photographed other public figures, such as politicians, businessmen, or sports celebrities.

Beginning in 1943, Brandt began making portraits for *Harper's Bazaar*; it was likely that Brandt's second wife, Marjorie Beckett, who worked as a fashion editor for *Harper's Bazaar* in London during World War II, made the introduction. The magazine (first the U.K. edition, then the U.S. version) was essential in building Brandt's portrait practice well into the 1970s, and this extended timeline allowed Brandt to photograph many leading British cultural figures in youth and in old age.[2] He emphasized the longevity of his engagement with the genre in his 1982 book, *Bill Brandt: Portraits*, in which he placed side by side pictures of an individual, often made decades apart. The self-portrait for which Brandt is best known (p. 29) was also a commission from *Harper's Bazaar*.

The one aspect of Brandt's portraiture that seems to have never appeared in a magazine are the ten closely cropped eyes that Brandt made in the early 1960s.[3] Each one features a notable visual artist, and a few seem to have been made at the same session as a published portrait, although none appear to be enlargements from known work. They are striking departures from Brandt's typical practice, mysterious despite their clarity of description, and they underscore Brandt's experimental impulse, even late in his career.

Brandt's first statement about making portraits appeared in *Lilliput* in 1948. In it he paraphrased André Breton's statement "that a portrait should not only be an image but an oracle one questions, and that the photographer's aim should be a profound likeness, which physically and morally predicts the subject's entire future." Brandt expanded upon this with his own observation that "[s]napshots show only the likeness of a certain moment and are never good portraits. The photographer has to wait until something between dreaming and action occurs in the expression of a face."[4] It is this suspended moment, this timelessness, that characterizes the best of Brandt's postwar portraits.

4

Portraits

1 Photographs that first appeared in these articles include the portrait of Alan Rawsthorne (p. 111), "English Composers of Our Time," *Lilliput* 19, no. 3 (September 1946): 239; Henry Moore (p. 115), "Six Artists," *Lilliput* 22, no. 6 (June 1948): 120; the Boulting twins (p. 114), "Nervy Birds in a Gilded Cage," *Lilliput* 24, no. 2 (February 1949): 58; and several from "An Odd Lot," *Lilliput* 25, no. 5 (November 1949): 49–56, including E. M. Forster (facing), Norman Douglas (p. 110), Robert Graves (p. 104), Edith and Osbert Sitwell (p. 103), Evelyn Waugh (p. 113), Ivy Compton-Burnett, Elizabeth Bowen, and Graham Greene, several of which were made previously for other purposes.

2 Brandt made a small number of portraits for *Vogue* as well, including those on pages 124 and 129.

3 Sarah Montross's excellent unpublished research regarding these portraits is located in the Bill Brandt object files, Department of Photography, The Museum of Modern Art, New York.

4 Bill Brandt, "5 Photographers in Search of a Portrait," *Lilliput* 23, no. 5 (November 1948): 95.

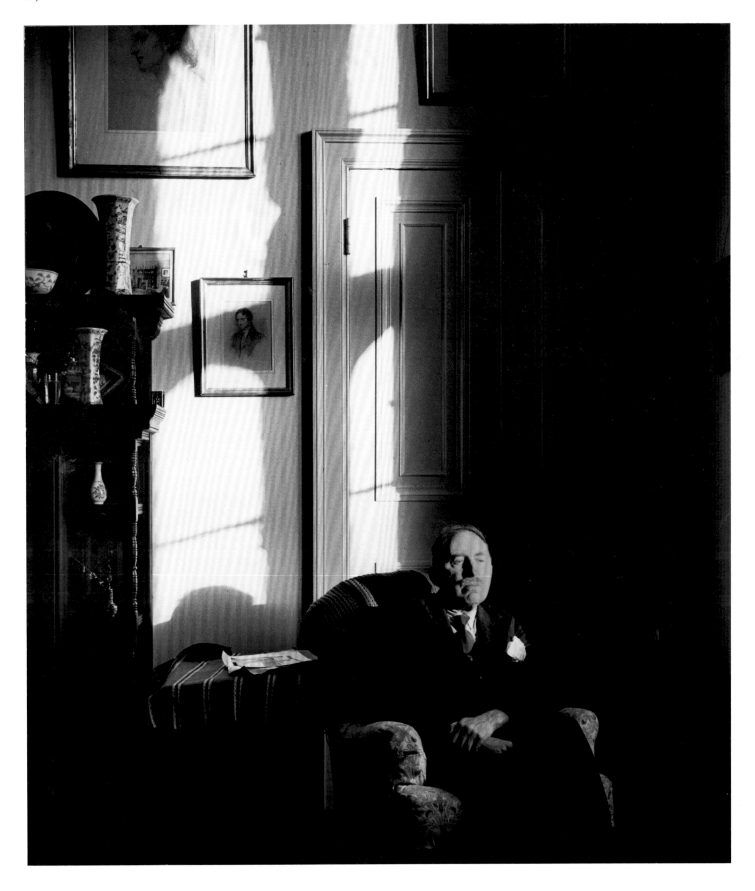

E. M. Forster in His Room at King's College, Cambridge. 1947

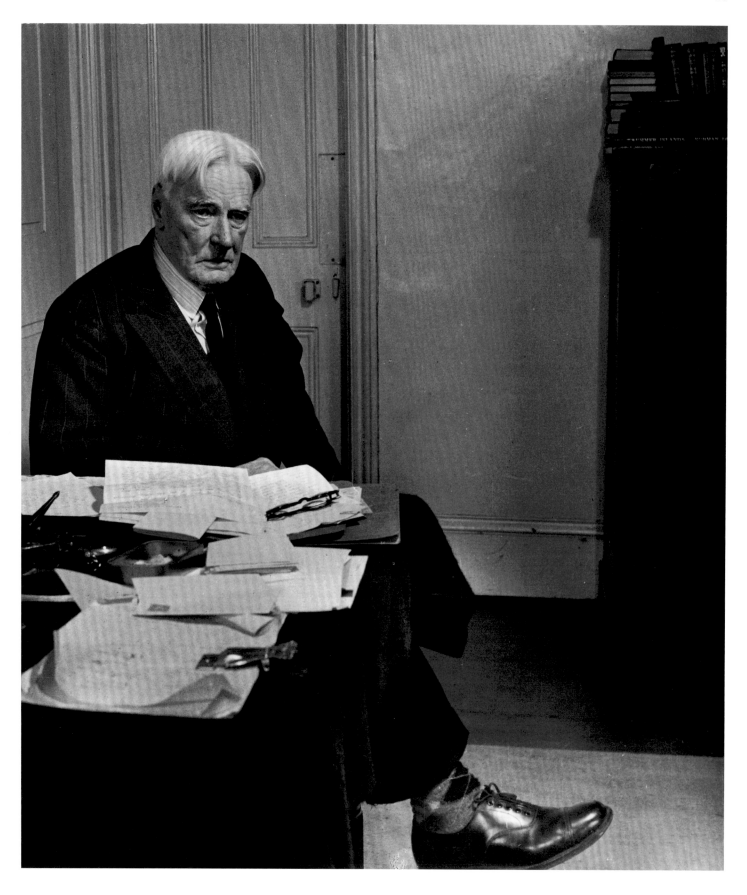

Norman Douglas. 1946

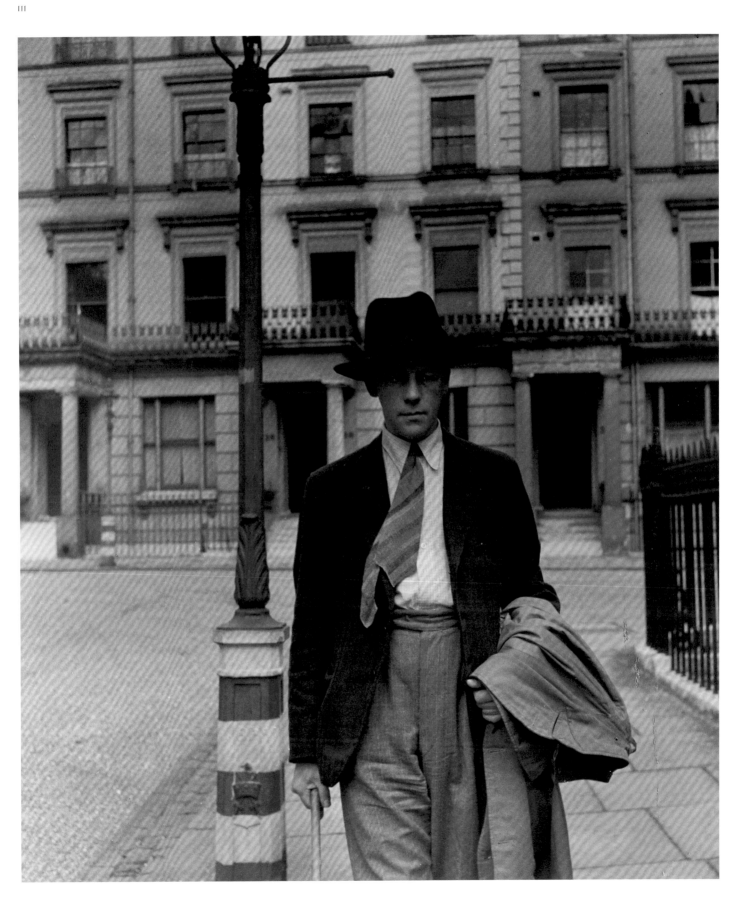

Alan Rawsthorne. 1946

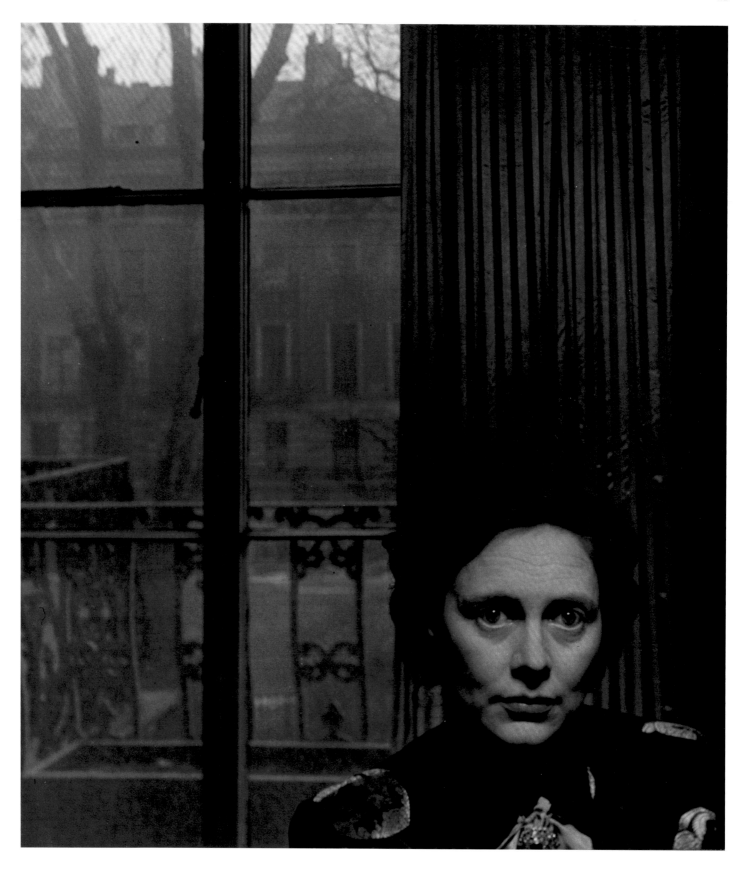

Celia Johnson. 1947

Evelyn Waugh at Piers Court. 1949

The Boulting Brothers. 1949

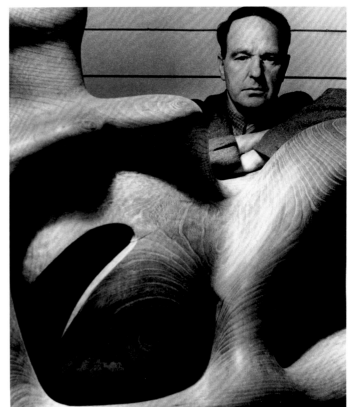

Barbara Hepworth. 1956

Henry Moore in His Studio at Much Hadham, Hertfordshire. 1946

Reg Butler. c. 1952

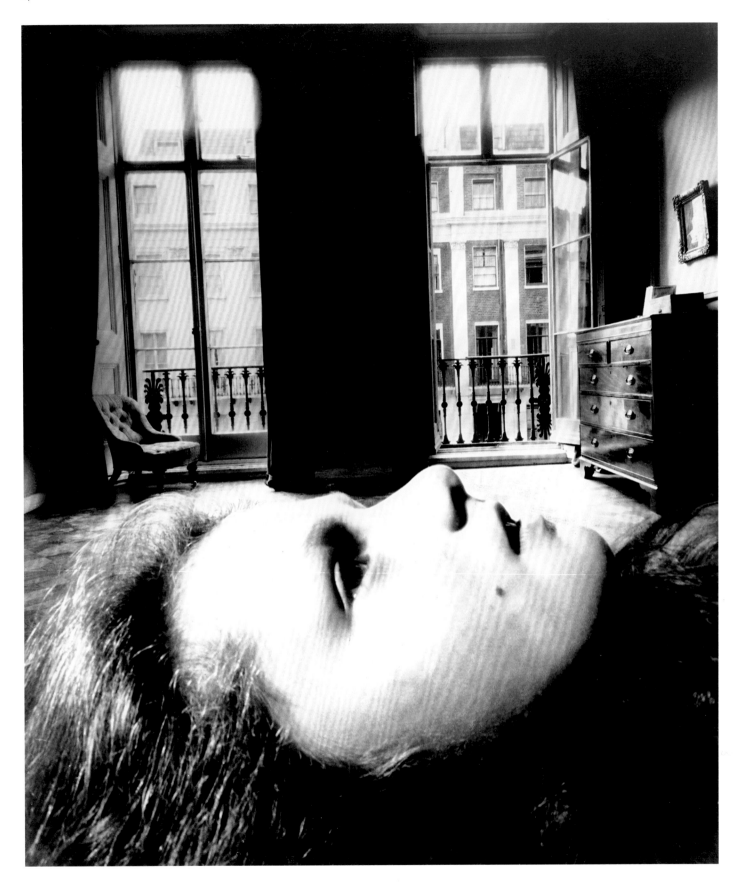

Portrait of a Young Girl, Eaton Place. 1955

Henry Moore. 1960 Georges Braque. 1960

Alberto Giacometti. 1963

Antoni Tàpies. 1964

Louise Nevelson. 1963

Jean Arp. 1960

Max Ernst. 1963

Jean Dubuffet. 1960

Franco Zeffirelli, Ennismore Gardens, London. 1962

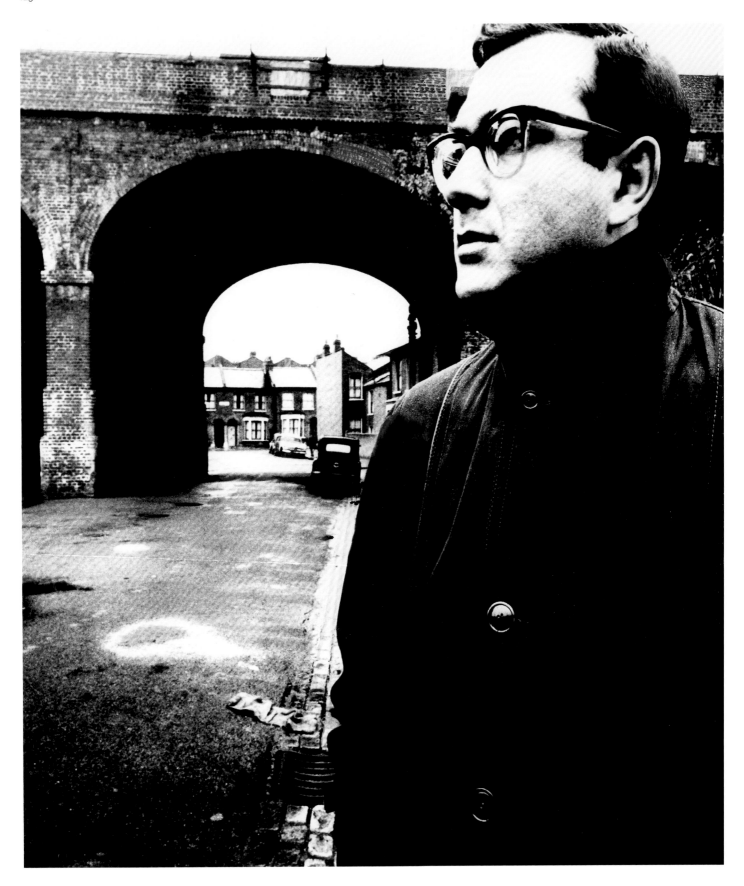

Harold Pinter, Battersea, London. 1961

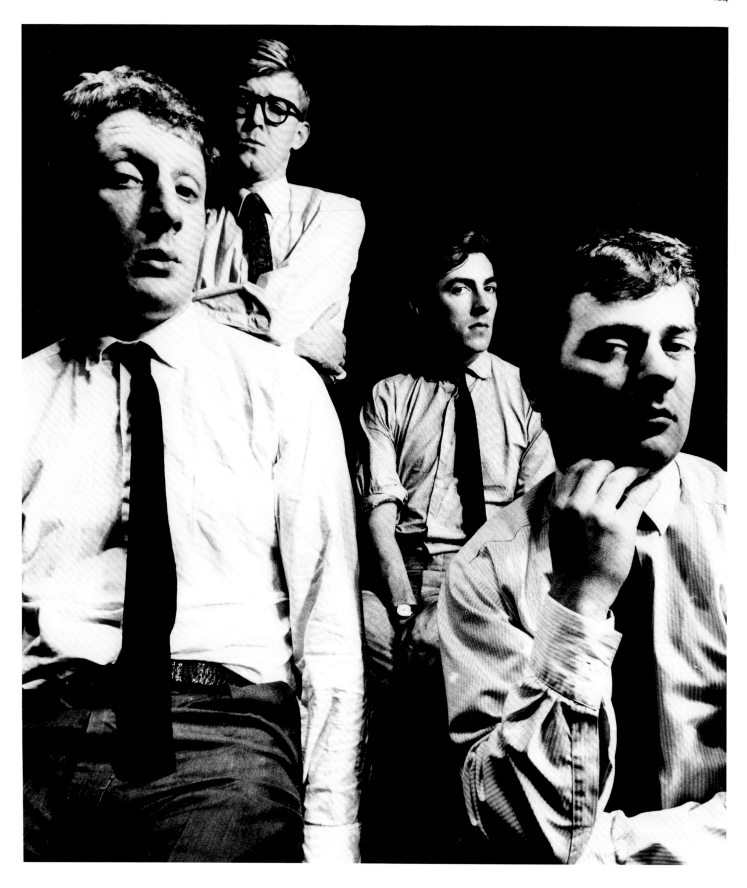

Jonathan Miller, Alan Bennett, Peter Cook, and Dudley Moore. 1961

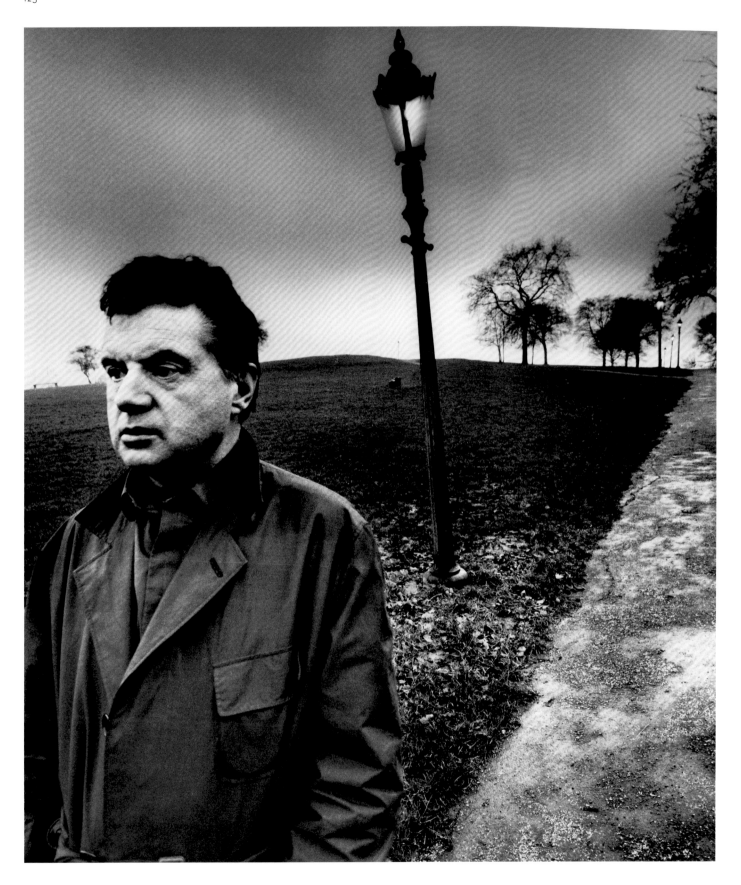

Francis Bacon Walking on Primrose Hill, London. 1963

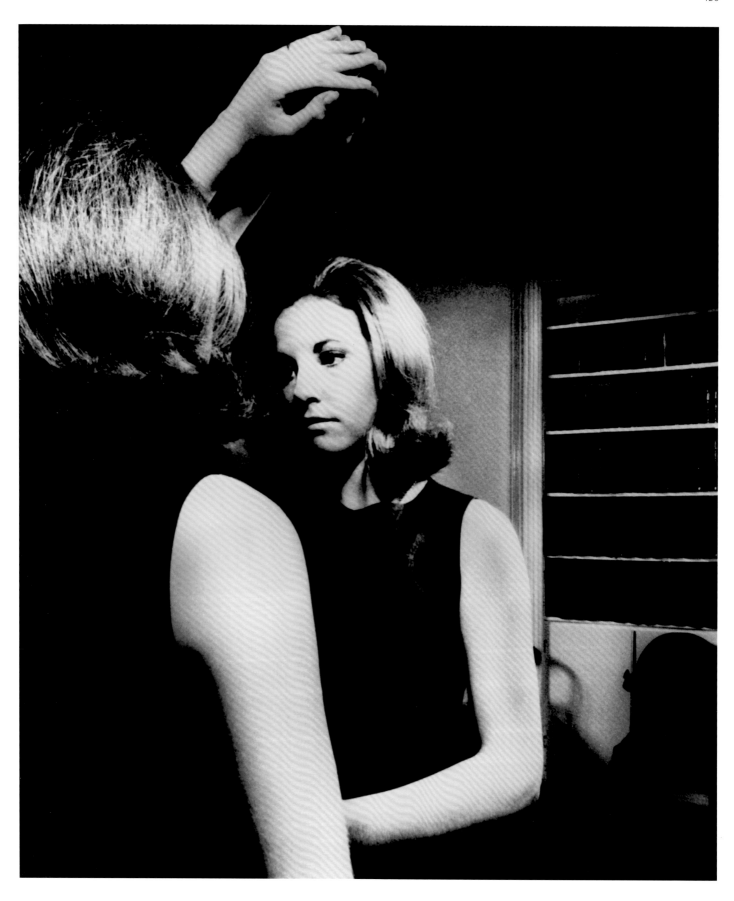

Jane Hamilton, London. 1966

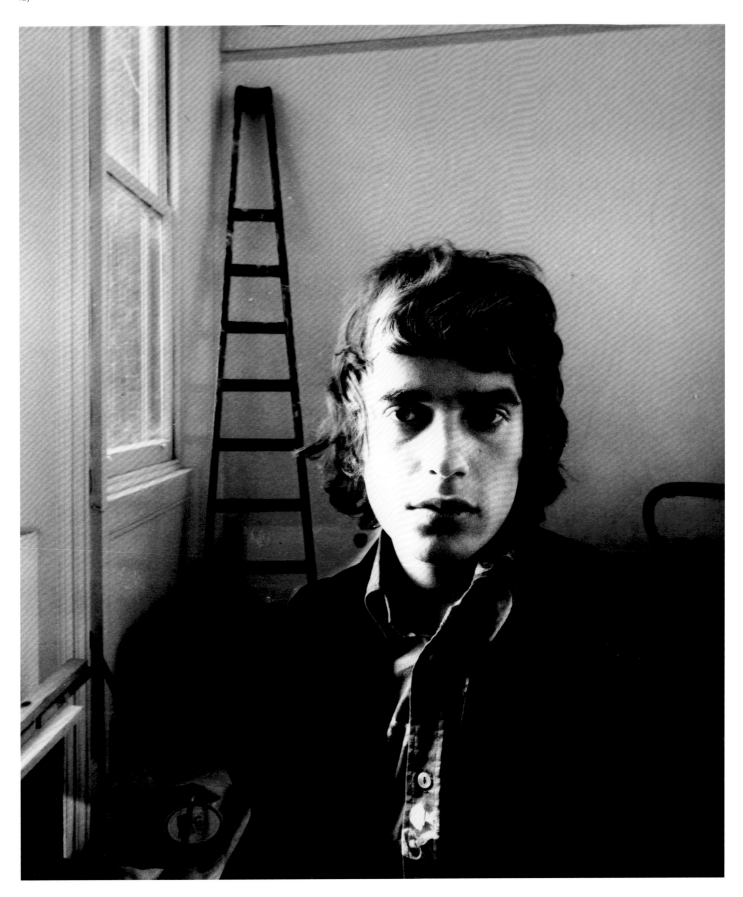

Martin Amis. 1974

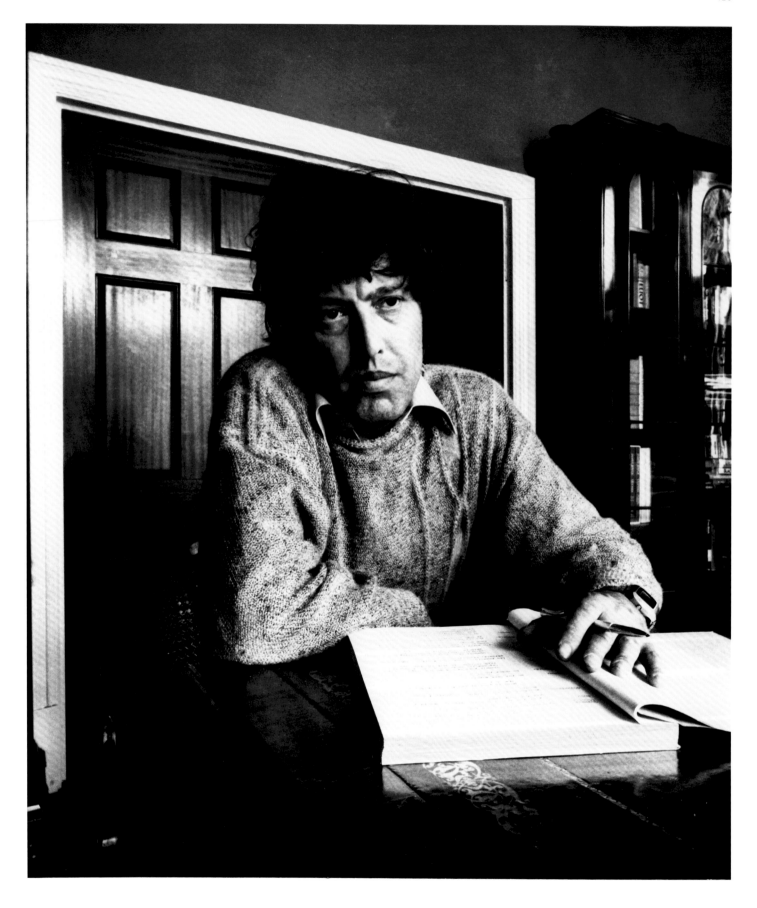

Tom Stoppard. 1978

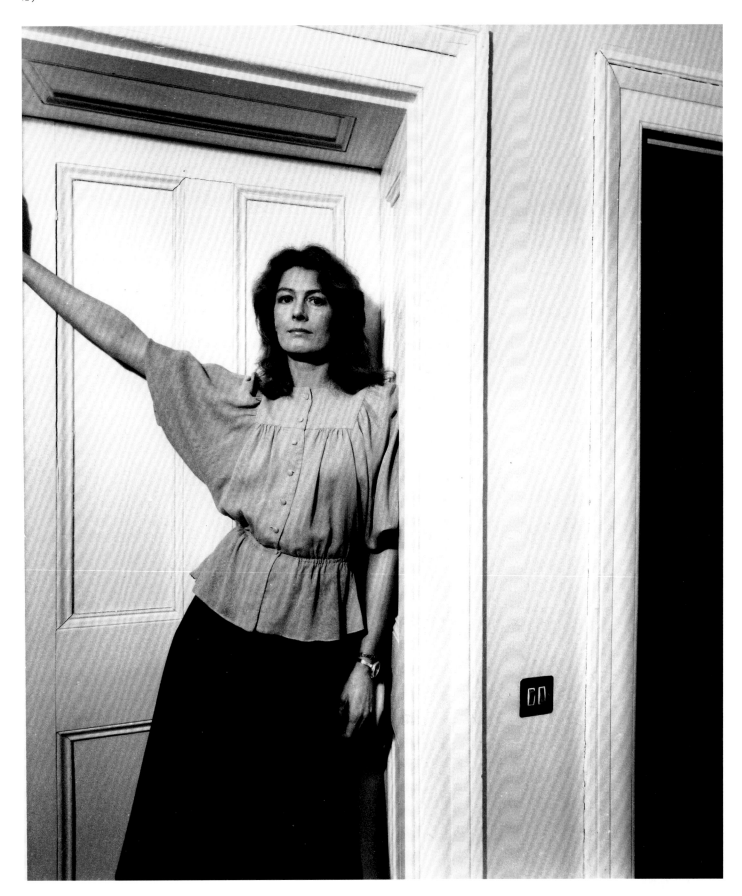

Vanessa Redgrave, London. 1976

Brandt's engagement with the English landscape was another significant factor in establishing his reputation as a distinctly British photographer. As with his portraits, Brandt's interest in landscape seems to have been piqued by assignments for *Lilliput* and *Picture Post* during World War II, in particular the photographs he made in 1943 of the massive fortified wall built by the Roman emperor Hadrian that stretched the width of the island, which seems to have kindled a spark in his imagination.[1]

It was *Lilliput* that first afforded Brandt the opportunity to express his interest in British literature through landscape. The first of these stories, "Bill Brandt Visits the Brontë Country," includes several pictures that reveal a deep sensitivity to the untamed territory described in Emily Brontë's *Wuthering Heights*, published almost exactly a century earlier.[2] The jumble of gravestones that envelop the Haworth Churchyard, just beside the Brontë family home, reinterprets a motif that Brandt enjoyed from the beginning of his career—a pattern of surfaces, slick with rain.[3] The success of this hybrid literary-and-landscape assignment led to assignments to photograph "Thomas Hardy's Wessex" (May 1946) and "The Poet's Crib" (March 1948), which featured the birthplaces of eight English poets.

In 1950, the publishers Cassell and Company approached Brandt about the possibility of producing a book that celebrated the great English writers as part of the Festival of Britain, scheduled for the summer of 1951 to further encourage recovery in the aftermath of the war. The result, *Literary Britain*, reproduced Brandt's photographs full-page, each accompanied by a brief biography of a particular luminary in the British literary canon or an excerpt of writing. The choice of text and the introduction fell to John Hayward, whose familiarity with English literature was likely unparalled. Hayward took pains to emphasize that the photographs were not meant as illustrations to the text, as might have commonly been assumed, but the other way around: "This book is a collection of such photographs … [whose] purpose, so it seems to me, is to transcend mere representation of their subject and to arouse, through association and memory, a deeper response in those who are disposed to study and enjoy them in the mind's eye."[4] Many of these pictures had been previously published in *Picture Post* or *Lilliput*, but this new context presented the images singly, marking a distinct break from the narrative sequences of Brandt's prewar books and the thematic constructs of his wartime picture stories.

5

Landscapes

1 "The Threat to the Great Roman Wall," *Picture Post* 21, no. 4 (October 23, 1943): 12–15. A reproduction of an unpublished image from this story appears here on page 102.

2 The story appeared in *Lilliput* 15, no. 6 (May 1945): 407–14. Reproductions of images from this story appear here on pages 132, 139, and 140.

3 See, for example, *Rainswept Roofs* (p. 39), *Policeman in Bermondsey* (p. 52), and *A Snicket in Halifax* (p. 71).

4 John Hayward, introduction to *Literary Britain* by Bill Brandt (London: Cassell and Company, Ltd., 1951), ix.

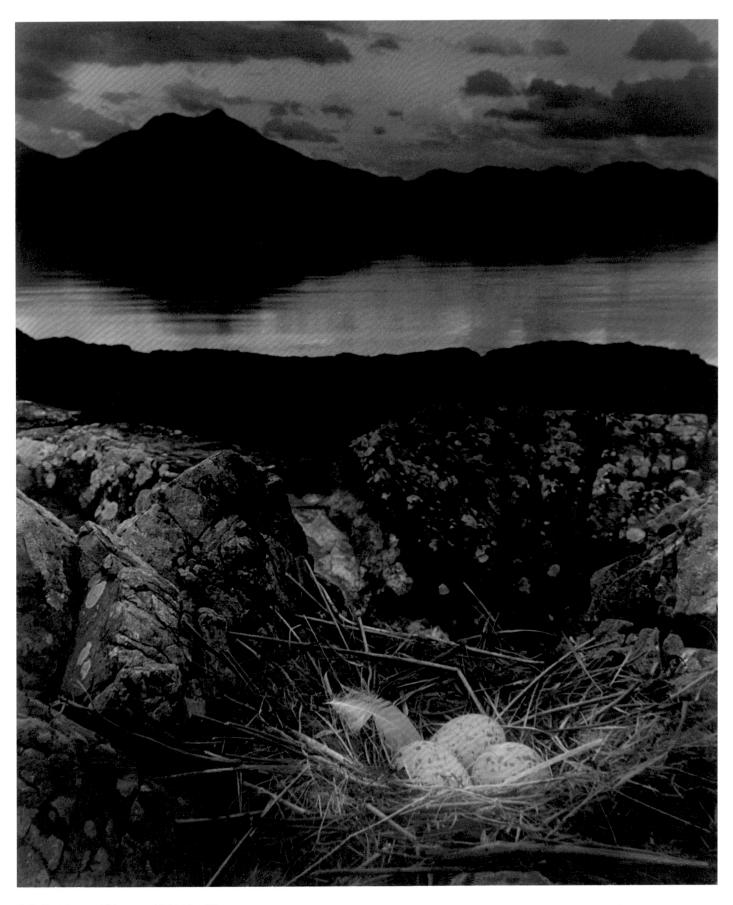

Gull's Nest, Late on Midsummer Night, Isle of Skye. 1947

Top Withens. 1945

Avebury Stone Circle, Wiltshire. 1945

Loch Fada, Trotternish, Skye. 1947

Marlborough Downs, Wiltshire. 1948

Barbary Castle, Marlborough Downs, Wiltshire. 1948

Lord MacDonald's Forest, Skye. 1947

Giant's Causeway, Antrim. 1946

Haworth Churchyard. 1945

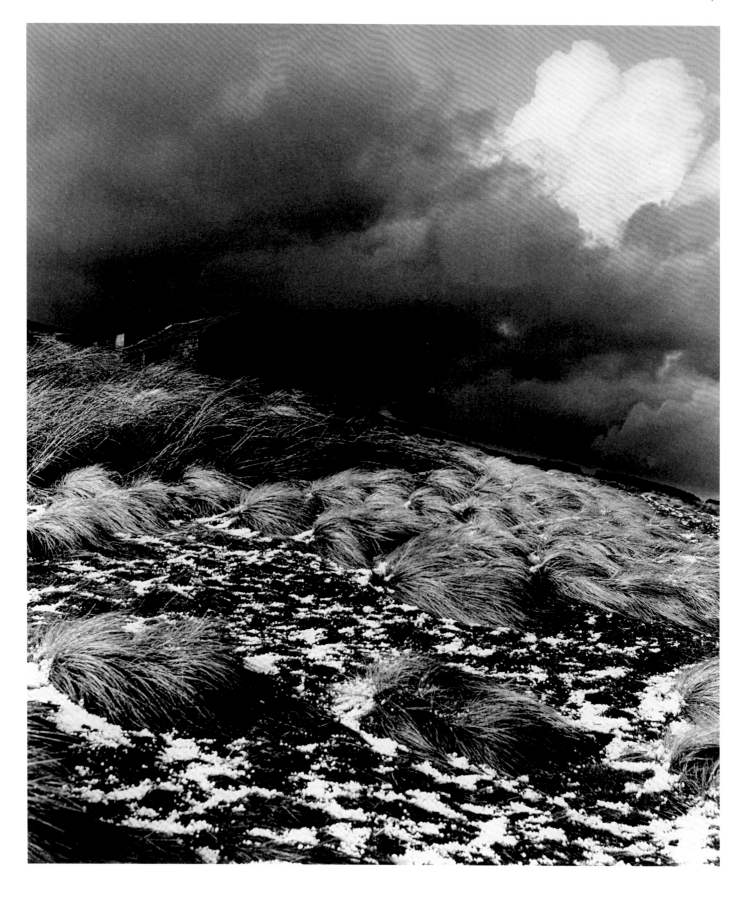

Top Withens, West Riding, Yorkshire. 1945

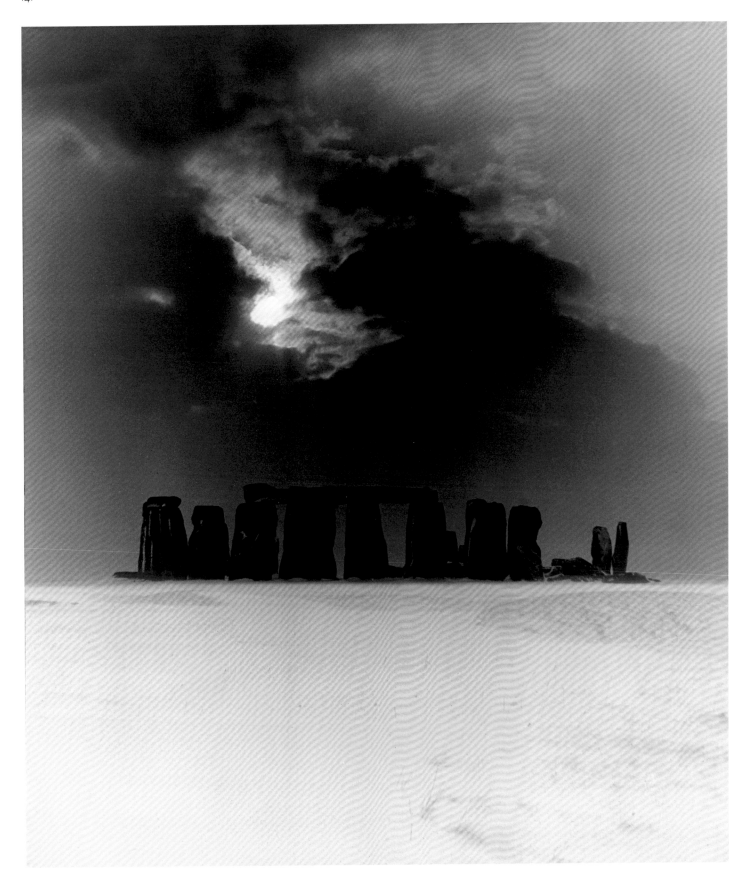

Stonehenge under Snow. 1947

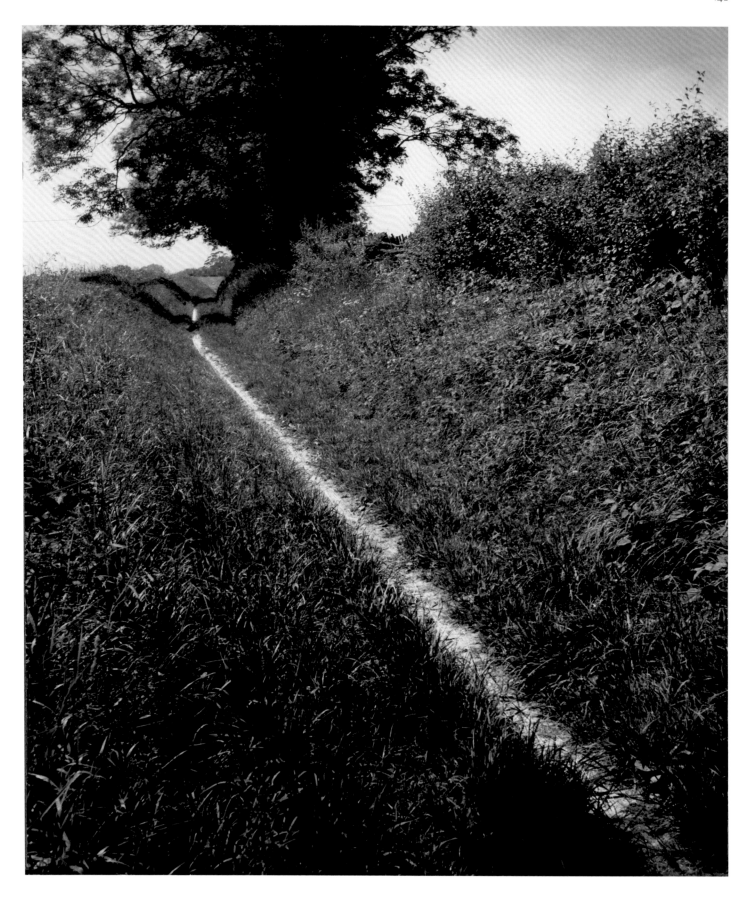

The Pilgrim's Way, Kent. 1950

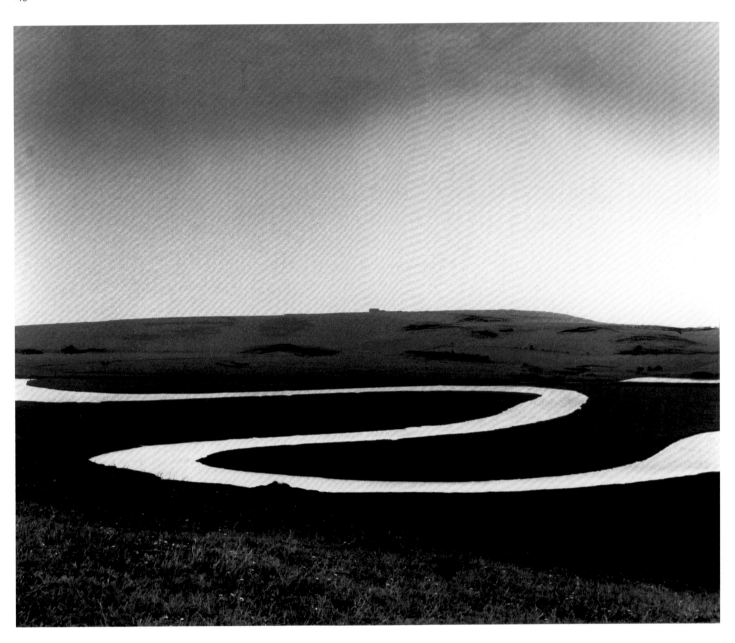

Cuckmere River, Sussex. 1963

If it was Brandt's images of London in the 1930s that established his reputation as a photographer, it was the series of nudes he made in the decades after the Second World War that solidified his reputation as an artist. The disembodied breasts, knees, and elbows are at once sensuous and surprisingly chaste, as if the female form were needed for its graphic beauty, its gender almost accidental. Lawrence Durrell described this quality when he wrote, "one forgets the human connotation as if one were reading a poem."[1] For all their flesh, these nudes are not about desire, although they flirt with fetish. There is an ambivalence that is typical of Brandt, concerned with neither passion, love, nor hate.[2] Their position in the history of the genre is unique.

Brandt made a handful of female nudes before *Lilliput* published his first in February 1942, but these adopt tropes that Man Ray (and others) had explored in the late 1920s. The earliest works that Brandt chose to include in his groundbreaking *Perspective of Nudes* (1961) date from 1945 and feature nudes in incongruously domestic interiors at twilight. With a large, wide-angle, fixed-focus mahogany-and-brass Kodak camera designed to inventory estates and crime scenes, Brandt placed his models in a Victorian wonderland, delighting in his camera's ability to present the world in a way the eye could not see. He then moved closer—the space and the figures become more distorted, and one senses a disquieting proximity when one recalls these are, in fact, pictures of real women. Finally, in the late 1950s Brandt found that he could use his "modern" camera to achieve his desired effects on the rocky beaches of England and France.[3]

On the occasion of the retrospective he organized of Brandt's work in 1969, John Szarkowski wrote of the nudes: "These pictures—at first viewing, strange and contorted—reveal themselves finally as supremely [poised] and untroubled works.... In photography only Edward Weston has made nudes of equal power. A comparison is instructive. The models in Weston's pictures retain a degree of their identity; they remain, in part, specific women seen in the sunlight of specific fine mornings. Brandt's late nudes in contrast seem to be no women and all women, as anonymous and as moving as a bleached and broken sculpture, fresh from the earth."[4] This reference to the sculptural quality of Brandt's nudes is an apt one. The connection between Brandt and Henry Moore was first established by their shared fascination with sleeping figures in the makeshift underground shelters during the Blitz, and their friendship grew from there. Brandt photographed the sculptor more than any other artist, and the resonance between their biomorphic forms in two and three dimensions enhances the appreciation of both artists' work.

6

Nudes

1 Lawrence Durrell, preface to *Perspective of Nudes* by Bill Brandt (London: The Bodley Head; New York: Amphoto, 1961), 5.

2 Brandt's late nudes, made between 1977 and 1980, which are not included here, might be considered an exception.

3 In *Perspective of Nudes*, Brandt arranges his images into six loosely thematic suites, but with few exceptions, his work from this fifteen-year period can be distilled into the three groups described here.

4 John Szarkowski, "Bill Brandt," in *The Museum of Modern Art Members Newsletter*, Fall 1969, n.p. This piece was republished along with sixteen photographs chosen by Brandt in *Album*, no. 1 (February 1970): 12–13.

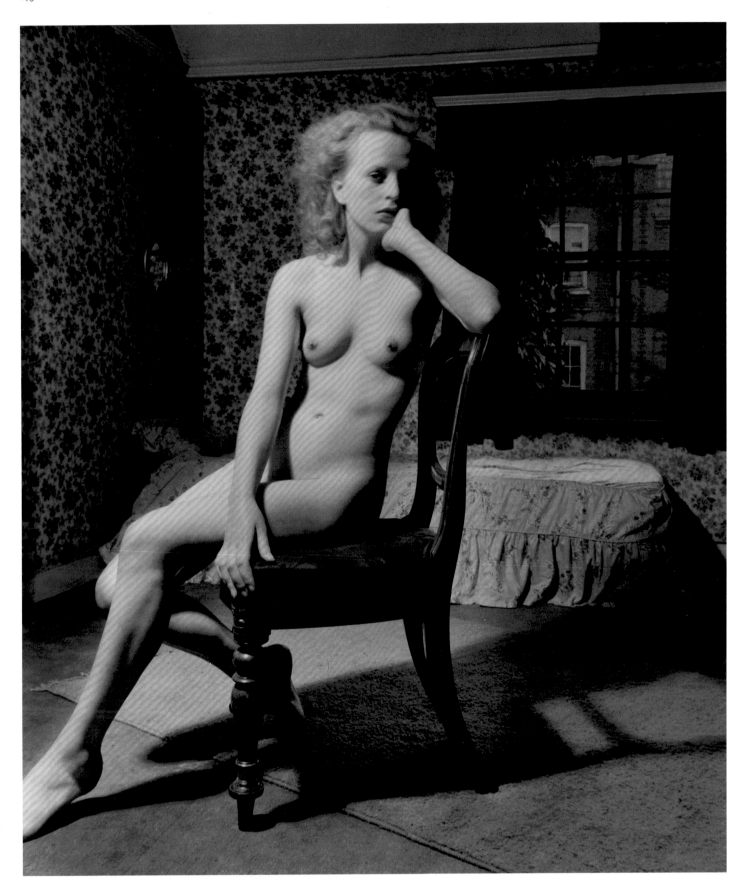

Hampstead, London. 1945

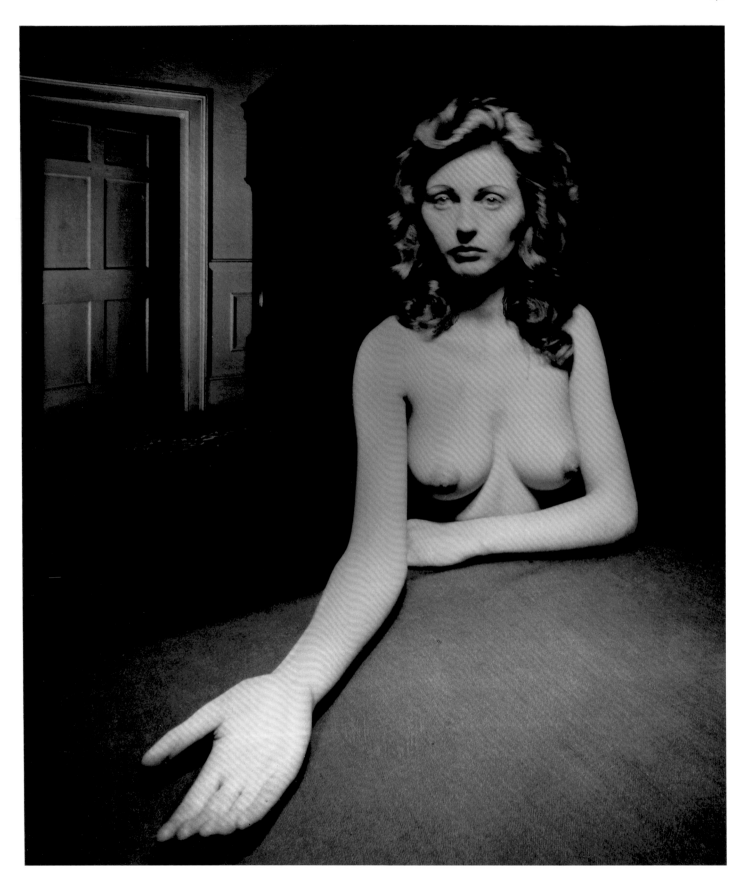

Micheldever, Hampshire. 1948

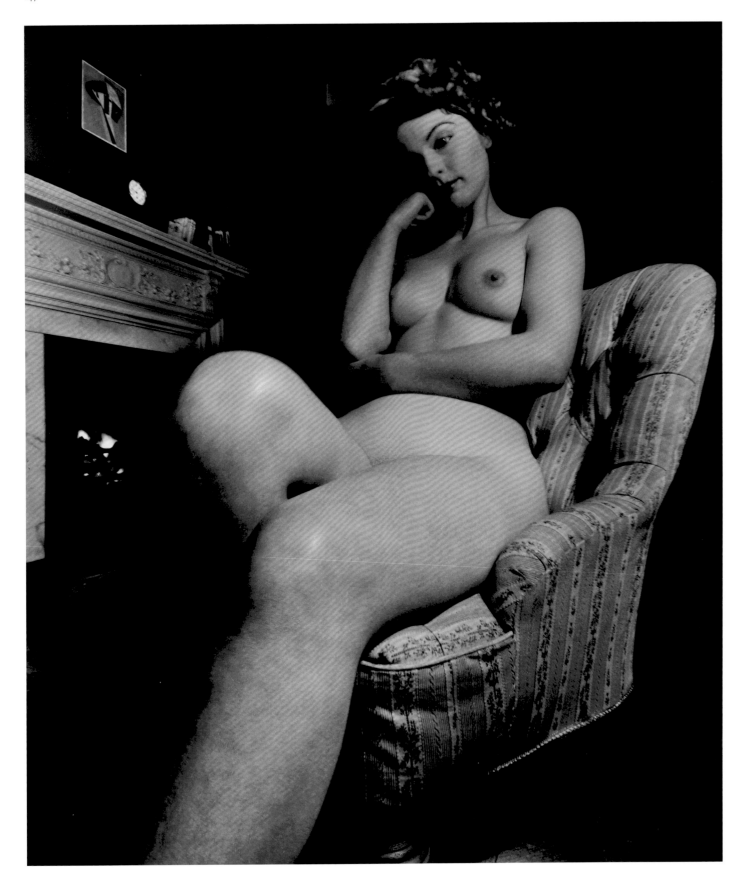

Nude. 1953

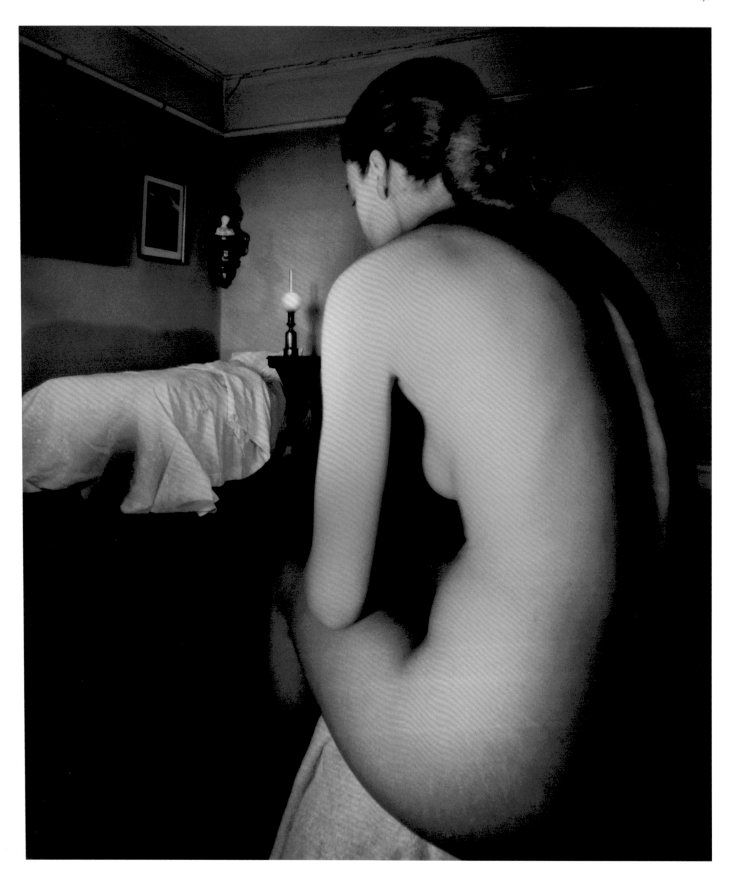

Campden Hill, London. 1949

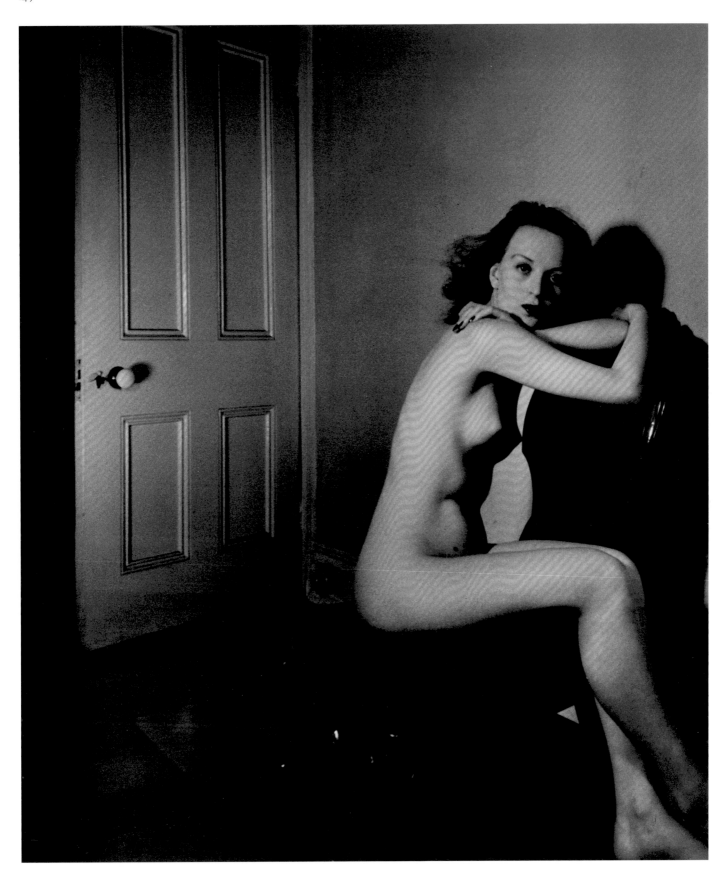

London. c. 1948

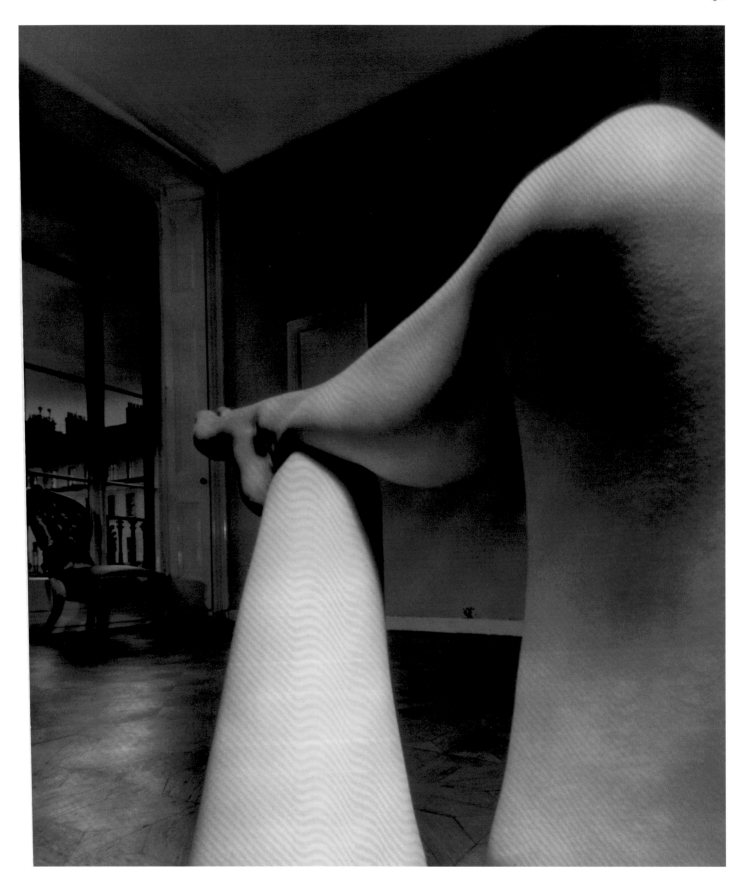

Belgravia, London. 1951

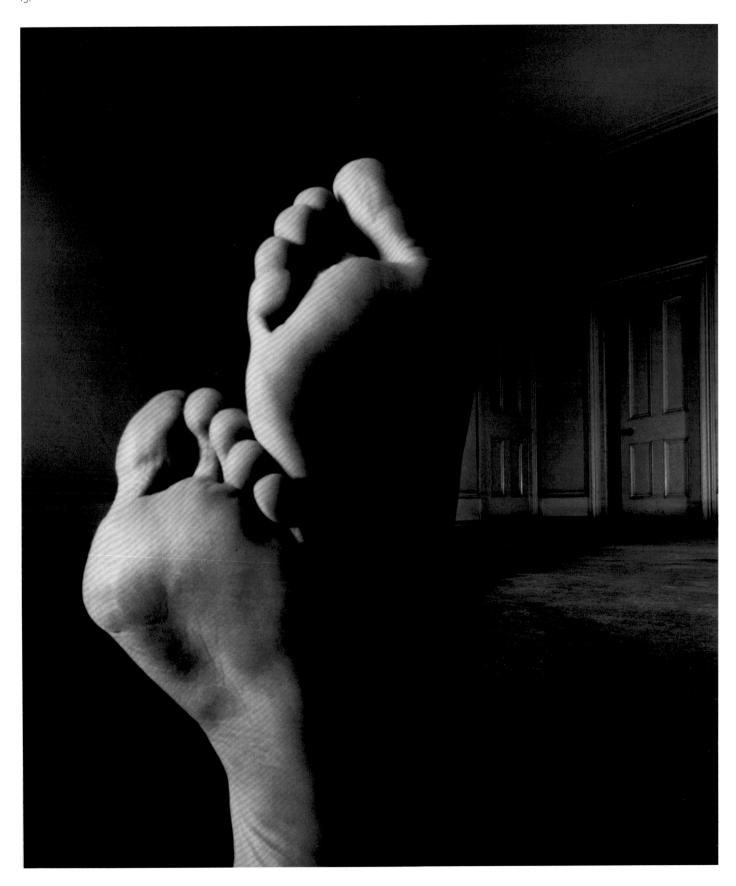

Hampstead, London. 1952

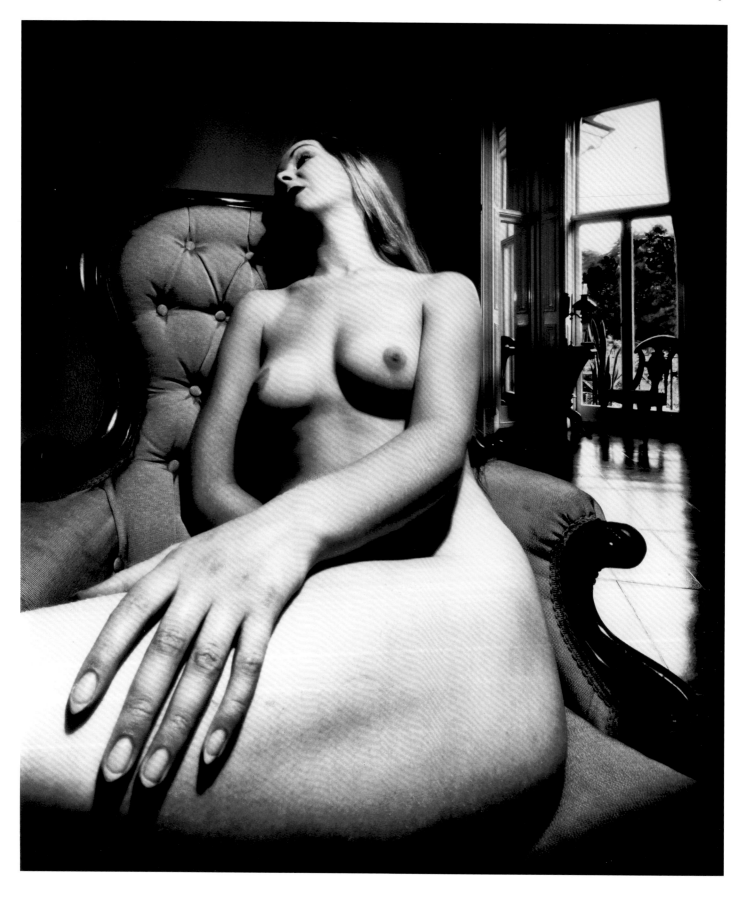

Campden Hill, London. 1953

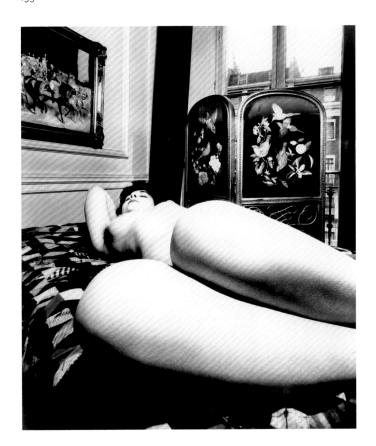 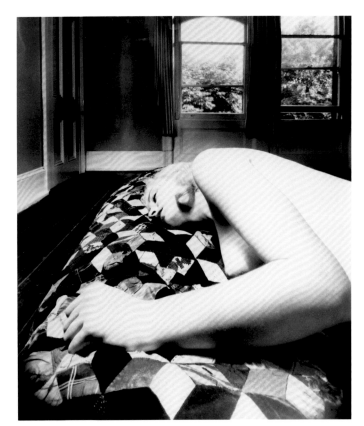

Campden Hill, London. 1955 Hampstead, London. 1955

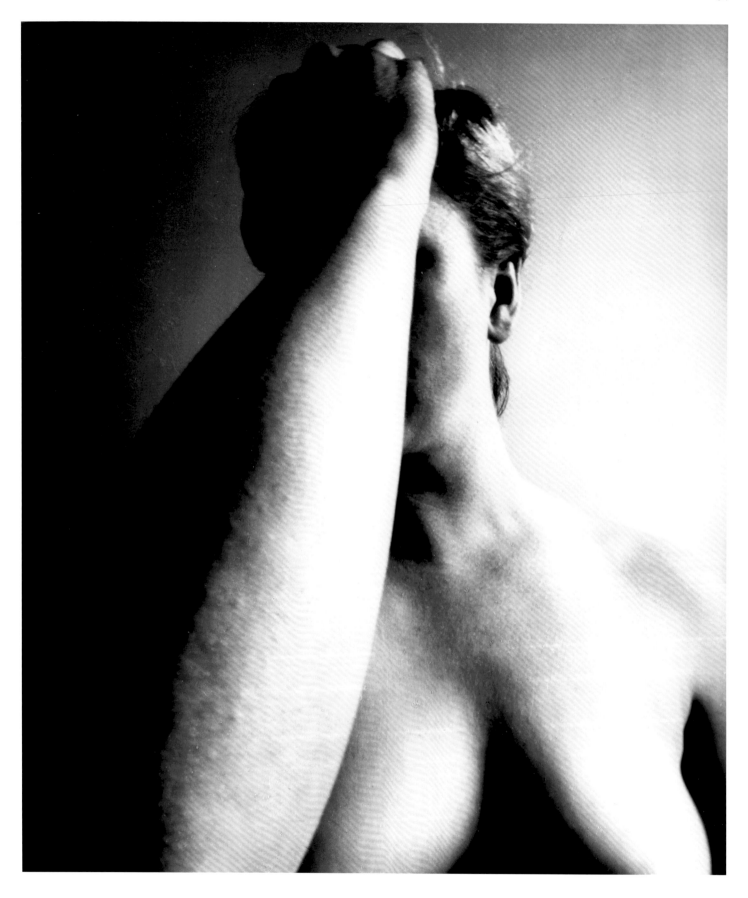

London. 1953

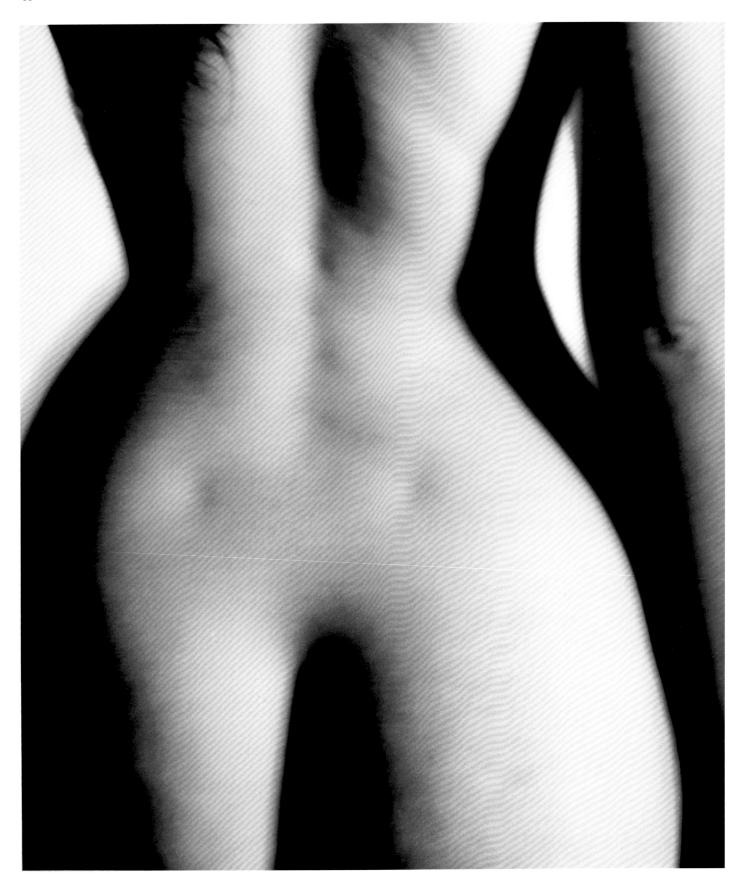

London. 1956

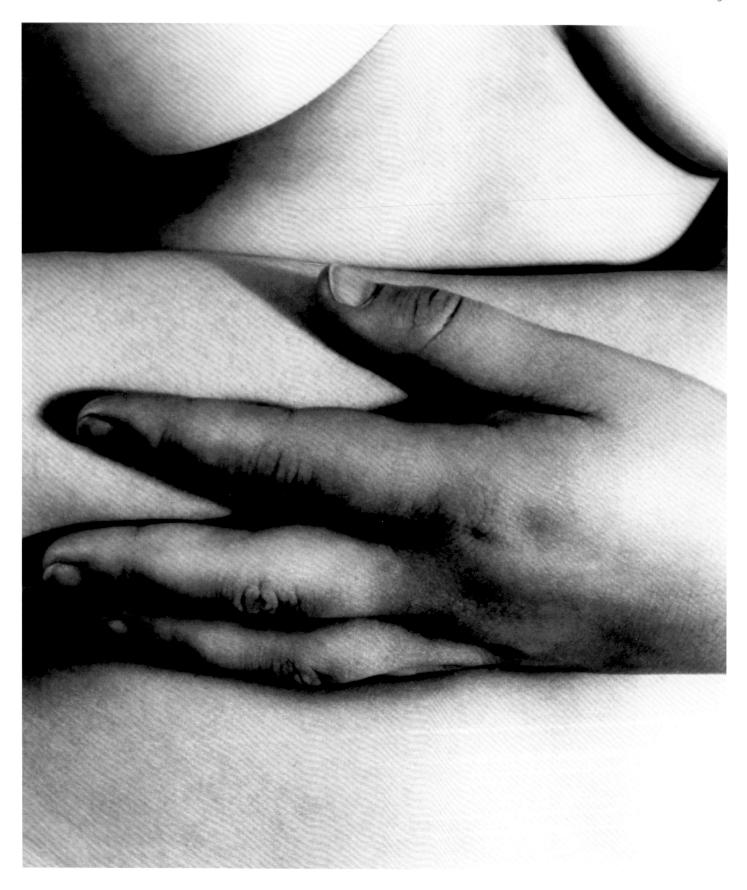

London. 1954

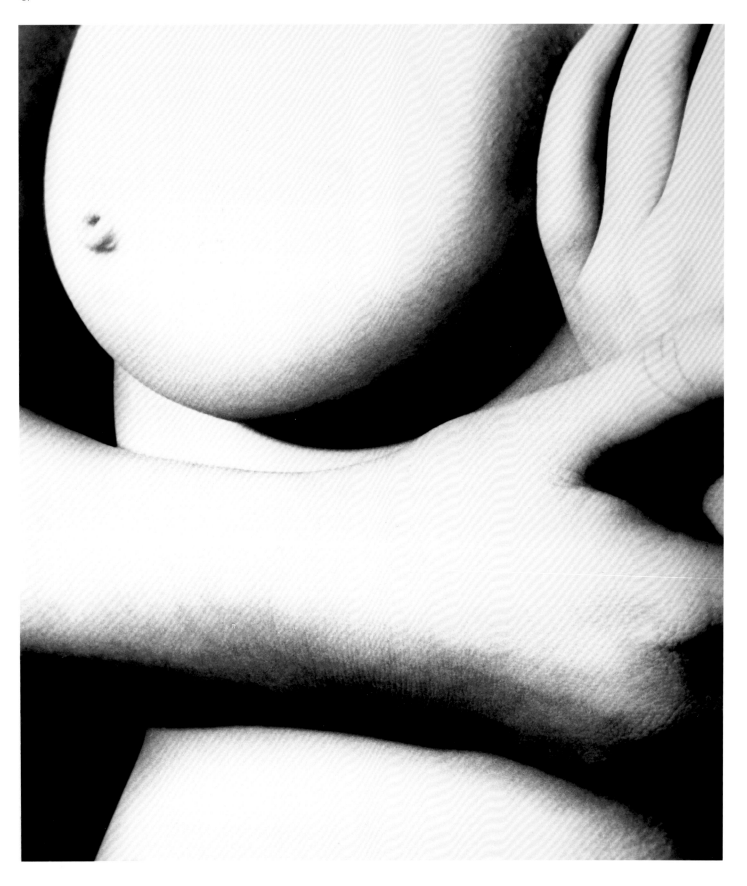

London. 1957

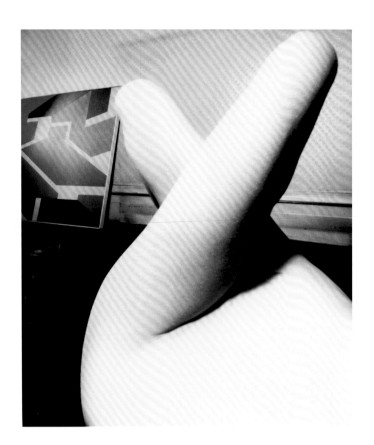

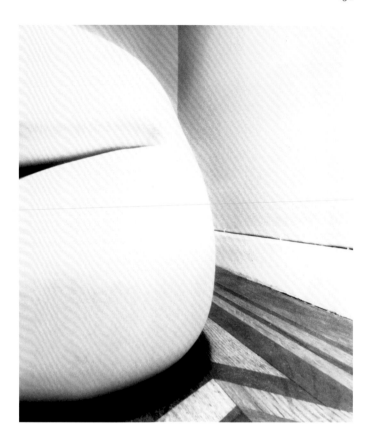

Campden Hill, London. c. 1957

Belgravia, London. 1958

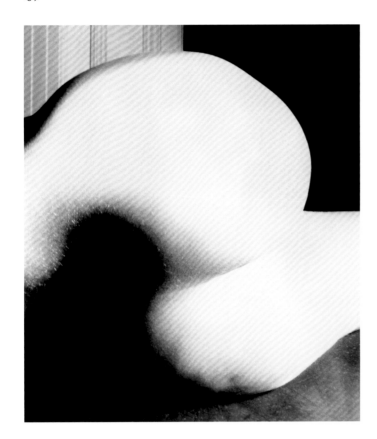

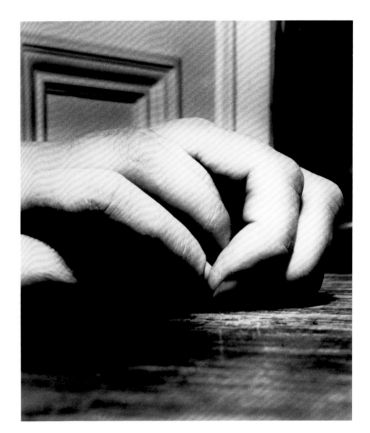

Campden Hill, London. 1957

Campden Hill, London. 1957

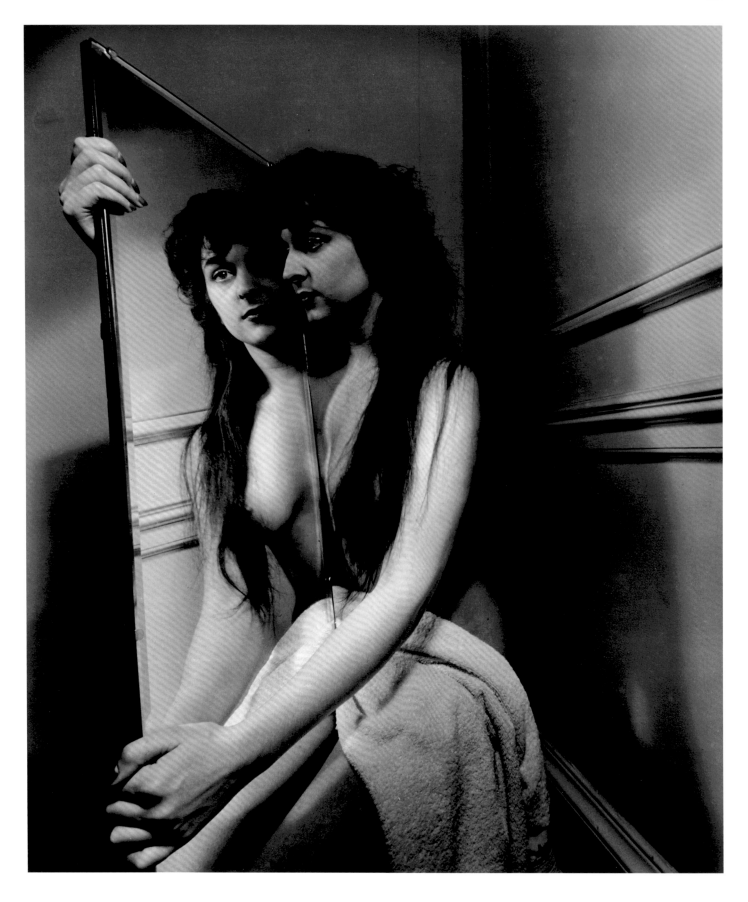

Belgravia, London. 1953

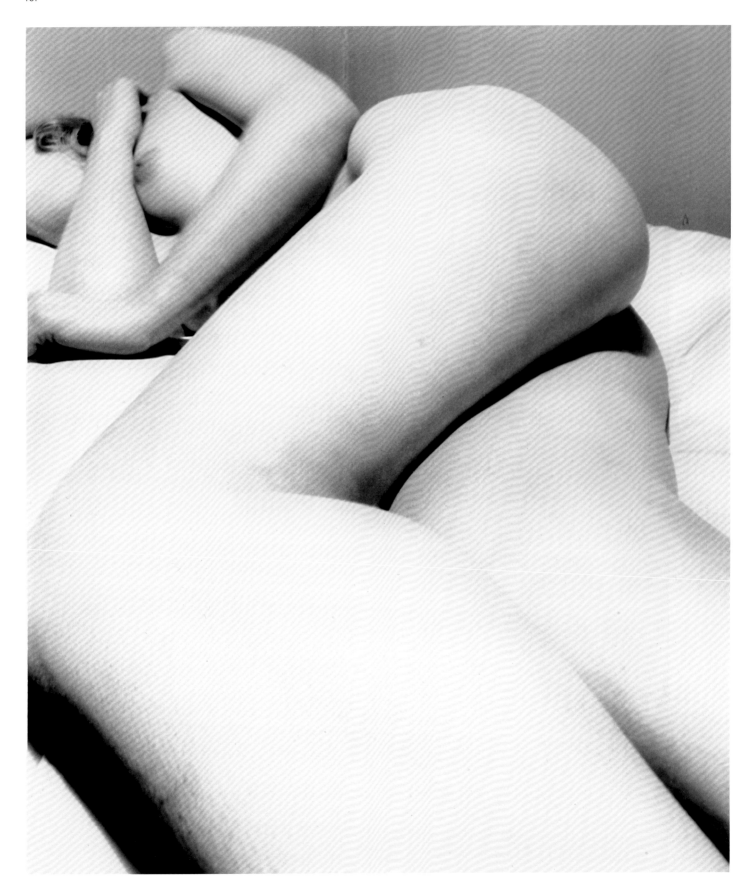

Campden Hill, London. 1956

Campden Hill, London. 1958

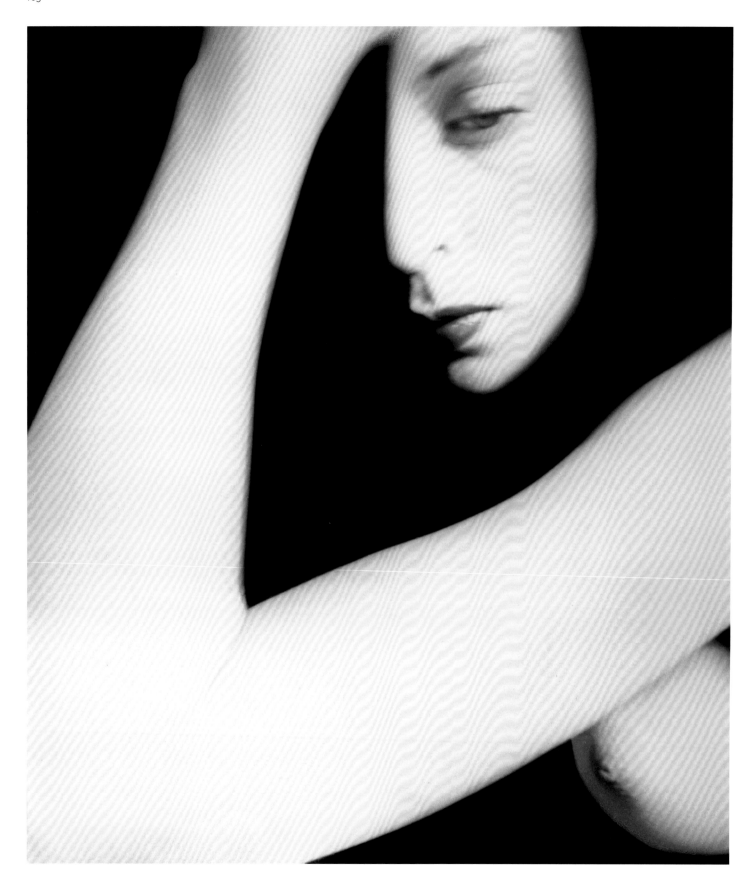

London. 1952

London. 1958

Hampstead, London. 1956

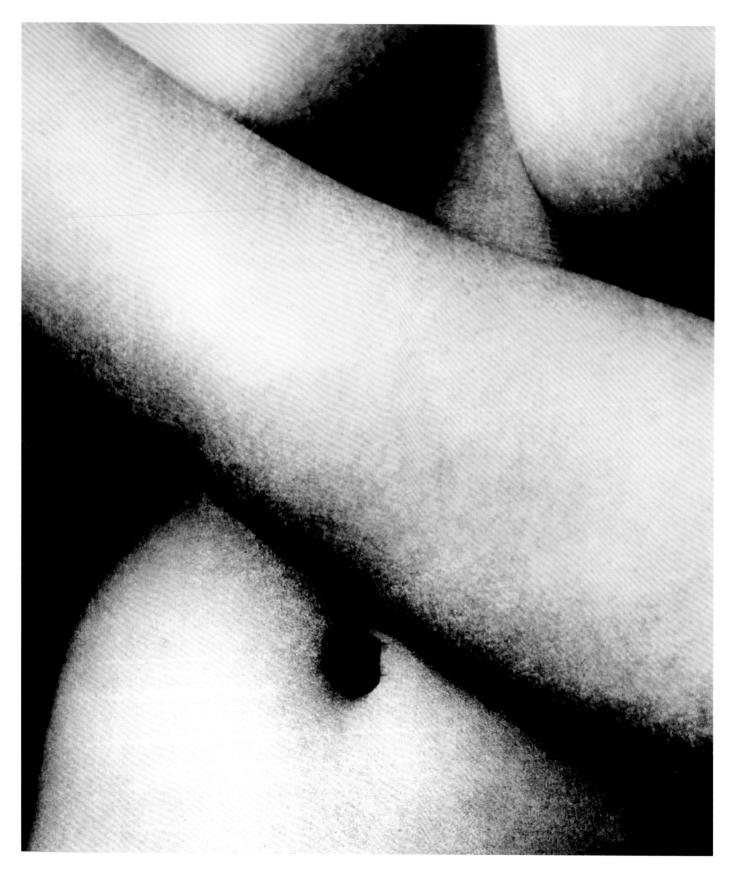

London. 1959

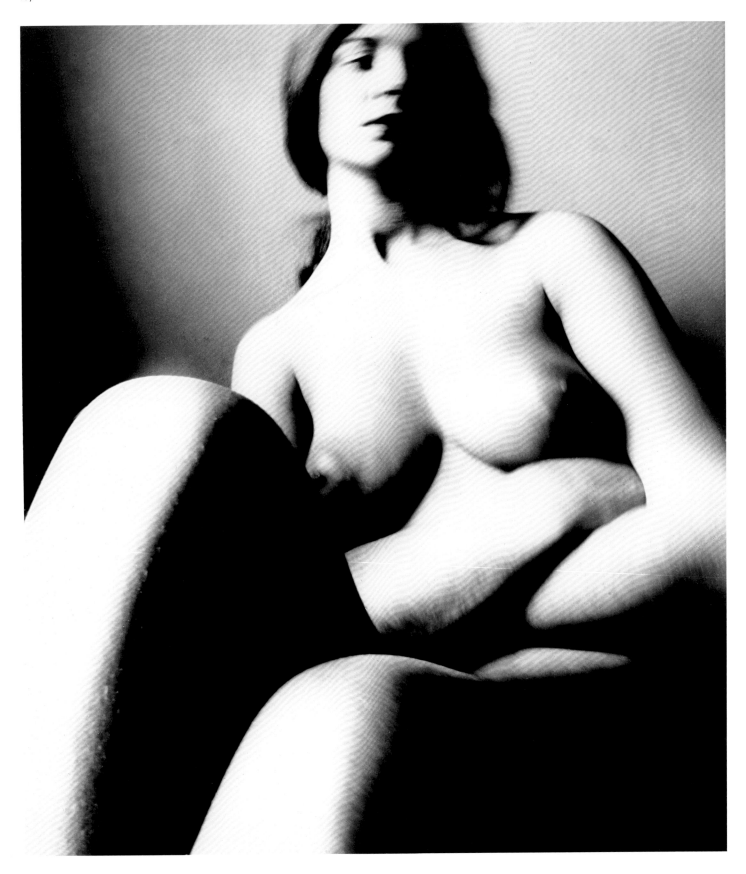

London. 1956

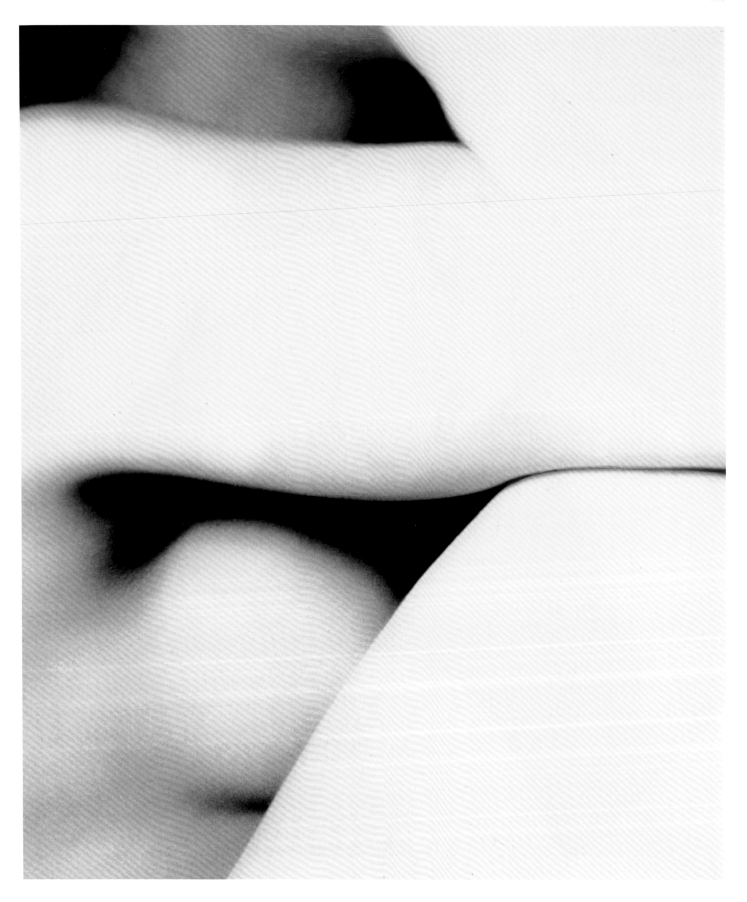

London. 1954

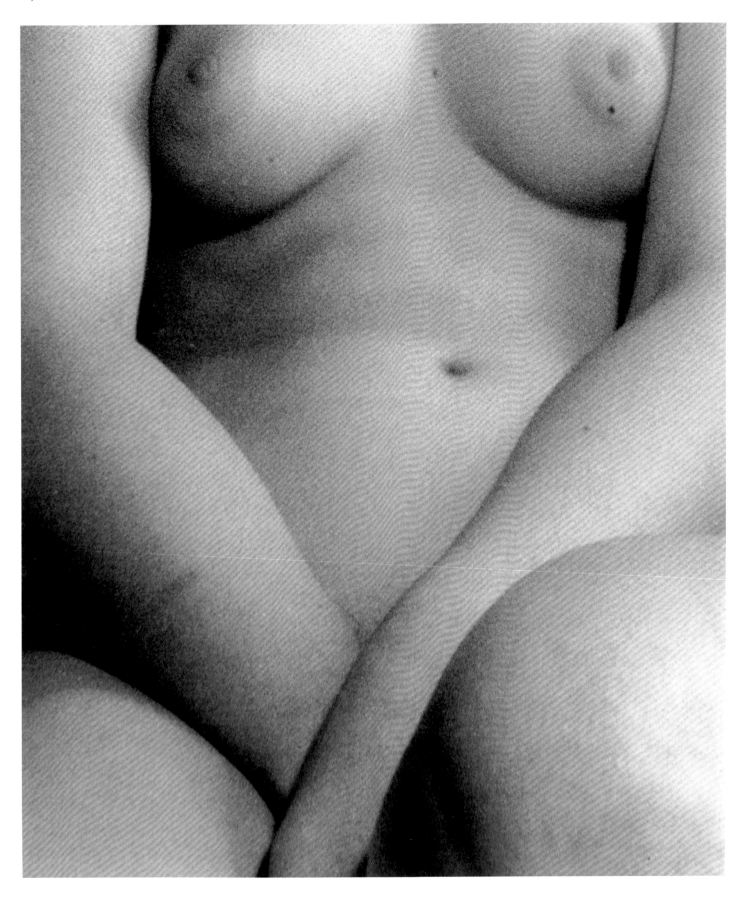

London. 1954

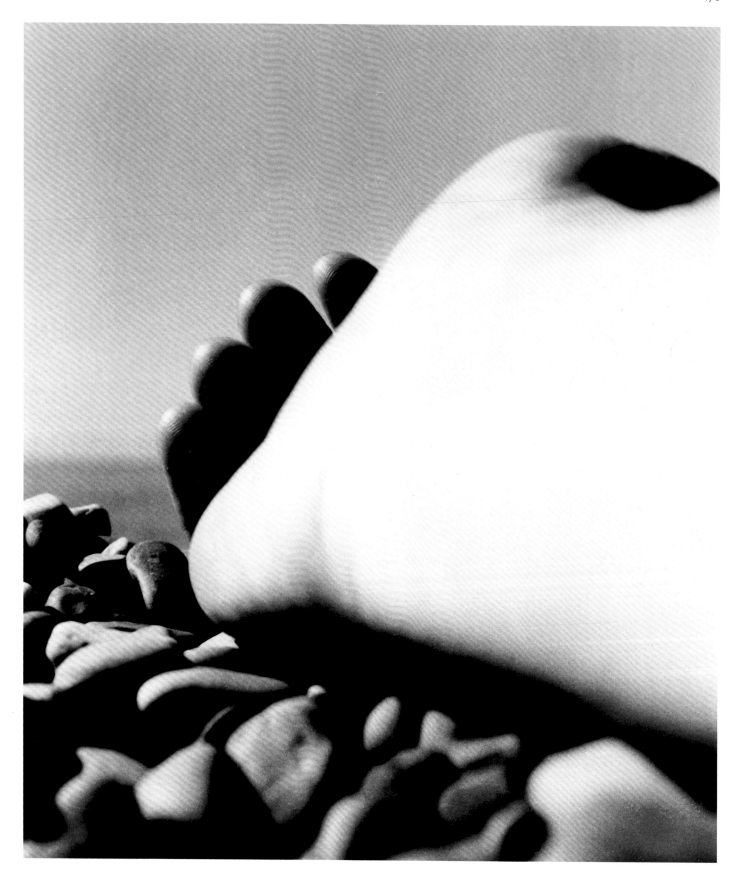

Baie des Anges, France. 1959

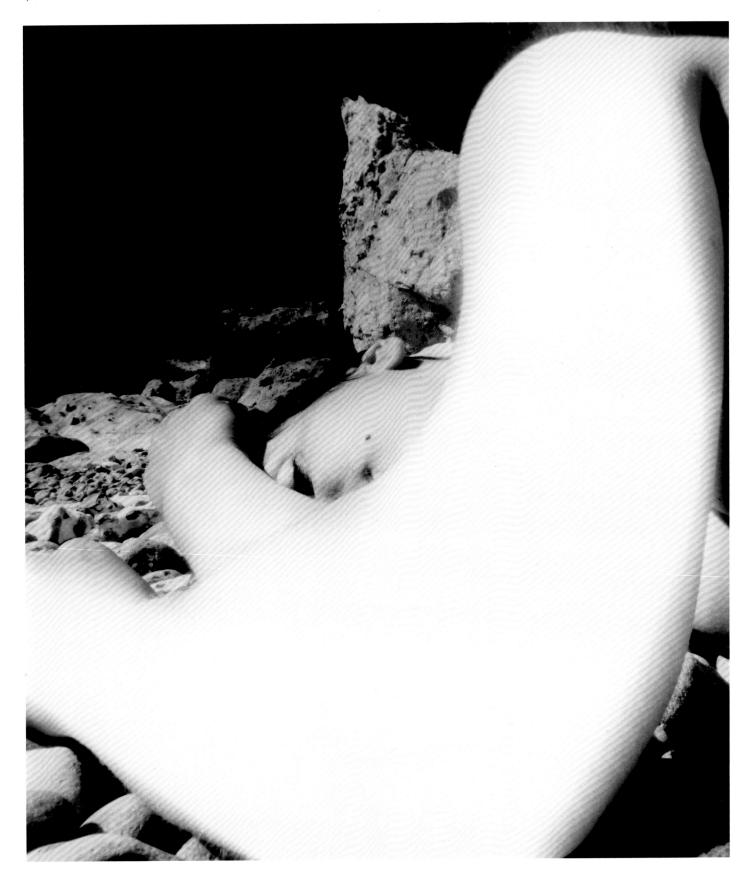

East Sussex Coast. 1957

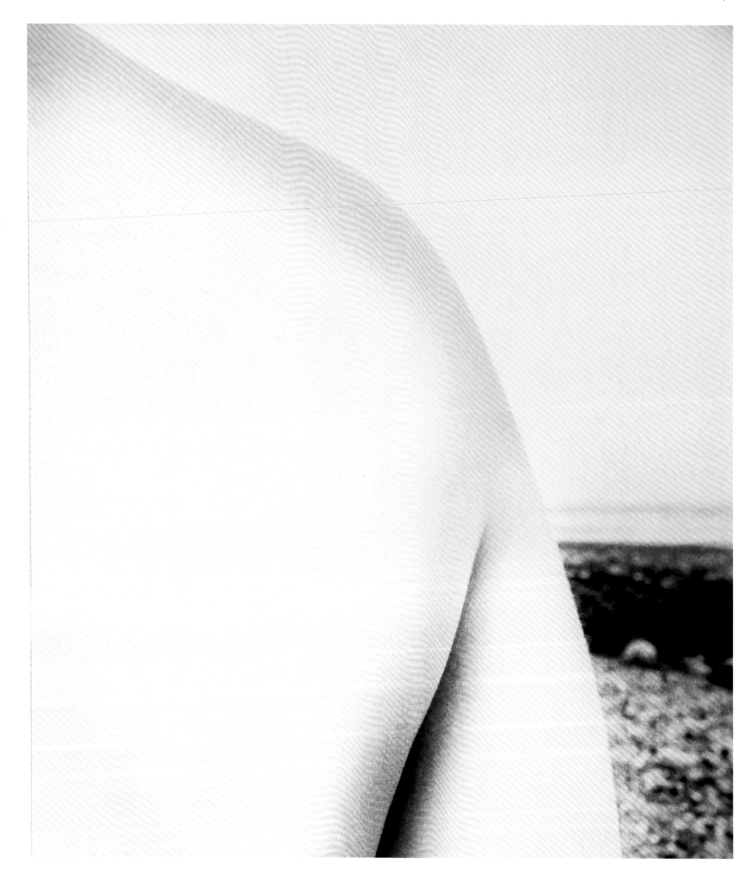

East Sussex Coast. 1959

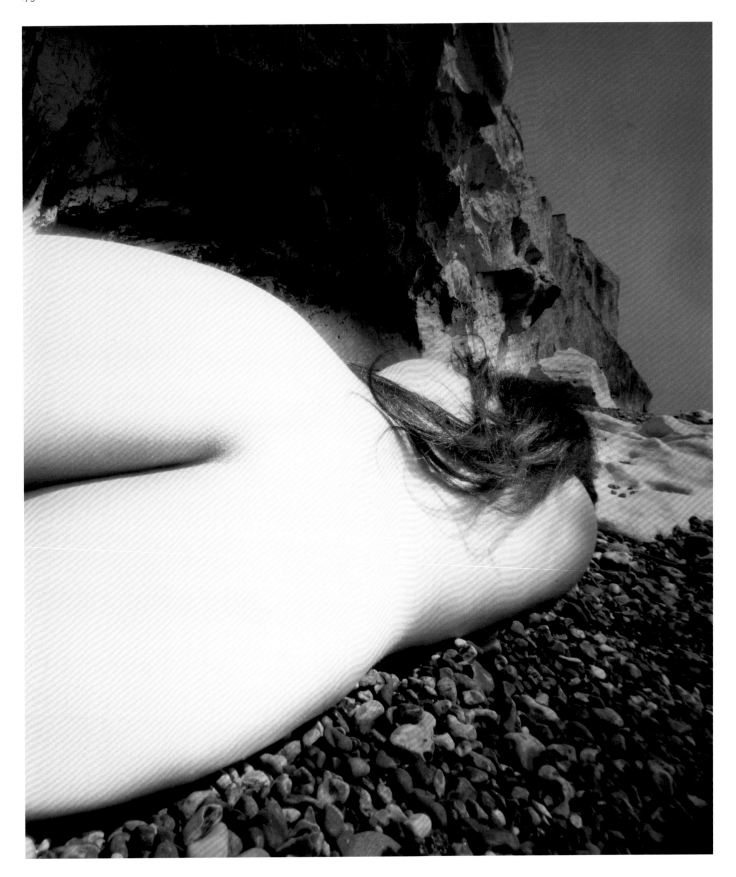

East Sussex Coast. 1953

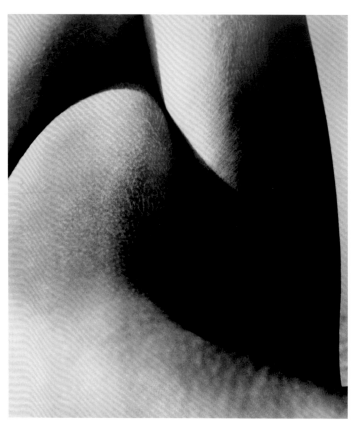

East Sussex Coast. 1958 East Sussex Coast. 1958

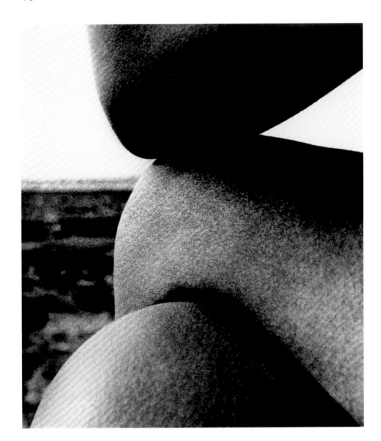

East Sussex Coast. 1959

Baie des Anges, France. 1959

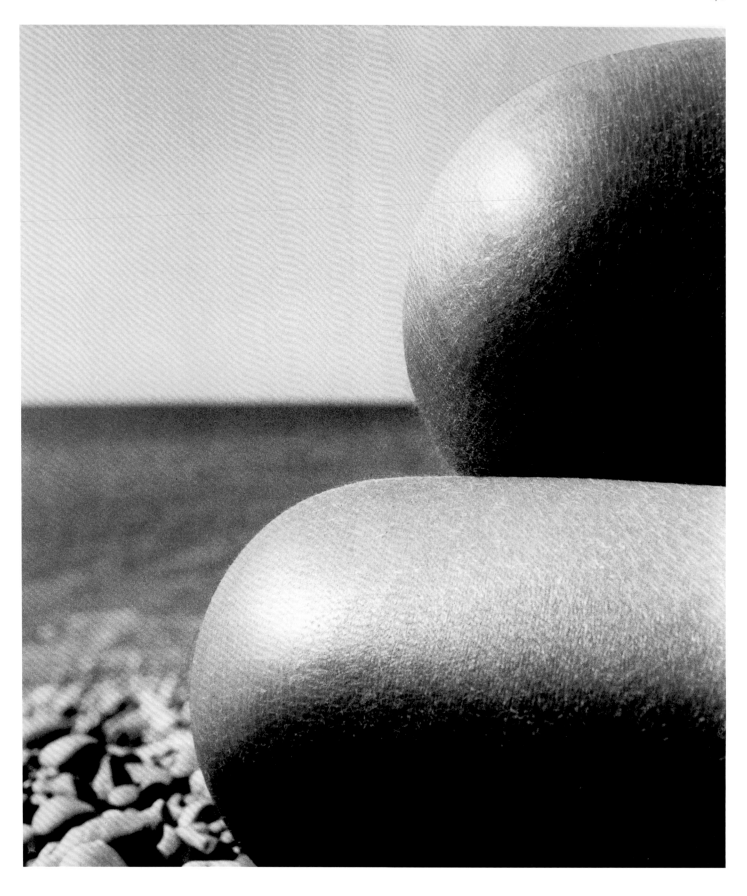

Baie des Anges, France. 1958

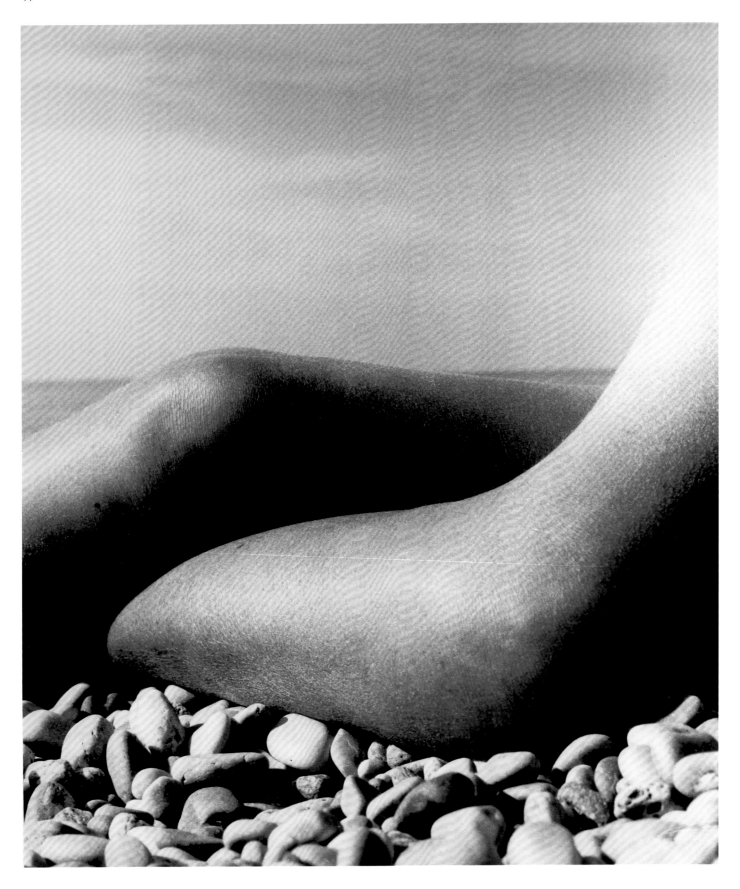

Baie des Anges, France. 1959

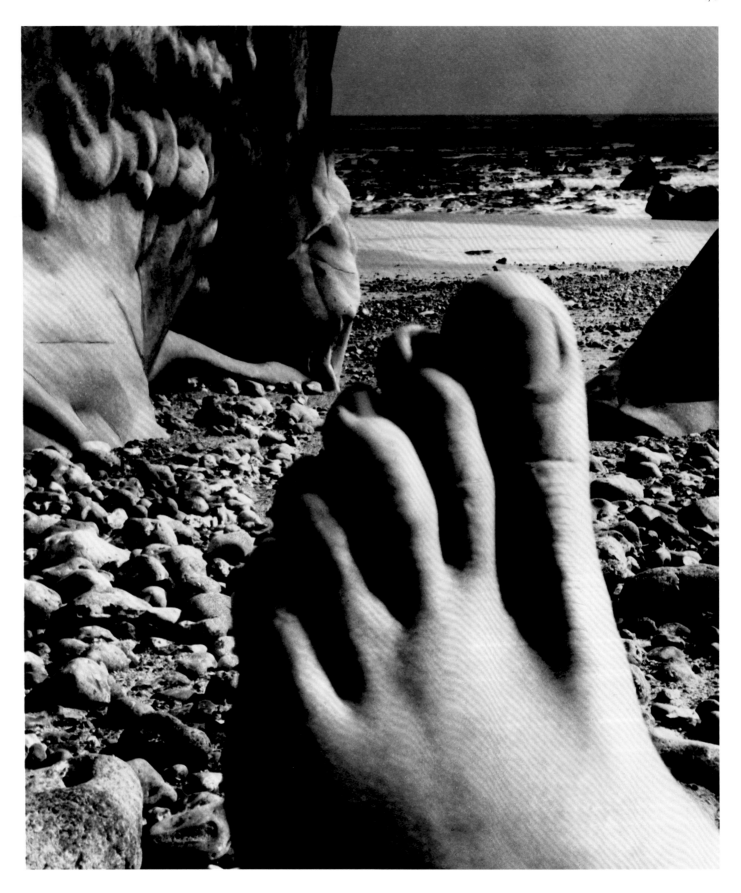

Vastérival Beach, Normandy. 1954

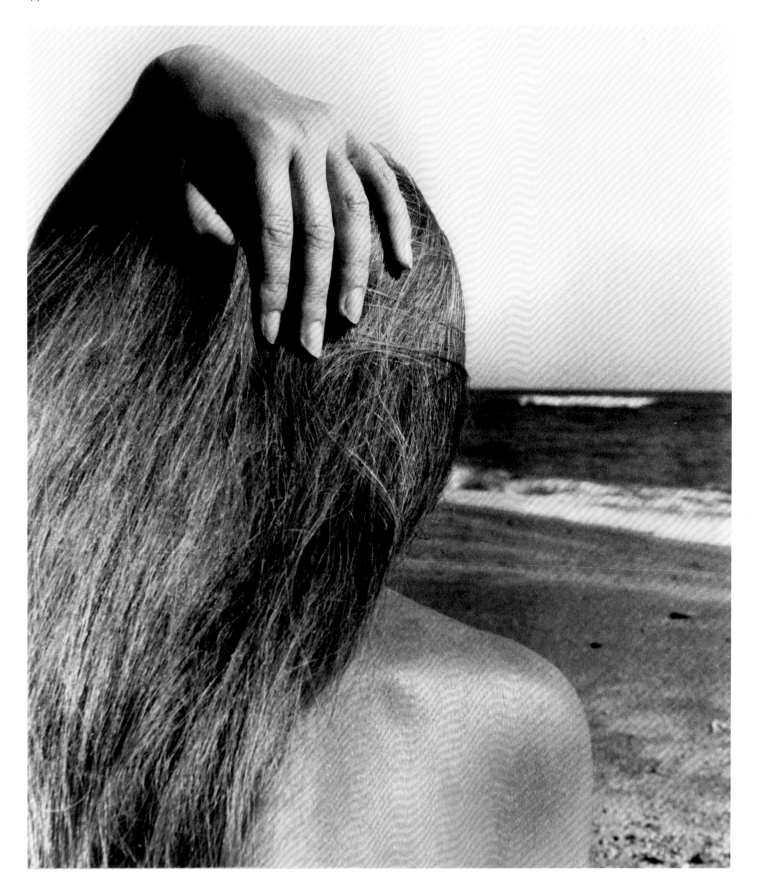

Taxo d'Aval, France. 1957

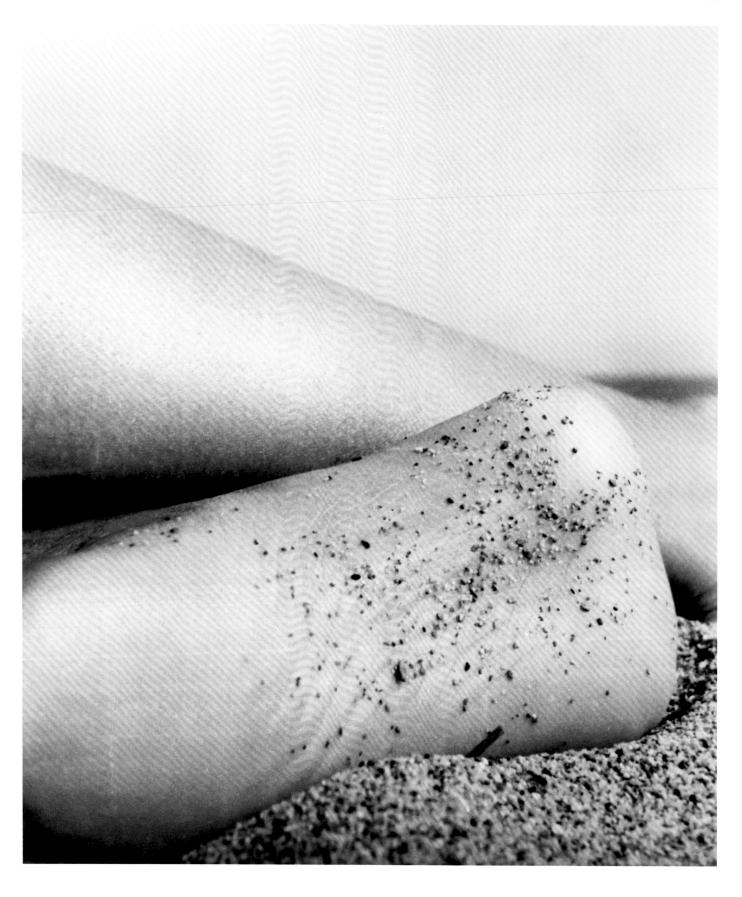

Taxo d'Aval, France. 1958

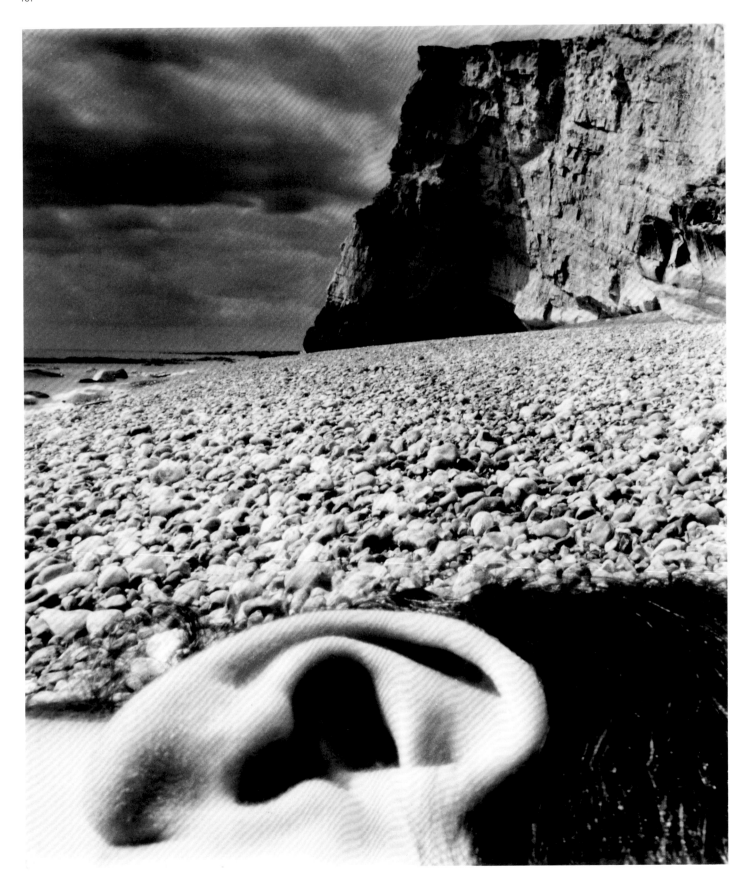

Seaford, East Sussex Coast. 1957

List of Plates

All works are by Bill Brandt and are gelatin silver prints. When a particular image was published with a significantly different title in Brandt's lifetime, the alternate title is included here. Prints made substantially later than the date of the original negative are noted and approximate dates given. In the dimensions, height precedes width.

MoMA=The Museum of Modern Art, New York
EHG=Courtesy Edwynn Houk Gallery, New York

PAGE 65
Billingsgate Porter
c. 1934
11 ¾ x 9 ¹¹⁄₁₆" (29.8 x 24.6 cm)
EHG

PAGE 66
*Prisoner in a Cell at
Wormwood Scrubs*
1939
8 ⁷⁄₁₆ x 7 ⁷⁄₁₆" (21.5 x 18.9 cm)
Hulton Archive/Getty Images

PAGE 67
Evening in Kenwood
Sunday Evening
c. 1934
Printed 1970s
9 x 7 ¾" (22.9 x 19.7 cm)
MoMA. Acquired through the
generosity of David Dechman
and Michel Mercure and the
Committee on Photography
Fund

PAGE 68
Circus Boyhood
1933
10 ¼ x 8 ¾" (26.1 x 22.2 cm)
EHG

PAGE 69
East End Morning
*Young Housewife in Bethnal
Green*
1937
9 ¹¹⁄₁₆ x 7 ¹¹⁄₁₆" (24.6 x 19.5 cm)
MoMA. Acquired through
the generosity of Richard O.
Rieger

NORTHERN
ENGLAND

PAGE 71
A Snicket in Halifax
1937
9 x 7 ¹¹⁄₁₆" (22.9 x 19.6 cm)
MoMA. Carl Jacobs Fund

PAGE 72
Halifax
1937
Printed c. 1965
9 ⅛ x 7 ¹⁵⁄₁₆" (23.1 x 20.2 cm)
EHG

PAGE 73
*Coal-Miners' Houses Without
Windows to the Street*
1937
Printed c. 1965
9 x 7 ¹³⁄₁₆" (22.9 x 19.8 cm)
EHG

PAGE 74
*A Group of Coal-Searchers
near Heworth, Tyneside;
Pithead Train in the Distance*
1937
Printed c. 1965
9 x 7 ¾" (22.9 x 19.7 cm)
EHG

PAGE 75
*Coal-Searcher Going Home to
Jarrow*
1937
Printed 1960s
9 x 7 ¾" (22.9 x 19.7 cm)
MoMA. Gift of Robert M. Doty

PAGE 76
Factory, Sheffield
1937
9 ½ x 7 ¾" (24.1 x 19.7 cm)
EHG

PAGE 77
Children in Sheffield
1937
9 ¹⁄₁₆ x 7 ⅝" (23 x 19.4 cm)
MoMA. Gift of Edwynn Houk

PAGE 78
*East Durham Coal-Miner
Just Home from the Pit*
1937
9 ½ x 7 ⁹⁄₁₆" (24.2 x 19.2 cm)
MoMA. Gift of Edwynn Houk
in honor of Noya Brandt

PAGE 79
*Northumbrian Miner at
His Evening Meal*
1937
8 ¾ x 7 ⅜" (22.2 x 18.8 cm)
MoMA. John Parkinson III
Fund

PAGE 80
Back Street in Jarrow, Tyneside
1937
9 ³⁄₁₆ x 7 ¹¹⁄₁₆" (24.5 x 19.5 cm)
Collection Michael Mattis and
Judith Hochberg

PAGE 81
*North Bridge over the
River Hebble, Halifax*
1937
9 x 7 ⅝" (22.9 x 19.4 cm)
EHG

PAGE 82
Jarrow
1937
9 ¹⁵⁄₁₆ x 7 ¹⁵⁄₁₆" (25.2 x 20.2 cm)
EHG

PAGE 83
*Pawnbroker's Premises in
Halifax*
1937
9 x 7 ¾" (22.9 x 19.7 cm)
EHG

WORLD WAR II

PAGE 85
Deserted Street in Bloomsbury
*London by Moonlight:
Street in a Bombed Area*
1942
9 ⅛ x 7 ¹³⁄₁₆" (23.1 x 19.8 cm)
MoMA. Acquired through the
generosity of Richard E.
Salomon and the Committee
on Photography Fund

PAGE 86
The Moon on Park Crescent
*Blackout in London:
Park Crescent, Regent's Park*
1939
8 ⅝ x 7 ⅛" (21.9 x 18.1 cm)
EHG

PAGE 87
The Bombed City
*London by Moonlight:
City Water-Front*
1942
9 x 7 ⅝" (22.9 x 19.4 cm)
EHG

PAGE 88
Moon on the Adelphi
*Blackout in London:
The Adelphi*
1939
9 x 7 ¾" (22.9 x 19.7 cm)
EHG

PAGE 89
*St. Paul's Cathedral in the
Moonlight*
*The Church Which Has
Seen It All*
1939
9 ⁷⁄₁₆ x 7 ¹¹⁄₁₆" (23.9 x 19.5 cm)
MoMA. Committee on
Photography Fund

PAGE 90
*A Sikh Family Sheltering in
an Alcove Where Coffins
Once Stood, in the Crypt of
Christ Church, Spitalfields*
1940
9 ⅛ x 7 ⅝" (23.2 x 19.4 cm)
EHG

*East End Wine Merchant's
Cellar: A Group of
Orthodox Jews Reading
Their Bibles*
1940
9 ½ x 7 ⅝" (24.1 x 19.4 cm)
EHG

PAGE 91
*East End Wine Merchant's
Cellar: Old Woman Sleeps on a
Bed Constructed on top of a
Row of Barrels*
1940
9 ¼ x 7 ½" (23.5 x 19.1 cm)
EHG

*Old Lady in a Pimlico Air-Raid
Shelter, Her Silver-Handled
Umbrella Safely Tucked Away
behind Her*
1940
10 ¹⁄₁₆ x 7 ¹⁵⁄₁₆" (25.6 x 20.2 cm)
EHG

PAGE 92
*Crowded, Improvised Air-Raid
Shelter in a Liverpool Street
Tube Tunnel*
1940
7 ½ x 6 ⁷⁄₁₆" (19.1 x 16.4 cm)
MoMA. Gift of Richard O.
Rieger

PAGE 93
*Liverpool Street
Underground Station Shelter*
Liverpool Street Extension
1940
9 ⅝ x 7 ⅝" (24.4 x 19.4 cm)
EHG

PAGE 94
*Liverpool Street
Underground Station Shelter*
1940
11 ¹¹⁄₁₆ x 9 ¹¹⁄₁₆" (29.7 x 24.6 cm)
MoMA. Acquired through the
generosity of Anne and
Joel Ehrenkranz in honor of
Peter Galassi

PAGE 95
*In the Public Bar at Charlie
Brown's, Limehouse*
c. 1942
9 x 7 ¹¹⁄₁₆" (22.8 x 19.6 cm)
MoMA. Purchase

PAGE 96
Outside a Soho Nightclub
1942
9 x 7 ⁵⁄₁₆" (22.8 x 18.6 cm)
MoMA. Agnes Rindge
Claflin Fund

PAGE 97
Soho
1942
8 ¾ x 7 ¼" (22.2 x 18.4 cm)
EHG

PAGE 98
Bath—The Circus
1942
9 ¼ x 7 ½" (23.5 x 19.1 cm)
EHG

NUDES

PAGE 145
Hampstead, London
The Policeman's Daughter
Perspective of Nudes, No. 1
1945
9 x 7 ¹¹/₁₆" (22.9 x 19.5 cm)
MoMA. Horace W. Goldsmith
Fund through Robert B.
Menschel

PAGE 146
Micheldever, Hampshire
Perspective of Nudes, No. 12
1948
9 ¼ x 7 ½" (23.5 x 19.1 cm)
Collection David Dechman
and Michel Mercure

PAGE 147
Nude
Perspective of Nudes, No. 9
1953
9 ⅛ x 7 ¹³/₁₆" (23.1 x 19.8 cm)
MoMA. Acquired through the
generosity of David Dechman
and Michel Mercure

PAGE 148
Campden Hill, London
Perspective of Nudes, No. 5
1949
9 ⁵/₁₆ x 8" (23.6 x 20.3 cm)
Wilson Centre for
Photography

PAGE 149
London
Reflection
c. 1948
9 ¹/₁₆ x 7 ¹¹/₁₆" (23 x 19.5 cm)
MoMA. Acquired through the
generosity of Thomas and
Susan Dunn

PAGE 150
Belgravia, London
Perspective of Nudes, No. 11
1951
9 ¼ x 7 ½" (23.5 x 19.1 cm)
Collection David Dechman
and Michel Mercure

PAGE 151
Hampstead, London
Perspective of Nudes, No. 6
1952
8 ¾ x 7 ½" (22.2 x 19.1 cm)
The Metropolitan Museum of
Art, Purchase, Joseph Pulitzer
Bequest, The Horace W.
Goldsmith Foundation Gift,
through Joyce and Robert
Menschel, and The Elisha
Whittelsey Collection, The
Elisha Whittelsey Fund, 1986
(1986.1053.3)

PAGE 152
Campden Hill, London
Perspective of Nudes, No. 10
1953
Printed 1970s
9 ¹³/₁₆ x 7 ¹¹/₁₆" (24.9 x 19.5 cm)
EHG

PAGE 153
Campden Hill, London
Perspective of Nudes, No. 13
1955
9 ⅛ x 7 ¾" (23.2 x 19.7 cm)
MoMA. Acquired through the
generosity of Rikki Conway

Hampstead, London
Perspective of Nudes, No. 16
1955
9 x 7 ¾" (22.9 x 19.7 cm)
Collection David Dechman
and Michel Mercure

PAGE 154
London
Perspective of Nudes, No. 30
1953
9 ¼ x 7 ½" (23.5 x 19.1 cm)
MoMA. Gift of David
Dechman and Michel Mercure
in honor of Peter Galassi

PAGE 155
London
Perspective of Nudes, No. 38
1956
9 ¼ x 7 ½" (23.5 x 19.1 cm)
Collection David Dechman
and Michel Mercure

PAGE 156
London
Perspective of Nudes, No. 34
1954
9 ¼ x 7 ½" (23.5 x 19.1 cm)
Collection David Dechman
and Michel Mercure

PAGE 157
London
Perspective of Nudes, No. 63
1957
9 ¼ x 7 ½" (23.5 x 19.1 cm)
Collection David Dechman
and Michel Mercure

PAGE 158
Campden Hill, London
Perspective of Nudes, No. 61
c. 1957
9 ¼ x 7 ½" (23.5 x 19.1 cm)
Collection David Dechman
and Michel Mercure

Belgravia, London
Perspective of Nudes, No. 60
1958
9 x 7 ¾" (22.9 x 19.7 cm)
Collection David Dechman
and Michel Mercure

PAGE 159
Campden Hill, London
Perspective of Nudes, No. 65
1957
9 ¼ x 7 ½" (23.5 x 19.1 cm)
EHG

Campden Hill, London
Perspective of Nudes, No. 53
1957
9 x 7 ¾" (22.9 x 19.7 cm)
Collection David Dechman
and Michel Mercure

PAGE 160
Belgravia, London
Perspective of Nudes, No. 26
1953
9 ³/₁₆ x 7 ¾" (23.3 x 19.7 cm)
MoMA. Acquired through the
generosity of Richard E.
Salomon

PAGE 161
Campden Hill, London
Perspective of Nudes, No. 29
1956
9 ³/₁₆ x 7 ¹¹/₁₆" (23.3 x 19.6 cm)
MoMA. Acquired through the
generosity of David Dechman
and Michel Mercure

PAGE 162
Campden Hill, London
Perspective of Nudes, No. 64
1958
9 x 7 ⅞" (22.9 x 20 cm)
Collection David Dechman
and Michel Mercure

PAGE 163
London
Perspective of Nudes, No. 36
1952
9 x 7 ⅝" (22.9 x 19.4 cm)
Collection David Dechman
and Michel Mercure

PAGE 164
London
Perspective of Nudes, No. 81
1958
9 x 7 ¾" (22.9 x 19.7 cm)
Collection David Dechman
and Michel Mercure

PAGE 165
Hampstead, London
Perspective of Nudes, No. 56
1956
9 x 7 ¾" (22.9 x 19.7 cm)
MoMA. Gift of David
Dechman and Michel Mercure

PAGE 166
London
Perspective of Nudes, No. 72
1959
13 ⅛ x 11 ⁵/₁₆" (33.4 x 28.7 cm)
MoMA. Gift of the
photographer

PAGE 167
London
Perspective of Nudes, No. 20
1956
9 ¹/₁₆ x 7 ⅞" (23 x 20 cm)
MoMA. Acquired through
the generosity of Charles
Heilbronn

PAGE 168
London
Perspective of Nudes, No. 62
1954
9 ⅛ x 7 ¾" (23.1 x 19.7 cm)
MoMA. Acquired through the
generosity of Clarissa Alcock
Bronfman and Richard E.
Salomon

PAGE 169
London
Perspective of Nudes, No. 33
1954
9 ⅛ x 7 ¾" (23.1 x 19.7 cm)
MoMA. Acquired through
the generosity of Richard O.
Rieger

PAGE 170
Baie des Anges, France
Perspective of Nudes, No. 42
1959
9 x 7 ¾" (22.9 x 19.7 cm)
MoMA. Acquired through the
generosity of David Dechman
and Michel Mercure

PAGE 171
East Sussex Coast
Perspective of Nudes, No. 47
1957
9 ¹/₁₆ x 7 ¹³/₁₆" (23 x 19.8 cm)
MoMA. Thomas Walther
Collection. Gift of Thomas
Walther

PAGE 172
East Sussex Coast
Perspective of Nudes, No. 69
1959
9 ¼ x 7 ½" (23.5 x 19.1 cm)
Collection David Dechman
and Michel Mercure

PAGE 173
East Sussex Coast
Perspective of Nudes, No. 41
1953
9 x 7 ¾" (22.9 x 19.7 cm)
Collection David Dechman
and Michel Mercure

PAGE 174
East Sussex Coast
Perspective of Nudes, No. 82
1958
13 ¹/₁₆ x 11 ⁵/₁₆" (33.2 x 28.8 cm)
MoMA. Gift of the
photographer

East Sussex Coast
Perspective of Nudes, No. 89
1958
13 ⁵/₁₆ x 11 ⁵/₁₆" (33.9 x 28.8 cm)
MoMA. Gift of the
photographer

PAGE 175
East Sussex Coast
Perspective of Nudes, No. 87
1959
13 ³/₁₆ x 11 ⁵/₁₆" (33.5 x 28.8 cm)
MoMA. Gift of the
photographer

Baie des Anges, France
Perspective of Nudes, No. 90
1959
9 ⅛ x 7 ¾" (23.2 x 19.7 cm)
Collection David Dechman
and Michel Mercure

PAGE 176
Baie des Anges, France
Perspective of Nudes, No. 88
1958
9 x 7 ⅞" (22.9 x 20 cm)
Collection David Dechman
and Michel Mercure

PAGE 177
Baie des Anges, France
Perspective of Nudes, No. 78
1959
9 x 7 ¾" (22.9 x 19.7 cm)
Collection David Dechman
and Michel Mercure

PAGE 178
Vastérival Beach, Normandy
Perspective of Nudes, No. 45
1954
9 ¹/₁₆ x 7 ¾" (23 x 19.7 cm)
MoMA. Gift of David
Dechman and Michel Mercure

PAGE 179
Taxo d'Aval, France
Perspective of Nudes, No. 39
1957
8 ¹⁵/₁₆ x 7 ¹³/₁₆" (22.7 x 19.8 cm)
MoMA. Promised gift of
Clarissa A. Bronfman

PAGE 180
Taxo d'Aval, France
Perspective of Nudes, No. 80
1958
9 ¹/₁₆ x 7 ¾" (23 x 19.7 cm)
MoMA. Acquired through the
generosity of Jon L. Stryker

PAGE 181
Seaford, East Sussex Coast
Perspective of Nudes, No. 43
1957
9 x 7 ¹¹/₁₆" (22.9 x 19.5 cm)
MoMA. Gift of David
Dechman and Michel Mercure

"No Rules"
An Illustrated Glossary of Bill Brandt's Retouching Techniques

Lee Ann Daffner

A technical examination of 133 photographs by Bill Brandt dating from 1930 to 1965 was carried out in the Conservation Department of The Museum of Modern Art, where a palette of retouching techniques was observed from the earliest prints to the late work.[2] Brandt's painterly and painstaking finishing techniques were notable among fine art photographers of his generation for the wide range of effects and the degree of image revision carried out with a handful of simple tools.

Retouching and spotting, as well as other finishing techniques such as hand-coloring, had been used in photography since the advent of the medium. Yet with the explosion of photographic enlargements in the 1920s, these practices gained new momentum. By the time Brandt began his career in the 1930s, retouching was an established professional trade. Known in the graphic arts as "working up" or "finishing,"[3] this type of retouching was often necessary due to the magnification of small defects in the negative. Because of the dramatic difference in scale, it was easier to work on a positive print than on a negative, and it was far less risky, too, as removing image details from a negative is irreversible, whereas a new print could always be made from an original negative.

At this time there were two opposing attitudes towards retouching: those who embraced it and those who regarded it as a profanation. Among the latter were Edward Weston and other members of Group f.64, a circle of photographers dedicated to creating and promoting direct, purely photographic images. "My finished print is there on the ground glass, with all its values, in exact proportions," Weston wrote in 1930. "The final result in my work is fixed forever with the shutter's release.... No after consideration such as enlarging portions, nor changing values—and of course no retouching—can make up for a negative exposed without a complete realization at the time of the exposure. Photography is too honest a medium, direct and uncompromising, to allow of subterfuge."[4]

Brandt did not share the view that to retouch was to engage in a kind of "subterfuge." His thoughts appear more aligned with those of a number of photojournalists and editors who saw retouching not as a dishonest manipulation of reality but as practical and essential. As the editors of a contemporary book on photojournalism put it: "The really clever editor… knows that the right amount of retouching is what is required to bring the picture up to reproduction standards, whether this means none, or a very slight amount, or so much that it seems like painting a new picture over the old shell."[5] For his part, Brandt consistently expressed his opinion that a photographer's role extended well beyond the click of the shutter. "I consider it essential that the photographer should do his own printing and enlarging," he wrote in 1948. "The final effect of the finished print depends so much on these operations, and only the photographer himself knows the effect he wants."[6] It is no stretch to include retouching in this process, as it was considered part of the general category of finishing, along with trimming, coating, and mounting.

More than a decade later, Brandt's thoughts remained consistent: "I can never understand how some photographers send their films out to a processing firm," he wrote. "Much of the powerful effect of William Klein's *New York* was due, I am sure, to his very personal printing, which stressed just what he wanted to bring out

1 Bill Brandt, "Bill Brandt" (artist's statement), *Album* no. 2 (March 1970): 46–47.

2 Print characteristics surveyed included: UV fluorescence, borders, mounts, paper weight, surface finish, inscriptions, variant printing/cropping, retouch, additive techniques, reductive techniques, character of retouching (careful or loose), and apparent purpose of retouching (corrective or enhancing). Technical examination of 133 photographs by Bill Brandt (1930–65), Conservation Department, The Museum of Modern Art, New York, May–August 2010.

3 L. P. Clerc, *Photography Theory and Practice* (London: Henry Greenwood, 1930), 437–40.

4 Edward Weston, "Photography—Not Pictorial," *Camera Craft* 37, no. 7 (July 1930): 313–20.

5 Laura Vitray and John Mills, *Pictorial Journalism* (London: McGraw-Hill Company, 1939), 154.

6 Bill Brandt, "A Photographer's London," in *Camera in London* (London: The Focal Press, 1948), 14.

in the pictures. And imagine what marvels we could have had if Cartier-Bresson had taken an interest in printing during the early days of his career." He goes on to give perhaps the best summation of his own view: "There are certainly no rules governing how a picture should be printed."[7] Indeed, Brandt appears to have made up his own rules as he went along. While he could be remarkably uninhibited with his image revisions, at times he demonstrated a restraint and lightness of touch that is almost invisible on his finished prints.

Retouch materials marketed for photographic finishing during Brandt's time, many of which had long been associated with painting and drawing, included watercolors, ink washes, Conté crayons in light and dark colors, pastels, pencil leads, and emery paper for sharpening graphite.[8] Removal of dark spots was carried out with a scraper, knife, or blade and is sometimes referred to as "etching." Materials more specific to photography included retouching fluid formulated to facilitate adhesion of aqueous washes to stubborn emulsions and opaquing liquid similar to gouache. Instructional books were available to guide professional and amateur alike, and until the recent rise of digital photography with its unique capacities for alteration, these tools and techniques were still very much in use.

Brandt emerged as a photographer in a world that was still largely defined by nineteenth-century traditions and culture, and he modified his images through a series of traditional retouching techniques acquired either from apprenticeships in Vienna or Paris, or through self-teaching. It is clear from technical examination that Brandt executed his own retouching, as the techniques remain remarkably consistent over the years and

multiple prints of the same image receive similar treatment.[9] (Brandt himself was by no means secretive about his adjustments; in preparation for his 1969 solo exhibition at MoMA, for example, he wrote to John Szarkowski, then the Director of the Photography Department at the Museum: "I had to retouch most of the prints a little. I hope this won't come off when you mount them.")[10]

Brandt's adjustments fall into two broad categories: corrective (hiding or removing image flaws caused from dust or debris) and enhancing (accentuating compositional elements such as facial features or shadows). There were two ways to achieve either objective, through reductive or additive methods, for which Brandt employed a limited selection of simple hand tools: magnifying glass, pencil holder, straight razors, and a fine brush.[11] In the reductive approach, minute quantities of the image were physically removed by cutting, scraping, or pressing the emulsion. In the additive approach, an application of wash, ink, or graphite (i.e., pencil) was applied to either darken or delineate. Often Brandt would work a detail until the preferred outcome was achieved, alternating between a light scraping, adding color with a wash, and then working again with a scraper. There was a range of effects, varying from delicate to heavy, where the artist worked the surface vigorously as described in the technical glossary that follows. Brandt's retouch style appears to have been dictated by the desired effect—careful and delicate for smoothing out texture or subtle enhancements, more invasive when elements where being added or removed. In later years, he regularly manipulated detail and texture through successive printing stages: a retouched print was

re-photographed, printed, and retouched again until he achieved the effect he wanted. (Brandt appears to have made little or no distinction between prints intended for exhibition and those developed for reproduction in periodicals or books; that is, he made such adjustments in both cases.) From the technical examination, the photographic papers were found to be primarily semi-glossy or glossy, the finish identified as most suitable for reproduction purposes due to greater detail, adhesion of the retouch medium, and for the purposes of matching tones.

Although there was one example of airbrushing (the application of a fine spray of paint delivered through a mechanical apparatus), all evidence suggests Brandt preferred to carefully adjust his images by hand. Like so many of the skilled trades, retouching followed a trajectory of hand to machine, with fine brushwork ultimately being overtaken by airbrushing.[12] Not so with Bill Brandt. In later years, the heaviness of his retouching, perhaps exacerbated by failing eyesight, affirms his doggedness to control the creative process and the craft involved in the production of his photographs.

7 Bill Brandt, quoted in "Bill Brandt Today … and Yesterday," *Photography*, June 1959: 32.

8 Spencer Adamson, *Retouching and Finishing for Photographers* (London: Pittman and Sons, 1935), 75.

9 Both *Losing at the Horse Races, Auteuil, Paris* (c. 1932; p. 34) and *London* (1952; p. 163) offer interesting examples. We examined three prints of each image; the prints of the former were likely made during a relatively short time span, while the prints of the latter span several decades. In all images the same basic areas were retouched each time. However, those areas retouched in *Losing at the Horse Races* appear to have been worked to the same degree, while the degree of retouch on the *London* prints varied.

10 Bill Brandt to John Szarkowski, November 30, 1968, The Museum of Modern Art Archives, New York.

11 Bill Brandt Archive, email correspondence with the author, April 2012.

12 Adamson, 82.

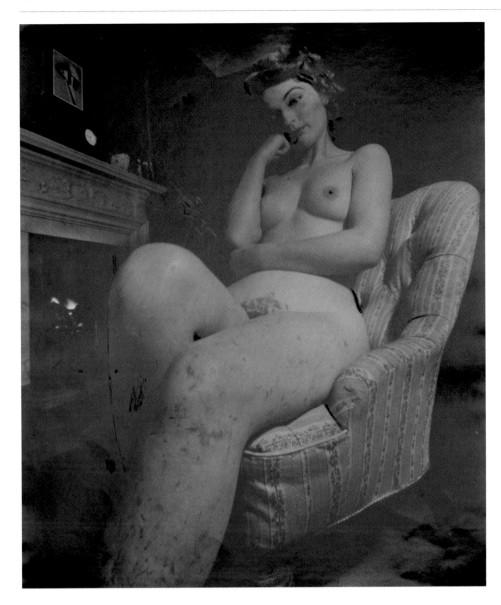

The following image glossary illustrates Brandt's most common retouching techniques, which can be found across much of his work. Sometimes the modification is isolated to one or two areas on an image; other times extensive retouch can be seen scattered over much of the photograph. In some examples, particular features such as shadows among rocks were almost entirely fabricated. Brandt's marks ranged from careful and tightly controlled to loose and imprecise, and several media could be used in tandem. The images here are taken from seven Brandt photographs; upon examination, it was determined that each photograph displayed at least one if not three or four different retouch methods. All images were made in the MoMA conservation lab. Detail views were captured using a Wild Heerbrugg M8 stereo microscope, while the overall specular images were made using a Hasselblad 555 ELD with Phase One H2O 16MP digital camera back, captured on Capture One Pro software.

Overall view of *Nude* (1953; p. 147)
made using specular light

The extent of Brandt's retouch is readily visible under specular light, which dramatically heightens the contrast between the matte and glossy aspects of a photograph's surface. Here, Brandt has primarily used additive wash techniques for the model's face and hair, and reductive scratching techniques for the legs and body. Significant retouching and smoothing of the leg in the foreground draws the viewer's gaze, uninterrupted, to the model's face.

Additive Techniques

Additive techniques are marks added to the surface of the photograph to modify the image. Marks can be added with a brush, graphite, or porous pointed pen. They can be dabs or spots, linear or in patches of black, blue, white, or gray. Some inks or dyes may fade over time, rendering the retouched area more visible than when the marks were first applied. Washes were a particularly favorite medium for Brandt, found on forty percent of the prints examined at MoMA; he employed graphite and porous pointed pen as well.

WASH

OPAQUE BLACK WASH
Detail of *Giant's Causeway, Antrim* (1946; p. 138). The field of view shown is 2.4 mm x 2.4 mm

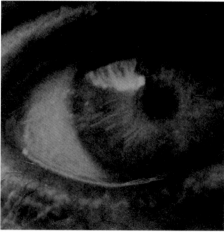

WHITE GOUACHE
Detail of *Jean Dubuffet* (1960, p. 121, right). The field of view is 6 cm x 6 cm

Opaque washes were frequently used by Brandt. He added heavily pigmented black washes, either a gouache or an opaquing medium specifically formulated for use on photographs, to create dense shadows. In a detail of *Giant's Causeway, Antrim*, for example, Brandt has applied the black wash to reinforce the checkerboard pattern of the rock formations, in some areas creating shadows where there were none. In *Barmaid at the Crooked Billet, Tower Hill*, he used several patches of black wash to add depth and uniformity to the shadowy background. He applied the passages thickly, so much so that brushstrokes can be seen by the naked eye upon close inspection, while particles of pigment are visible as sandy texture under magnification. In addition to black washes, a white opaque wash could hide dark spots, or it could add highlights to a darker area. In *Jean Dubuffet*, Brandt applied white gouache to the iris and whites of the eye to lighten and brighten the details.

OPAQUE BLACK WASH
Detail of *Barmaid at the Crooked Billet, Tower Hill* (1939; p. 54). The field of view is 2.5 mm x 2.5 mm

GRAPHITE

POROUS POINTED PEN

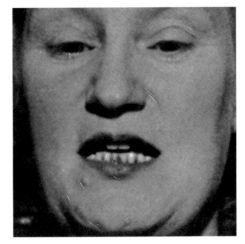

GRAPHITE
Detail of *Barmaid at the Crooked Billet, Tower Hill.*
The field of view is 4 cm x 4 cm

POROUS POINTED PEN (WITH ABRASION)
Detail of *Jean Dubuffet.* The field of view is 3 cm x
3 cm

WASH (WITH ABRASION AND SCRATCH)
Detail of *Losing at the Horse Races, Auteuil, Paris*
(1932, p. 34). The field of view is 8 mm x 8 mm

TRANSPARENT WASH
Detail of *Vastérival Beach, Normandy* (1954, p. 178).
The field of view is 1.7 cm x 1.7 cm

GRAPHITE
Detail of *Vastérival Beach, Normandy.* The field of
view is 1 cm x 1 cm

In later years Brandt expanded his tool kit to
include porous pointed pen, also known as felt-
tip marker. Marketed to artists as early as 1946,[13]
these pens with their semi-transparent color
were used to similar effect as a wash but were
remarkably convenient, which likely appealed to
Brandt, in addition to their ready adherence
to the water-resistant emulsion. Identifiable in
specular light by its iridescence and even, fluid
line, the dye in these ubiquitous pens may
have faded or shifted over time, now appearing
light blue in color.

The photographer employed more transparent
washes as well, either by thinning the black wash
or using neural-toned watercolors, which allowed
him to approximate mid-tones or gradations
of tone. In *Vastérival Beach, Normandy*, Brandt
used the wash to further delineate an area of
rocks, while in *Losing at the Horse Races, Auteuil,
Paris*, he dabbed on a darker wash to greatly
enhance a mustache and beard.

Readily available and easy to use, graphite is sold
in grades of hardness. Brandt used this medium
in two ways: to outline or enhance compositional
elements in sharp, clean lines, such as the eyebrows
and facial features of the title subject in *Barmaid
at the Crooked Billet*, or applied in a circular
motion to create mid-tone shadows, such as in the
background of *Vastérival Beach*, where the marks
mimic the rounded composition of the rocks. This
style of marking was cited in the instructional
guides of the day alongside cross-hatching and
parallel linear marks.

13 Margaret Holben Ellis, "The Porous Pointed Pen as Artistic
Medium," in Shelia Fairbrass, ed., *The Institute of Paper Conservation:
Conference Papers, Manchester 1992* (London: Institute of Paper
Conservation, 1992), 11–18.

Reductive Techniques

Reductive techniques are defined as modifications to the surface of the photograph for the purpose of eliminating undesired image material by physically altering or removing portions of the emulsion. When carried out by a light hand using either an etching knife or a straight razor, the shallow abrasions are only barely visible in strong specular light or under magnification. When carried out more forcefully, marks are readily visible to the naked eye.

IMPRESSION

IMPRESSION
Detail of *Jean Dubuffet*. The field of view is 7 cm x 7 cm

One distinctive method that appears in many Brandt photographs is the use of a graphite point to impress the emulsion—that is, the emulsion membrane is not broken but a deep furrow or impression can be seen under magnification, as well as graphite particles pressed into the furrow. Such impressions cause a slight shadow from certain angles but can also catch the light from different angles as well. The facial wrinkles in *Jean Dubuffet* were enhanced in this fashion.

ABRASION

SHALLOW ABRASION BREAKING SURFACE, CARRIED OUT WITH A LIGHT TOUCH
Detail of *Nude* (1953, p. 147). The field of view is 4.5 cm x 4.5 cm

Image material is not so much removed as it is partially obscured or lightened, almost as if the surface had been lightly sanded, as in the detail of *Losing at the Horse Races* on the previous page, where Brandt used either a straight razor or etching knife to barely abrade the surface of the emulsion. Although visible, such an effect is not immediately apparent upon viewing and in many cases is only visible under specular lighting or high magnification. Likewise, in the detail of *Nude* above, many spots of the model's leg and pubic region were lightly abraded away in an effort to even out the skin tone.

SCRATCH

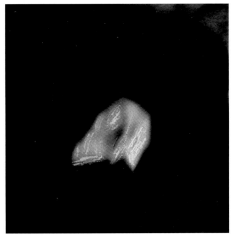

STRAIGHT RAZOR USED TO ABRADE AND
REDUCE DARK LINE
Detail of *London* (1952, p. 163). The field of view is
1.4 cm x 1.4 cm

DEEP SCRATCH THROUGH EMULSION DOWN TO
PAPER (WITH ABRASION AND GRAPHITE)
Detail of *Losing at the Horse Races, Auteuil, Paris*.
The field of view is 1.5 cm x 1.5 cm

STRAIGHT-RAZOR SCRATCH USED
TO EVEN OUT SURFACE
Detail of *London*. The field of view is 2 cm x 2 cm

The regular, even marks typical of scraping with a straight razor are visible under magnification in this detail of *London*. The razor would be held with the flat edge nearly parallel to the plane of the paper and the edge lightly flicked across the surface. This tool could also be used to create thin lines by angling one corner onto the paper, as we see in another area of this image: the dark line under the breast was carefully diminished by this careful cross-hatching.

A more forceful use of a straight razor or etching knife results in what we classify here as a scratch, where much of the emulsion is removed to reveal the white baryta or paper fibers below the image layer, a technique Brandt used to create pure white highlights. This procedure is readily visible to the naked eye, particularly when the image is viewed under specular light; the resulting area reads as a bright white highlight. In this detail of the pocket handkerchief in *Losing at the Horse Races*, highlights have been created, while the center has a dark impression.

Brandt worked over a relatively large area to obliterate any shadows in the elbow in the detail from *London* above. He appears to have used a flat razor, as the marks are regular and perfectly even on the left, but on the right they are more pointed and forceful. Again, the result is a flat, bright patch of white where the emulsion was taken down almost to the baryta layer. It would have been much easier to remove shadow in such a large area by airbrushing, but here Brandt sticks with his tools and methods, no matter how laborious.

Bill Brandt's
Published Photo-Stories
1939–1945

Sarah Hermanson Meister and Marley Blue Lewis

Bill Brandt's increasingly regular contributions to illustrated publications during the years that spanned World War II proved to be highly productive and generative for his career. While Brandt's wartime work has become synonymous with his images of London during the Blackout and the Blitz, his output during these years was in fact much more diverse and would lay the groundwork for the wide range of genres he would explore in the decades that followed.

Artists frequently contributed to illustrated publications during the early half of the twentieth century, a particularly common practice among the modernist photographers working on the continent; such an opportunity could offer an artist a platform and an audience, as well as a source of income. While Brandt had a photograph published as early as May 1932 in the German magazine *Der Querschnitt*, with others published in 1934 in *Weekly Illustrated* and *Minotaure*, it was not until the late 1930s that he began to carve out a place for himself within the field. What began as a chance to publish photographs

taken in and around London would blossom during the war years into assignment-driven work, undertaken primarily for *Lilliput*, *Picture Post*, and *Harper's Bazaar*, that would become the impetus for Brandt to expand his subject matter and to begin photographing, in earnest, landscapes, architecture, portraits, and nudes.

Lilliput and *Picture Post* were both founded by the visionary publisher Stefan Lorant, who was lauded for his contributions to modern photojournalism and, specifically, for his emphasis on picture essays and intuitive layouts and designs, a skill he honed in Munich during his tenure as the editor of *Münchner Illustrierte Zeitung*. Lorant worked briefly as the founding editor of *Weekly Illustrated* before launching *Lilliput* (in July 1937) and *Picture Post* (with Edward G. Hulton, on October 1, 1938). Tom Hopkinson, who first met Brandt in 1936 while working as an assistant editor at *Weekly Illustrated*, followed Lorant to *Lilliput* in 1938; he assumed the position of editor there in July 1940 when Lorant, a Hungarian

national and former German resident, was denied British citizenship and emigrated to the United States. With *Lilliput*'s niche as a sophisticated cultural magazine and *Picture Post*'s strong populist bent, Brandt's involvement with both publications allowed him to focus on a broad range of subjects in photographs that would be seen by two distinct audiences. Hopkinson, in particular, regarded Brandt as a photographer of singular talent, and Brandt was given the opportunity to photograph the people and places around the United Kingdom as he saw fit, in addition to his war-specific assignments.

The photo-stories reproduced below, organized chronologically, suggest the breadth of Brandt's activity leading up to and throughout the war, complemented by citations for major articles not illustrated. Unless relevant to his postwar practice, individual pictures or stories consisting of previously published material are not mentioned. Images reproduced as plates are noted with the page number on which they appear.

Gustav Doré's London Rediscovered by Bill Brandt in 1938
VERVE
January–March 1939: 107–14

Three of Brandt's photographs are paired with Doré engravings from the 1870s. In May 1939, *Lilliput* would expand this concept to include seven pairings, calling the story "Unchanging London," Brandt's second

for the publication. The opening image in *Lilliput* is a slightly cropped version of *Rainswept Roofs* (p. 39), and the last is *Evening in Kenwood* (p. 67). Brandt's first article for *Lilliput*, "London Night," appeared in June 1938 and featured eight photographs, seven of which were included his collection *A Night in London*, which apeared that same year.

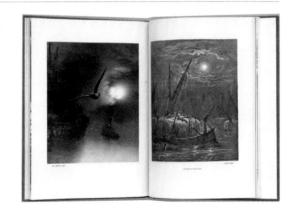

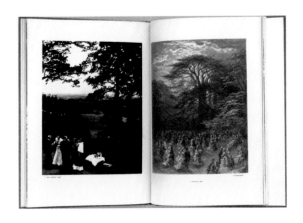

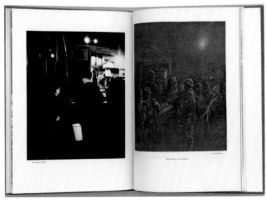

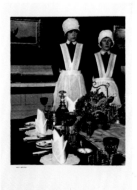

Day in the Life of an Artist's Model
PICTURE POST
January 28, 1939: 34–37

The first of four *Picture Post* "Day in the Life of…" features for Brandt. The "surrealist commercial artist," whom we see painting the artist's model, is Rolf Brandt, Bill's brother. This story would be followed by "Nippy. The Story of Her Day…" (March 4, 1939) (a "nippy" being a nickname for waitresses who worked in J. Lyons & Co.–brand tea houses around England); "A Barmaid's Day" (April 8, 1939), featuring Alice, the barmaid at the Crooked Billet pub in Stepney (see pp. 54–55 for two unpublished pictures from this story); and "The Perfect Parlourmaid" (July 29, 1939), which followed Pratt, the parlormaid in the home of Brandt's uncle. Variant images from the feature on Pratt appear on pages 46, 47, and 48; Brandt's self-portrait with Pratt, the final image in the article, is on page 17. Perhaps wanting to retain control over images he deemed more successful, Brandt frequently supplied variants of what would come to be his best-known images to *Picture Post*, although this was not the case with *Lilliput*.

Blackout in London
LILLIPUT
December 1939: 551–58

For Brandt's first war assignment, he was commissioned by *Lilliput* to document the "spirit of the blackout" in London with this photo-story of eight cityscapes. A number of the images published in this issue have since become some of Brandt's most iconic photographs. In the first edition of Brandt's retrospective collection, *Shadow of Light* (1966),the second image from this story appears with four street lights shining brightly, underscoring Brandt's willingness to adapt his printing from a particular negative; a daytime view of the same street appears on page 63.

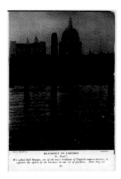

p. 86

Nightwalk … a dream phantasy in photographs
CORONET
January 1941: 47–54

The female model for this photo essay is Marjorie Beckett, Brandt's companion for more than thirty years; the bearded man is Rolf Brandt. Here, Brandt attempts to depict one woman's dreams throughout the course of a night. While much of Brandt's work has a dreamlike quality and surrealist undertones, in no work following this story would Brandt attempt such a literal representation.

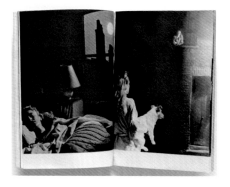
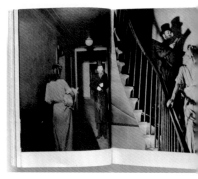

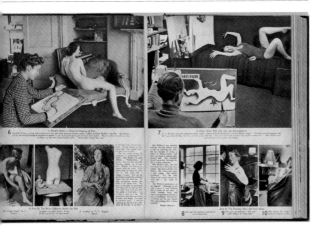

Daybreak at the Crystal Palace
PICTURE POST
February 11, 1939: 54–55

A series of eight photographs taken in the gardens of the Crystal Palace. In these pictures, Brandt experimented with perspective and cropping to create a surreal effect for the overgrown and decaying statues.

Enough of All This!
PICTURE POST
April 1, 1939: 54–57

This story contains images by Brandt of children living in squalor and dire conditions in London's East End neighborhood, illustrating an article about rent strikes and poverty. It marks one of Brandt's last social critiques published before Britain declared war on Germany, after which *Picture Post* maintained a stalwart position focused on publishing nationalistic, morale-boosting stories on the home front.

Twenty-Four Hours in Piccadilly Circus
LILLIPUT
September 1939: 233–40

Here *Lilliput* adopts the chronoglogical sequencing of *A Night in London* from the previous year, following a formula that *Picture Post* had used.

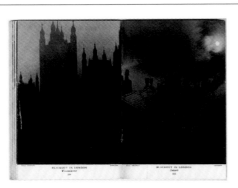

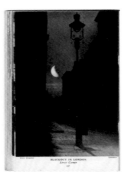

p. 88

England at War: Life Goes On in the Dark
LIFE
January 1, 1940: 40–41

Brandt's first photo-story in an American publication; four of the images from "Blackout in London" are reproduced (at left, the first, sixth, seventh, and eighth pages).

Autumn in a Forgotten Wood
LILLIPUT
October 1940: 343–45

Three early landscape photographs taken by Brandt, and his only photo-story for *Lilliput* in 1940, although a number of his images were published singly.

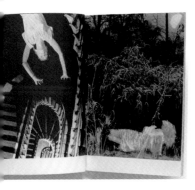

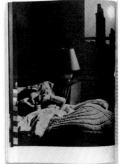

Spring in the Park
PICTURE POST
May 10, 1941: 18–21

I Look at Bournemouth by J. B. Priestley
PICTURE POST
June 21, 1941: 20–23

This Was the War-Time Derby!
PICTURE POST
July 5, 1941: 13–17

A Day on the River
PICTURE POST
July 12, 1941: 12–15

What Are All These Children Laughing At?
PICTURE POST
August 23, 1941: 16–17

A Simple Story about a Girl
LILLIPUT
September 1941: 235–42

A love story narrated by eight photographs and accompanying text about a young woman seeking an adventure who happens to meet a young soldier while walking in a local park. An unusually sentimental story by Brandt, perhaps explained by the fact that the idea originated not with him but with *Lilliput* assistant editor Kaye Webb.

Young Poets of Democracy
LILLIPUT
December 1941: 477–84

Photographs of eight contemporary English poets, which includes Stephen Spender, Cecil Day Lewis, Dylan Thomas, Louis MacNeice, Alun Lewis, Anne Ridler, Laurie Lee, and William Empson. This series marks the beginning of Brandt's mature portraits.

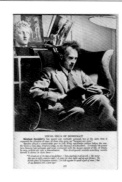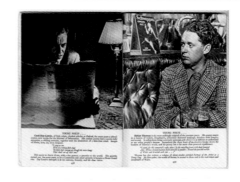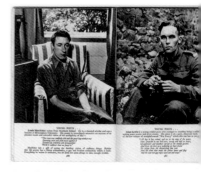

The Northern Capital in Winter
LILLIPUT
February 1942: 145–52

In this story, Brandt seeks to capture the historical character of the old city of Edinburgh, for the first time applying the stylistic qualities he honed in his work in London to his photographs of another city.

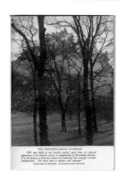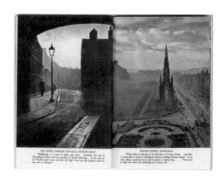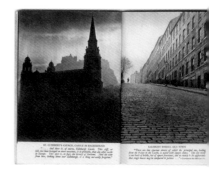

London by Moonlight
LILLIPUT
August 1942: 131–40

Ten Blackout photographs accompanied by a profile of Brandt written by Tom Hopkinson, *Lilliput*'s editor and a longtime advocate for Brandt. Hopkinson, illustrating some of the qualities he admires in Brandt and his work, writes: "A sense of justice and social contract, a keen edge for beauty, an entire absence of cynicism or contempt towards one's fellow human beings, a presentiment of the phantom in the doorway— these are rare gifts with which to start any kind of work, from founding a University to making photographs. [Yet] Brandt has another, a delicate sense of irony and humour." See pages 85, 87, and 89 for images reproduced in this article.

Flower Portraits by Brandt
LILLIPUT
September 1942: 239–46

Saving Britain's Plum Crop
PICTURE POST
September 12, 1942: cover; 17

Transport: Key to Our War Effort
PICTURE POST
September 26, 1942: 11–15

Backstage at the Windmill
LILLIPUT
October 1942: 323–30

A Town that Takes Care of Its Troops
PICTURE POST
October 3, 1942: 16–17

In these seven photographs accompanying an article describing Number Sixty, a house that operated as a resting place for off-duty soldiers in St. Andrews, Scotland, Brandt takes an idiom of domestic familiarity that is often seen throughout his prewar work (such as Bloomsbury Party [p. 51, right], for example), and applies it to his wartime pictures.

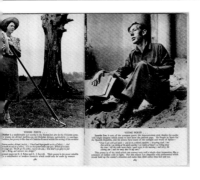

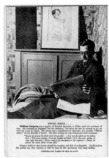

Chorister in King's
Chapel of Savoy
PICTURE POST
December 17, 1941: cover

"What I Believe about
Ghosts," by
Robert Graves
PICTURE POST
December 27, 1941: 22–25

Brandt submitted a variant
of what would become his
best-known portrait of
Graves (p. 104, left), in
which the poet is seen in
profile.

Whoe'er She Be,
that Not Impossible She
LILLIPUT
February 1942: 136

Brandt's first published
nude. The title is from a
seventeenth-century poem
by Richard Crashaw.
Brandt's photograph was
likely made in Paris in the
early 1930s.

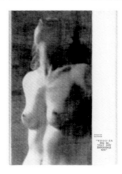

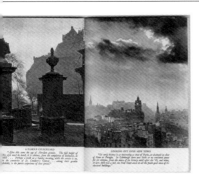

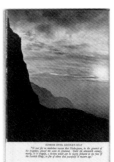

London Night
HORIZON
February 1942: between
pages 120–21

Cyril Connolly, *Horizon*'s
editor who would draft the
introduction to *Shadow
of Light* in 1966, reproduced
four of Brandt's classic
wartime photographs: two
of London by moonlight
(one of which appears on
p. 88), and two of under-
ground shelters (pp. 90
[left] and 92).

Soho in Wartime—
Eight Bits of a Quarter
LILLIPUT
April 1942: 323–30

The photographs on pages
96 and 97 appeared in this
article.

Bath: What the Nazis
Mean by a "Baedeker Raid"
PICTURE POST
July 4, 1942: 20–21

The lefthand photograph on
page 98 appeared in this
article with a caption that
read: "THE BOMB THAT MISSED
THE CIRCUS: It missed the
loveliest houses built by
the elder Wood. Here
Gainsborough painted, Clive
lived, Chatham entertained."

Fire Guard on the
House of Commons
PICTURE POST
November 14, 1942: 11–13

Ten images by Brandt
accompanying a profile of
the House of Commons
fire-guard staff. Employing
the vernacular of the
photographs he published
in *A Night in London*, Brandt
captured a range of staged
and quotidian nocturnal
activities, but here relied
solely on the moon for
exterior illumination.

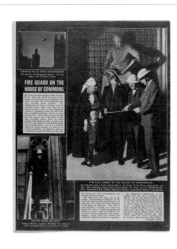

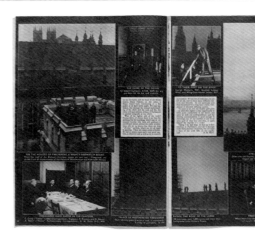

Shelter Pictures
LILLIPUT
December 1942: 473–82

In September 1940, following the beginning of the London Blitz, the Ministry of Information hired both Bill Brandt and Henry Moore to document the scenes in the London Underground shelters, where by November approximately 200,000 people were taking refuge. The commissions were to be used as propaganda and included in government reports, art exhibitions (such as *Britain at War*, The Museum of Modern Art's 1941 show in New York), and published in this issue of *Lilliput* as well as the February 1942 issue of *Horizon*. This photo-story opens with a Brandt photograph of Henry Moore in his studio and then features four photographs by Brandt of the shelters juxtaposed with five drawings by Moore of the same subject. Additional shelter drawings by Moore were reproduced in color in the June 1945 U.S. edition of *Harper's Bazaar*, along with another of Brandt's portraits of Moore in his studio.

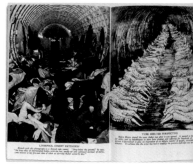

p. 93

The First Wartime Christmas to Bring a Vision of Peace
PICTURE POST
December 26, 1942: 7–9

The Child Who Has Never Known Peace
PICTURE POST
January 2, 1943: cover

Are We Planning a New Deal for the Youth?
PICTURE POST
January 2, 1943: 17

The first time that Brandt's celebrated picture *East End Girl Dancing the Lambeth Walk* (p. 60) is published.

What Our Artists Look Like
LILLIPUT
March 1943: 239–46

This photo-story includes a portrait of Walter Trier, who illustrated every *Lilliput* cover from 1937 to 1949 and drew the caricature of Brandt on page 24.

The Cathedrals of England
LILLIPUT
May 1943: 389–98

The Gardens of England
LILLIPUT
September 1943: 239–46

Summer at "Coppins"
HARPER'S BAZAAR [U.K.]
September 1943: 24–25

Photographs of the Duchess of Kent and Prince Edward, the Duke of Kent, at Coppins, their country home in Buckinghamshire. It marks Brandt's first photo-story for the U.K. edition of *Harper's Bazaar*.

Françoise Rosay
HARPER'S BAZAAR [U.K.]
September 1943: 40

Brandt's first published portrait in *Harper's Bazaar*. The same image would be reprinted in the U.S. edition of *Harper's Bazaar* in December.

The Portraits in the Servants' Hall
PICTURE POST
December 24, 1943: 22–24

We Plan a Valley in South Wales
and
The Story of the Swansea Valley
PICTURE POST
January 1, 1944: 6–7; 8–11

A Year's Work by the National Trust
PICTURE POST
January 22, 1944: 13–17

This story includes seventeen photographs of houses and land acquired by the National Trust, which in 1941 commissioned Brandt to document buildings of historical or architectural significance around the United Kingdom. Brandt's work here clearly foreshadows the imagery he would include in *Literary Britain*, his 1951 collection of landscape photographs tied to British literature.

Odd Corners of Museums
LILLIPUT
February 1944: 155–62

A series of eight photographs taken in various museums around London, highlighting a particular installation within each museum. Brandt's inclination towards the surreal and uncanny reappears in this story.

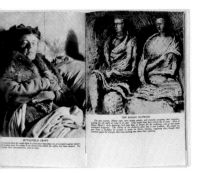
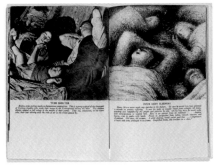
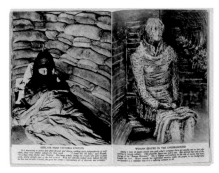
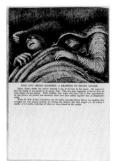

p. 91

The Threat to the Great Roman Wall
PICTURE POST
October 23, 1943: 12–15

Ten Brandt photographs of Hadrian's Wall threatened by quarrying at House-steads. Atmospheric and evocative of the ever-looming nature of the past in the English landscape, Brandt's aligns himself with the Roman era of British history. See page 102 for an unpublished picture from this assignment.

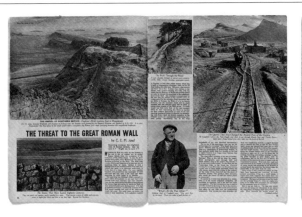
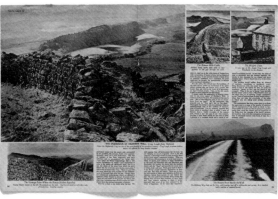

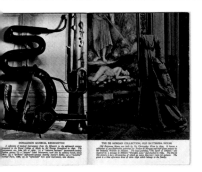

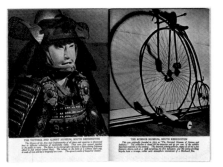
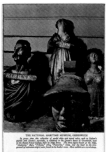

Animal Portraits
LILLIPUT
June 1944: 491–98

Chelsea: Photographed by Bill Brandt
LILLIPUT
August 1944: 137–46

Opening with Brandt's 1939 image of Battersea Bridge (p. 43), the article consists mostly of portraits of Chelsea's noteworthy inhabitants, including the painter/photographer Peter Rose Pulham and Dylan and Caitlin Thomas (p. 106).

A Small Town in the Autumn Sunlight
LILLIPUT
December 1944: 491–98

Sir Kenneth and Lady Clark
HARPER'S BAZAAR [U.K.]
December 1944: 42–43

Clark, who at the time was the director of the National Gallery in London, selected the paintings from England for MoMA's *Britain at War* exhibition in 1941. Brandt would continue to contribute portraits to *Harper's Bazaar* until October 1945, and he made portraits for the U.S. edition from the end of 1943 though the 1970s.

Frosty Morning in the Park
PICTURE POST
January 20, 1945: 13–15

Sphinx, Chiswick House Gardens (p. 100) was photographed for this story.

scene. I have to feel as if I've been to this place long ago and am trying to recapture how it used to look. I don't know whether this feeling is literary—that having read the Brontës gives me a special feeling about Haworth. I only know I can't take a good picture unless I get this feeling."[1] Two photographs from this article would appear in the U.S. edition of *Harper's Bazaar* in June, in an article titled "Wuthering Heights."

1. Bill Brandt, quoted in Tom Hopkinson, "Bill Brandt's Landscapes," in Nigel Warburton, ed., *Bill Brandt: Selected Texts and Bibliography* (Oxford, U.K.: Clio Press, 1993), 100.

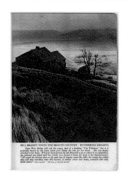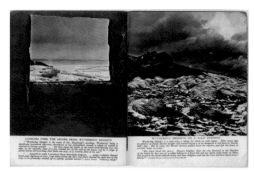

p. 132

p. 140

FROSTY MORNING IN THE PARK

(top) p. 100

The Magic Lantern
of a Car's Headlights
PICTURE POST
March 31, 1945: 13–15

Bill Brandt Visits the
Brontë Country
LILLIPUT
May 1945: 407–14

Here, Brandt enmeshes
Britain's long literary
tradition with the country's
landscape. Brandt would
portray his process of
landscape photography in
strong romantic terms
rather than as an applic-
ation of strictly technical
skill: "I have to become
obsessed with a particular

continued next row

This Was V.E. Day in
London
PICTURE POST
May 19, 1945: 2–15

Brandt had only one
photograph in this story,
but it filled the entire first
page above the caption:
"The First Dawn of Peace:
Sunrise over St. Paul's on
the morning of Tuesday,
May 8." The same image
was also used on the first
page of the *Harper's Bazaar*
special section on England,
reproduced below.

The Common Reader
and the Modern Poet
HARPER'S BAZAAR [U.K.]
June 1945: 43–44; 71

This article reproduced
many images that had first
appeared in Brandt's 1941
Lilliput story, "Young Poets
of Democracy," but with
some notable additions,
including Brandt's portrait
of T. S. Eliot, reproduced
below.

England
HARPER'S BAZAAR [U.S.]
July 1945: 22–39

This special section on
England included eighteen
images by Brandt that
ranged from portraits to
landscapes to pictures in
and around London, inclu-
ding a reversed repro-
duction of *Sphinx, Chiswick
House Gardens*. Numerous
photographs by Henri
Cartier-Bresson also
appeared, along with an
excerpt from Edith Sitwell's
book *Fanfare for Elizabeth*.

Only spreads on which
Brandt's images appear are
reproduced below

left) p. 105

ttom right) p. 104

p. 100, reversed

For additional information
on Brandt's work for the
illustrated press, see
Ian Jeffrey, ed., *Bill Brandt:
Photographs, 1928–1983*
(London: Thames and
Hudson, in association with
the Barbican Art Gallery,
1993); Nigel Warburton, ed.,
*Bill Brandt: Selected Texts
and Bibliography* (Oxford,
U.K.: Clio Press, 1993); and
Warburton, "The Career," in
*Brandt: The Photography of
Bill Brandt* (New York: Harry
N. Abrams, 1999), 286–315.

Gallery of New South Wales, Sydney, March 1–April 1, 1973; Queensland Art Gallery, Brisbane, Australia, April 19–May 20, 1973; Newcastle City Art Gallery, New South Wales, Australia, June 1–July 1, 1973; National Gallery of Victoria, Melbourne, Australia, August 3–September 11, 1973; Albert Hall, Canberra Arts Council of Australia, Canberra, September 20–October 21, 1973; Tasmanian Museum and Art Gallery, Hobart, Tasmania, November 15–December 16, 1973.

1930s

Londres de Nuit. Galerie du Chasseur d'Images, Paris. 1938.

1940s

Modern Photography (group exhibition). Marx House, London. 1940.

Britain at War (group exhibition). The Museum of Modern Art, New York. May 22–September 2, 1941 (catalogue).

Four Photographers: Lisette Model, Bill Brandt, Ted Croner, Harry Callahan (group exhibition). The Museum of Modern Art, New York. December 1, 1948–January 30, 1949 (installation view above).

Leading Photographers: Brandt. Organized and circulated by The Museum of Modern Art, New York. Traveled to American International College, Springfield, Massachusetts, November 28–December 19, 1949; Washburn Municipal University, Topeka, Kansas, March 17–April 7, 1950; University of Manitoba, Minneapolis, Minnesota, April 21–May 12, 1950; David Strawn Art Gallery, Jacksonville, Illinois, January

1–22, 1951; University of New Hampshire, Durham, February 7–28, 1951; Corning Glass Center, Corning, New York, October 25–November 15, 1951; Bennington College, Bennington, Vermont, November 30–December 21, 1951; Midwestern University Museum, Wichita Falls, Texas, January 15–February 5, 1952; J. B. Speed Art Museum, Louisville, Kentucky, March 21–April 11, 1952; Georgetown College, Georgetown, Kentucky, January 5–26, 1954; Saginaw Museum, Saginaw, Michigan, September 5–26, 1955; University of Delaware, Newark, January 4–25, 1956; The Hill School, Pottstown, Pennsylvania, February 8–29, 1956; Carolina Art Association, Gibbes Art Gallery, Charleston, South Carolina, May 4–25, 1956.

1950s

Twelve Photographers (group exhibition). The Museum of Modern Art, New York. July 13–August 12, 1951.

The Family of Man (group exhibition). The Museum of Modern Art, New York. January 24–May 8, 1955 (catalogue).

1960s

Diogenes with a Camera V: Bill Brandt, Lucien Clergue, Yasuhiro Ishimoto (group exhibition). The Museum of Modern Art, New York. September 26–November 12, 1961 (installation view, facing, left).

The Photography of Bill Brandt. George Eastman House, Rochester, New York. April 15–June 17, 1963.

The Photographer's Eye (group exhibition). The Museum of Modern Art, New York. May 27–August 23, 1964 (catalogue).

Bill Brandt. The Museum of Modern Art, New York. September 15–November 30, 1969 (installation view, facing, right). Circulated by the Arts Council of Great Britain as *Bill Brandt: Photographs* (brochure, with text by Aaron Scharf) to the following venues in the United Kingdom: Hayward Gallery, London, April 30–May 31, 1970; Royal Albert Memorial Museum, Exeter, June 13–July 5, 1970; Newport Museum and Art Gallery, July 11–August 1, 1970; Oldham Museum and Art Gallery, August 8–30, 1970;

Harris Museum and Art Gallery, Preston, September 9–26, 1970; Hatton Gallery, Newcastle-upon-Tyne, October 5–24, 1970; Castle Museum, Norwich, November 7–22, 1970; Sunderland Art Gallery, November 28–December 27, 1970; Aberdeen Art Gallery, January 4–24, 1971; Middlesbrough Art Gallery, January 30–February 21, 1971; Lancaster University, February 27–March 21, 1971; Dartington Hall, Totnes, March 27–April 18, 1971; Museum of Modern Art, Oxford, April 28–May 16, 1971. Circulated by The International Program of The Museum of Modern Art, New York, to the San Francisco Museum of Modern Art, September 15–October 24, 1971; Walker Art Center, Minneapolis, Minnesota, February 20–April 9, 1972; City of Auckland Art Gallery, New Zealand, May 9–June 5, 1972; Govett-Brewster Art Gallery, New Plymouth, New Zealand, June 28–July 27, 1972; Manawatu Art Gallery, Palmerston North, New Zealand, September 14–28, 1972; Art Gallery of South Australia, Adelaide, November 22–December 17, 1972; Western Australian Art Gallery, Perth, January 8–February 4, 1973; Art

1970s

Bill Brandt: Early Photographs 1930–1942. Organized and circulated by the Arts Council of Great Britain (brochure, with text by Peter Turner). Traveled to sixty venues in the United Kingdom, May 1975–January 1982.

Bill Brandt: Photographs. Organized and circulated by The British Council, London (brochure, modified version of brochure accompanying *Bill Brandt: Photographs*, 1970). Traveled to Galerie Municipale Château d'Eau, Toulouse, France, February 2–29, 1976 (brochure, with introduction in French by Jean Dieuzade); Palais des Beaux Arts, Charleroi, Belgium, October 2–31, 1976; Rheinisches Landesmuseum, Bonn, Germany, May 12–June 5, 1977; British Council Office, Vienna, September 1, 1982–February 28, 1983; Neue Galerie der Stadt Linz/Wolfgang-Gurlitt-Museum, Linz, Austria, January 13–February 26, 1983; Centar za Fotografiju, Film i Televiziju, Zagreb, Yugoslavia, September 1983; British Council Office, Cyprus, Greece, December 1, 1983–January 31, 1984; British Council Office, Prague, Czechoslovakia, July 1–August

Selected Exhibition History

Installation views of three exhibitions at The Museum of Modern Art, New York: (top) *Four Photographers* (1948); (facing, left) *Diogenes with a Camera V* (1961); and (facing, right) *Bill Brandt* (1969). The Museum of Modern Art Archives, New York

31, 1987; British Council Office, Havana, Cuba, April 1–May 31, 1988; British Council Office, Bogotá, Colombia, January 1989; British Council Office, Santiago, Chile, April 1989; unknown location, Quito, Ecuador, August 1989; Irish Gallery of Photography, Dublin, December 15, 1992–January 28, 1993; Teatro General San Martin, Buenos Aires, July 5–31, 1994; Centro Cultural Villa Victoria, Mar Del Plata, Argentina, August 5–28, 1994; Centro Cultural Parque de España, Rosario, Argentina, September 2–26, 1994; Centro Cultural Adolfo Calle, Mendoza, Argentina, October 7–30, 1994; Galería Fotograma, Tucumán, Argentina, November 12–December 12, 1994. *Information for this exhibition, including venues and exhibition dates, was compiled based on the records of the British Council, which are incomplete.*

Bill Brandt. Marlborough Gallery, New York. March 27–April 17, 1976 (catalogue). Traveled to Marlborough Fine Art, London, November 1976–January 15, 1977.

Bill Brandt. Moderna Museet/Fotografiska Museet, Stockholm. January 21–February 26, 1978 (brochure, with text by Rune Jonsson). Prints from the collection of Fotografiska Museet and Marlborough Fine Art Ltd., London.

1980s

Photographs by Bill Brandt. Organized by the International Exhibitions Foundation, Washington, D.C., with prints from the collection of the Victoria and Albert Museum, London (brochure, with introduction by Mark Haworth-Booth). Traveled to University of Oklahoma Museum of Art, Norman, Oklahoma, January 1–February 15, 1981; Seattle Art Museum, March 5–April 12, 1981; Winnipeg Art Gallery, Manitoba, May 1–June 15, 1981; Dalhousi Art Gallery, Dalhousi University, Halifax, Nova Scotia, July 1–August 15, 1981; Worcester Art Museum, Massachusetts, September 1–October 15, 1981; Glenbow Museum, Calgary, Alberta, November 1–December 15, 1981; Edmonton Art Gallery, Alberta, January 1–February 15, 1982; Surrey Arts Centre, British Columbia, March 1–April 15, 1982; National Gallery of Canada, Ottawa, May 1–June 20, 1982; Saidye Bronfman Centre, Montreal, July 1–24, 1982; Herbert F. Johnson Museum of Art, Cornell University, Ithaca, New York, August 15–September 30, 1982; Art Gallery of Ontario, Toronto, October 15–November 30, 1982; International Center of Photography, New York, April 8–May 8, 1983.

Bill Brandt: A Retrospective Exhibition. The Royal Photographic Society, National Centre of Photography, Octagon Gallery, Bath, United Kingdom. April 15–July 4, 1981 (catalogue). Prints from the collections of the Imperial War Museum, London, the Victoria and Albert Museum, the Royal Photographic Society, and the Arts Council of Great Britain. Circulated by the Arts Council of Great Britain as *Bill Brandt: Photographs* to the following venues in the United Kingdom: Poole Arts Centre, February 20–March 27, 1982; Quay Arts Centre, Newport, April 10–May 8, 1982; Usher Gallery, Lincoln, May 15–June 20, 1982; Ikon Gallery, Birmingham, June 26–July 31, 1982; Elizabethan Exhibition Gallery, Wakefield, August 7–September 11, 1982; Darlington Arts Centre, September 20–October 23, 1982; The Minorities, Colchester, November 2–December 5, 1982; Ramsgate, Library Gallery, December 11, 1982–January 15, 1983.

Bill Brandt: Portraits. National Portrait Gallery, London. May 7–August 22, 1982 (brochure, with text by Richard Ormond).

Atelier Man Ray, 1920–1935: Berenice Abbott, Jacques-André Boiffard, Bill Brandt, Lee Miller (group exhibition). Centre Georges Pompidou, Paris. December 2, 1982–January 23, 1983 (catalogue).

Bill Brandt: War Work. The Photographers' Gallery, London. June 24–September 3, 1983 (brochure, with introduction by Rupert Martin).

Literary Britain: Photographed by Bill Brandt. Victoria and Albert Museum, London. March 6– May 20, 1984 (catalogue).

Bill Brandt: Behind the Camera, Photographs 1928–1983. Organized and circulated by the Philadelphia Museum of Art, June 15–September 22, 1985 (catalogue). Prints from the collections of the Brandt Estate, Rolf Brandt, and Marlborough Fine Art, London. Traveled to Aperture Foundation, Burden Gallery, New York, April 8–June 7, 1986; Port Washington Public Library, New York, July 1–August 27, 1986; Detroit Institute of Arts, May 30–July 26, 1987; San Francisco Museum of Modern Art, November 14, 1987–January 10, 1988; New Orleans Museum of Art, April 29–June 19, 1988; The John and Mable Ringling Museum of Art, Sarasota, Florida, July 23–September 11, 1988; Columbus Museum of Art, Ohio, November 19, 1988–January 8, 1989.

Bill Brandt: Vintage Photographs. Edwynn Houk Gallery, Chicago. November 22, 1985–January 4, 1986 (catalogue). Traveled to Pace/MacGill Gallery, New York, May 2–August 4, 1986.

1990s

Bill Brandt: Photographs, 1928–1983. Barbican Art Gallery, London. September 30–December 12, 1993 (catalogue). Traveled to Mead Gallery, Coventry, United Kingdom, January 8–February 12, 1994; Centre National de la Photographie, Paris, December 14, 1994–February 27, 1995; Fotomuseum Winterthur, Zurich, November 11, 1995–January 7, 1996.

Bill Brandt: The Assemblages and Associated Vintage Prints, 1967–1974. Reed's Wharf Gallery, London. September 30–October 30, 1993 (brochure, with text by Nigel Warburton).

Bill Brandt. Musée National Fernand Léger, Biot, France. September 6–October 6, 1996.

Bill Brandt: A Retrospective. Organized by the Bill Brandt Archive and circulated by Curatorial Assistance, Pasadena, California (catalogue). Traveled to International Center of Photography, New York, August 26–October 31, 1999; Museum of Photographic Arts, San Diego, California, October 28, 2001–January 6, 2002; Monash Gallery of Art, Wheeler's Hill, Victoria, Australia, July 14–September 1, 2002; National Portrait Gallery of Australia, Canberra, September 13–November 10, 2002; Milwaukee Art Museum, Wisconsin, December 13, 2002–February 9, 2003; Yale Center for British Art, New Haven, Connecticut, April 16–July 20, 2003; Naples Art Museum, Florida, November 1, 2003–February 1, 2004; Victoria and Albert Museum, London, March 22–July 25, 2004; National Museum of Photography, Copenhagen, August 25–October 30, 2004; Aberystwyth Arts Centre, University of Wales, United Kingdom, July 27–September 3, 2005; Fondation Henri Cartier-Bresson, Paris, September 21–December 18, 2005; Boca Raton Museum of Art, Florida, June 28–August 27, 2006; Albuquerque Museum, New Mexico, March 2–May 18, 2008; Bermuda National Gallery, Hamilton, September 28–December 24, 2008.

2000s

Bill Brandt: A Centenary Retrospective and Other Sides of Bill Brandt. Victoria and Albert Museum, London. March 24–July 25, 2004.

Bill Brandt: Portraits 1982. National Portrait Gallery, London. May 7–August 22, 2004.

Bill Brandt: Shadows and Substance. Organized and circulated by art2art Circulating Exhibitions, New York. Traveled to University Museums, University of Delaware, Newark, October–December 2007; Akron Art Museum, Ohio, May 31–August 24, 2008.

Photographs by Bill Brandt: A Sense of Wonder. Museum of Fine Arts, Houston. February 2–April 27, 2008.

Bill Brandt: Photographs 1932–1957, and Books. Bernard Quaritch, London. May 15–June 12, 2008 (catalogue).

Bill Brandt. Chris Beetles Gallery, London. June 23–July 18, 2009 (catalogue).

BOOKS BY THE ARTIST

The English at Home. Introduction by Raymond Mortimer. London: B. T. Batsford Ltd., 1936.

A Night in London. Introduction by James Bone. London: Country Life; New York: Charles Scribner's Sons, 1938. Published as *Londres de Nuit*, with introduction by André Lejard, Paris: Arts et Métiers Graphiques, 1938.

Camera in London. Introduction by Bill Brandt and text by Norah Wilson. London: The Focal Press, 1948.

Literary Britain. Introduction by John Hayward. London: Cassell and Company Ltd., 1951.

Perspective of Nudes. Preface by Lawrence Durrell and introduction by Chapman Mortimer. London: The Bodley Head; New York: Amphoto, 1961. Published as *Perspectives sur le Nu*, Paris: Les Éditions Prisma, 1961.

Shadow of Light: A Collection of Photographs from 1931 to the Present, first edition. Introduction by Cyril Connolly and notes by Marjorie Beckett. London: The Bodley Head; New York: The Viking Press, 1966. Published as *Ombres d'une Île: Une collection de photographies de 1931 à nos jours*, with introduction by Michel Butor, Paris: Éditions le Bélier-Prisma, 1966.

The Land: Twentieth Century Landscape Photographs Selected by Bill Brandt. Edited by Mark Haworth-Booth. Texts by Jonathan Williams, Aaron Scharf, and Keith Critchlow. London: The Gordon Fraser Gallery Ltd., 1975; New York: Da Capo Press, 1976.

Shadow of Light, second edition. Original introduction by Cyril Connolly with additional introduction by Mark Haworth-Booth. London: The Gordon Fraser Gallery Ltd.; New York: Da Capo Press, 1977. Published as *Ombre de Lumière*, Paris: Chêne, 1977.

Bill Brandt: Nudes 1945–1980. Introduction by Michael Hiley. London: The Gordon Fraser Gallery Ltd.; Boston: The New York Graphic Society/Little, Brown and Company, 1980.

Bill Brandt: Portraits. Introduction by Alan Ross. London: The Gordon Fraser Gallery Ltd.; Austin: University of Texas Press, 1982.

London in the Thirties: Bill Brandt. Introduction by Mark Haworth-Booth. London: The Gordon Fraser Gallery Ltd., 1983; New York: Pantheon Books, 1984.

Literary Britain, second edition. Foreword by Sir Roy Strong and original introduction by John Hayward with additional text by Tom Hopkinson and afterword by Mark Haworth-Booth. London: Victoria and Albert Museum, in association with Hurtwood Press, 1984.

BOOKS ABOUT THE ARTIST

Bill Brandt. Introduction by Norman Hall. New York and London: Marlborough, 1976.

Bill Brandt: A Retrospective Exhibition. Foreword by Valerie Lloyd and introduction by David Mellor. Bath, United Kingdom: The Royal Photographic Society, National Centre of Photography, 1981.

Bill Brandt. Introduction and afterword by Mark Haworth-Booth. Milan: Gruppo Editoriale Fabbri S.P.A., 1982 (Italian edition); Paris: Union des Editions Modernes, 1984 (French edition).

Sers, Philippe, ed. *Atelier Man Ray 1920–1935: Berenice Abbott, Jacques-André Boiffard, Bill Brandt, Lee Miller*. Essay by Roméo Martinez. Paris: Centre Georges Pompidou, 1982.

Bill Brandt: Behind the Camera, Photographs 1928–1983. Text by Mark Haworth-Booth and David Mellor. Oxford, United Kingdom: Phaidon; New York: Aperture, 1985.

Bill Brandt: Vintage Photographs. Introduction by David Travis. Chicago, Illinois: Edwynn Houk Gallery, 1985.

Roegiers, Patrick. *Bill Brandt: Essai*. Paris: Pierre Belfond, 1990.

Jeffrey, Ian, ed. *Bill Brandt: Photographs, 1928–1983*. London: Thames and Hudson, in association with the Barbican Art Gallery, 1993.

Cheatle, Zelda, and Adam Lowe, eds. *Bill Brandt: The Assemblages*. Kyoto, Japan: Kyoto Shoin, 1993.

Warburton, Nigel, ed. *Bill Brandt: Selected Texts and Bibliography*. Oxford, United Kingdom: Clio Press, 1993.

Bill Brandt. Introduction by Ian Jeffrey. Paris: Centre nationale de la photographie/Photo Poche, 1994 (French edition); New York: Thames and Hudson/Photofile, 2007 (English edition); Tokyo: Sogensha Japan, 2012 (Japanese edition).

Brandt: The Photography of Bill Brandt. Foreword by David Hockney and essays by Bill Jay and Nigel Warburton. London: Thames and Hudson; New York: Harry N. Abrams, 1999.

Brandt Icons. Text by Nigel Warburton. London: Bill Brandt Archive, 2004.

Brandt Nudes: A New Perspective. Original preface by Lawrence Durrell from *Perspective of Nudes* with additional text by Mark Haworth-Booth. London: Bill Brandt Archive, 2004 (limited edition); London: Thames and Hudson, 2012 (trade edition).

Delany, Paul. *Bill Brandt: A Life*. Stanford, California: Stanford University Press, 2004.

James, Peter, and Richard Sadler. *Homes Fit for Heroes: Photographs by Bill Brandt, 1939–1943*. Stockport, United Kingdom: Dewi Lewis Publishing, 2004.

Bill Brandt: Photographs 1932–1957 and Books. London: Bernard Quaritch Ltd., 2008.

Huxley-Parlour, Giles, ed. *Bill Brandt*. Text by David Wootton. London: Chris Beetles Ltd., 2009.

Selected Bibliography

All books listed in chronological order

PHOTO CREDITS

All works by Bill Brandt are © 2013 Bill Brandt Archive Ltd.

Unless listed below, photographs of works of art reproduced in this volume have been provided by the owners or custodians of the works, who are identified in the captions or in the list of plates.

Individual works of art appearing here may be protected by copyright in the United States or elsewhere and may not be reproduced without the permission of the rights holders. In reproducing the images contained in this publication, the Museum obtained the permission of the rights holder whenever possible. Should the Museum have been unable to locate a rights holder, notwithstanding good-faith efforts, it requests that any contact information concerning such rights holders be forwarded, so that they may be contacted for future editions.

Courtesy Vince Aletti © 2013 Hearst Magazines; photography by David Allison: pages 29, 202–3 (bottom).

Courtesy David Dechman and Michel Mecure; photography by David Allison: pages 43, 119, 120 (left), 125, 146, 150, 153 (right), 155–58, 159 (right), 162–64, 172–73, 175 (right), 176–77.

Courtesy Pryor Dodge; photography by David Allison: pages 14, 17 (right).

Courtesy Edwynn Houk Gallery/Bill Brandt Archive; photography by David Allison: pages 17 (left), 25, 38, 40, 42, 44–45, 50, 51 (left), 57–60, 62–63, 65, 68, 72–74, 76, 81–83, 86–88, 90–91, 93, 97–98, 104 (left), 105 (left), 110–12, 115, 124, 127–29, 134–35, 142, 152, 159 (left).

Courtesy Michael Mattis; photography by David Smith: pages 36, 80, 102.

Courtesy The Metropolitan Museum of Art. Image Source: Art Resource, NY: pages 39, 100, 151.

The Museum of Modern Art, New York, Imaging and Visual Resources: page 126; photography by David Allison: pages 35, 37, 49, 51 (right), 61, 64, 85, 94, 96, 98 (right), 99, 104 (right), 109, 114, 116, 122–23, 136, 138, 143, 154, 165, 180; photography by Peter Butler: pages 195–203 (except as indicated elsewhere here); photography by Thomas Griesel: pages 15, 18, 23, 26, 34, 46, 52, 54, 92, 95, 103, 121, 145, 147, 170, 178; photography by James Mathews: page 205 (right); photography by Soichi Sunami: pages 204, 205 (left); photography by John Wronn: pages 33, 41, 48, 53, 55–56, 67, 69, 71, 75, 77–79, 89, 106, 113, 115 (right), 117–18, 120 (right), 131–33, 137, 139, 140–41, 149, 153 (left), 160–61, 166–69, 171, 174, 175 (left), 177, 179, 181.

Courtesy Robert Stevens; photography by David Allison: pages 200, 201 (top).

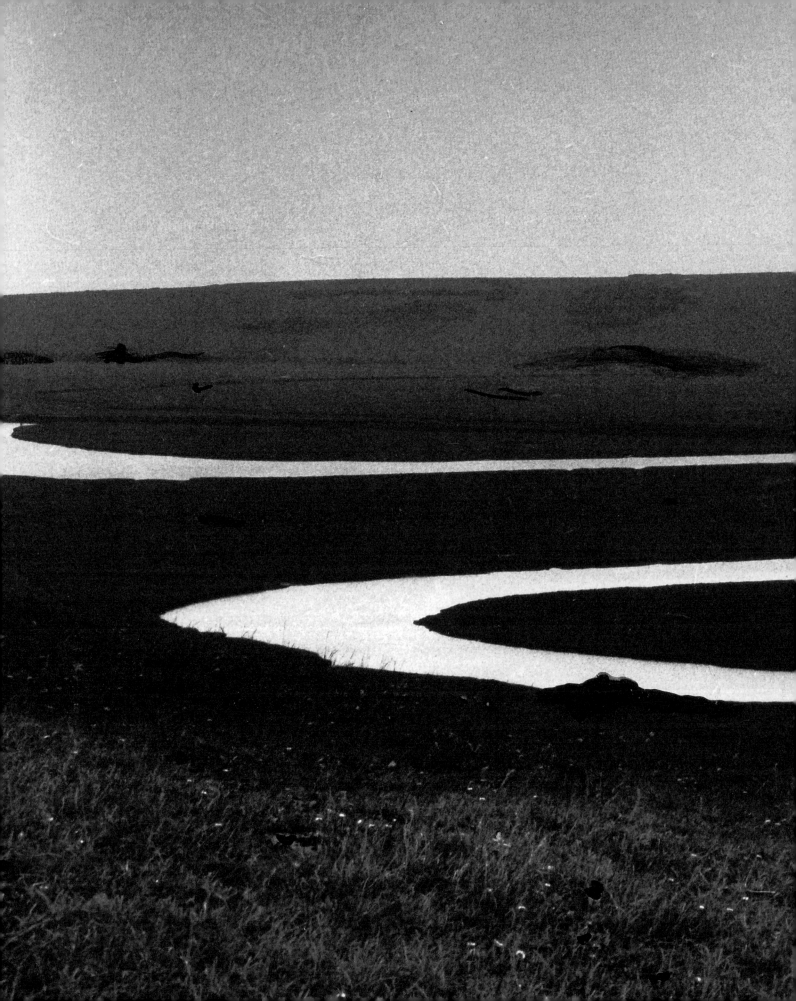